SCHIELE

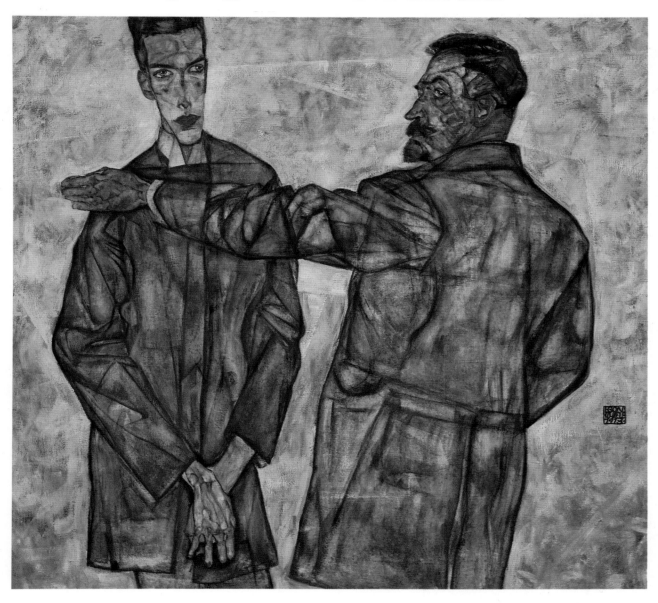

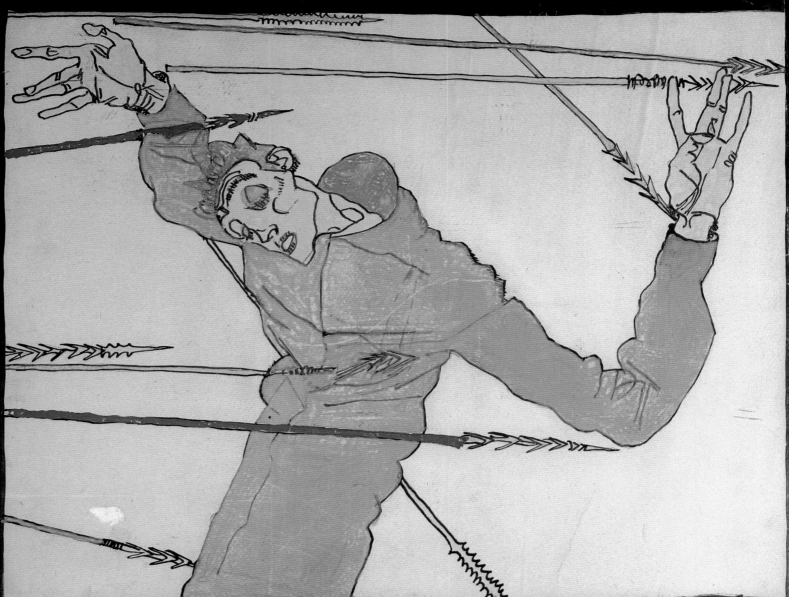

SCHIELE

Tim Marlow

KNICKERBOCKER
PRESS

Published in 1999 by Knickerbocker Press
276 Fifth Avenue
New York, New York 10001

Produced by PRC Publishing Ltd
Kiln House, 210 New Kings Road
London SW6 4NZ

ISBN 1 57715 096 1

Printed in China

For Beth, without whom this book
would have been completed a great deal
sooner.

Page 1: *Double Portrait (Otto and
Heinrich Benesch)*, 1913

Page 2: *Self-Portrait as Saint Sebastian,
1914-15*

Contents and List of Plates

Introduction

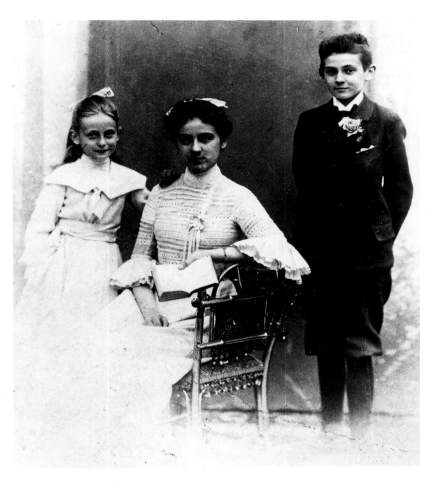

He is a child, an adolescent, a mature and old man at the same moment. A child who possesses the maturity of all experience, an adolescent who feels himself to be dying, a man for whom all the abundant energy of youth has not evaporated, an old man who lives in the sweet dreams of childhood.

When Egon Schiele died, on 31 October 1918, he was twenty-eight years old. Artistically, spiritually, physically, he was in the prime of his life and yet there remains the overriding feeling that in many ways his oeuvre was complete. Ironically, Schiele had only just begun to receive the critical acclaim which he had sought, bitterly at times, over the previous ten years, but just as other Expressionist painters like Kirchner, Nolde, and even, in some respects, Kokoschka can be seen to have lost a power and vitality in their art during World War I, so Schiele's art had lost much of its disquieting and expressive force by 1918. 'He had,' Hans Tietze wrote in an obituary, 'expended all his vitality racing across a narrow space.'

At its most cynical, the argument might be construed to mean that he died at the right moment, at a time when his art seemed to have developed from angst-ridden urgency to a stage of gentle sensitivity, even sentimentality, and in circumstances which are totally in keeping with the sense of personal tragedy so strong throughout his life. In the final analysis

this is unfair, but nevertheless sets the tone for a brief examination of an artistic career full of contradictions: of an artist who often basked in indulgent self-pity yet who felt a genuine sense of isolation and persecution; whose insight and emotions range from childlike to adolescent to adult to those of an old man, often within one painting. Schiele examined and expressed a variety of themes and subject-matter but the majority of his works deal unequivocally with mankind, body and soul (or 'psyche' to be more historically apt). Working at the beginning of a century in which the human figure rapidly became marginalized as valid artistic subject-matter and remained so for decades within the 'mainstream' tradition, Egon Schiele nevertheless presents a body of work rarely surpassed in the history of Western art in terms of its perception and analytical human intensity.

Art historians have a tendency to categorize artists within stylistic groups and the twentieth century has witnessed this virtually to the point of excess. Schiele's short career spanned a period of immense stylistic variety with a corresponding variety of categorization, invariably with the suffix 'ism.' Within what is simplistically regarded as the mainstream European tradition (but which is essentially French or Paris-centered), Post-Impressionism, Fauvism, and Cubism waxed and all but waned. Schiele stands outside

this tradition but the tendency remains to locate him firstly as emerging from a more broadly European idiom, that of Symbolism, but ultimately within a Germanic-based mode of art, loosely entitled 'Expressionism.' While this tendency has some justification, Schiele must be viewed first and foremost as the product of fin-de-siècle Vienna, a cultural nexus every bit as vital as Paris at the turn of the century. This has posed considerable difficulties for those scholars rooted in a narrow linear approach to art history; as Schiele is often perceived as being on the fringes of twentieth-century art, he has consequently often been unfairly denied the status of a major artist.

Schiele was born on 12 June 1890, in Tulln, a small town on the Danube in Lower Austria, some twenty miles west of Vienna. Tulln was a station town on the main railroad which linked Vienna to the cities of Western Europe and his father was station master. At the age of eleven he went to school in nearby Krems, living with relatives, and a year later he rejoined his family in Klosterneuburg in the northern outskirts of Vienna. Even in childhood, therefore, Vienna loomed large in Schiele's life.

In 1906, precociously gifted, he submitted some drawings to the Kunstgewerbeschule (or School of Arts and Crafts) in Vienna and was subsequently advised to apply to the more prestigious,

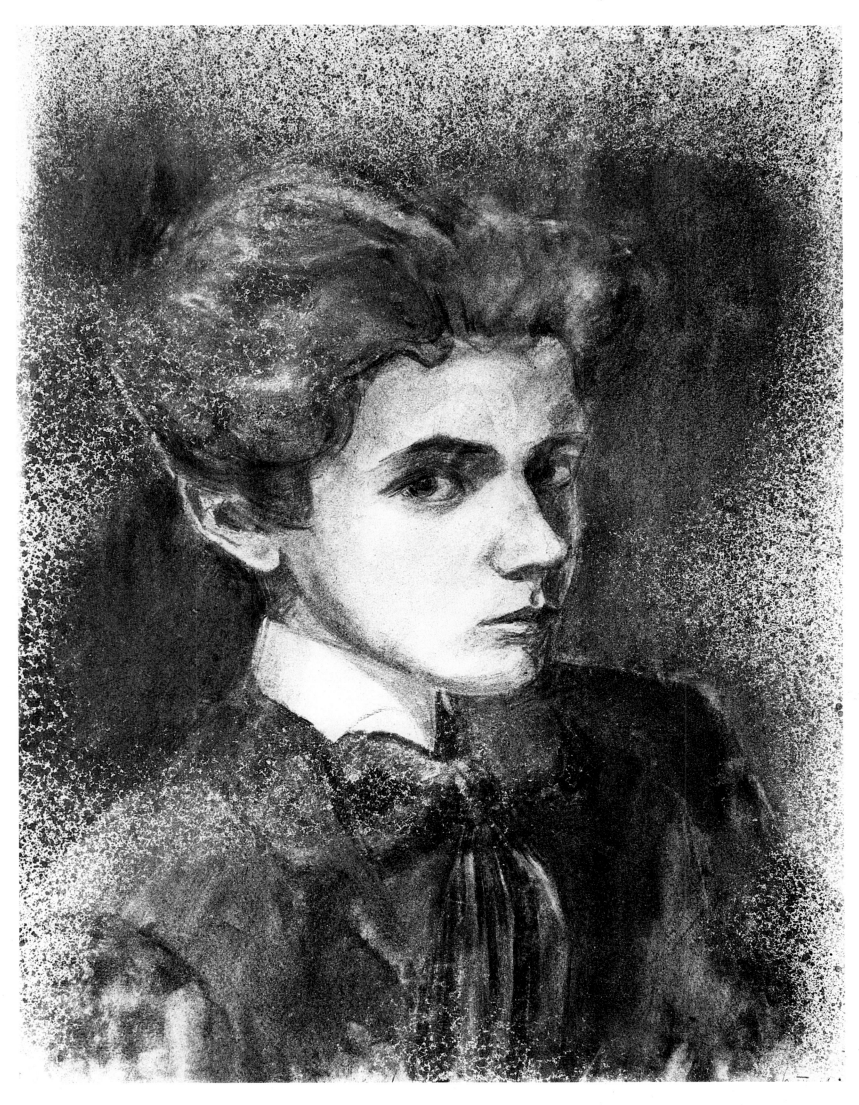

Left: Egon Schiele and his two sisters, Gerti and Melanie, photographed around 1903.

Above: *Self-Portrait*, 1906. The graphic precision and melancholic expressiveness which typified so much of Schiele's art had already begun to emerge even before the young artist went to the Academy of Fine Arts in Vienna.

if more traditional, Academy of Fine Arts. He passed the entrance examination in October and duly enrolled in Professor Christian Griepenkerl's painting class. Although he frequently left Vienna for short periods throughout his life, and had a strong love/hate relationship with the city, by the time Schiele was 16, Vienna had become the center stage on which his career was enacted.

Vienna was the capital of the vast, multi-racial and essentially anachronistic Austro-Hungarian Empire. It was also known as the Dual Monarchy, which is appropriate because of the widespread sense of duality that pervaded much of Viennese life by the turn of the century. After the revolution of 1848, the Empire underwent a period of rapid and large-scale industrialization together with a corresponding surge in bourgeois prosperity particularly among Viennese merchants, bankers, and financial speculators. Vienna expanded with great rapidity, increasing its population fourfold to two million by 1900, with the migration of hundreds of thousands of Slavs, Czechs, Magyars, Jews, and other subjects from the less prosperous eastern part of the Empire, for whom cosmopolitan Vienna offered seemingly rich opportunities. Stefan Zweig, whose family were wealthy industrialists, wrote in his autobiography of the optimism generated by late nineteenth-century Viennese prosperity:

This belief in an uninterrupted, inexorable 'progress' had for that era in truth the force of religion; indeed, people believed in 'progress' even more than in the Bible, and this belief appeared justified by the daily wonders of mechanics and science. A general raising of standards became ever-more perceptible, more rapid, more widespread as this century of peace drew to a close.

In fact, 'progress' had its costs: there were two sides to Vienna whose slums, mainly inhabited by immigrants, were among the worst in Europe. The city had a chronic housing shortage, the suicide rate increased dramatically, and prostitution was rife.

Political power remained with the aristocracy led by Emperor Franz Josef, who had celebrated 50 years of rule in 1898. Consequently, and with the aid of an elaborate bureaucracy, stability was maintained through a deepset conservatism. Despite scientific and technological advance, an intellectual stagnation was evident among the ruling classes which spread into the academic and cultural institutions of the city. In the words of the essayist Hermann Barr: 'Nothing happens here, absolutely nothing.'

This image contrasts strongly with the view of Vienna as the 'cultural laboratory of the world,' the Vienna of Schnitzler

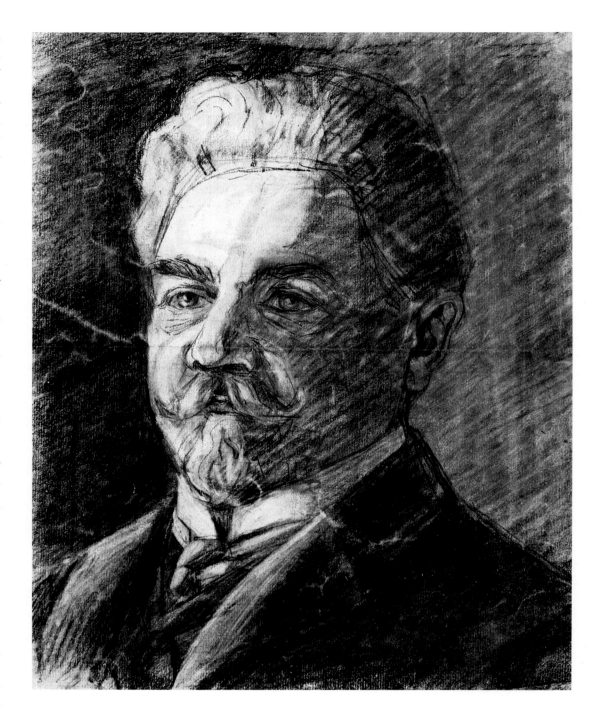

and Freud, of Mach and Wittgenstein, of Mahler and Schoenberg. What linked an essentially disparate cultural avant-garde was the desire to transcend the superficially stable but ultimately sham façade of the city, what the architect Adolf Loos called 'Potemkin city,' to acknowledge the hidden life of the city and to confront the problems of human existence directly, without pretence. Within three years of arriving in Vienna as an enthusiastic adolescent, Egon Schiele shared these concerns and had begun to strip away what he saw as the shallow façade of traditional portrait painting in a quest for a deeper 'psychic' reality.

The Vienna Academy of Fine Arts maintained a disciplined and traditional curriculum, unchanged in over a century. Schiele spent the first year drawing from plaster-cast human figures and learning the rudiments of academic art history. Only then were pupils exposed to life-drawing classes. His mother recalled how as a young boy, Schiele would spend hours alone drawing the surrounding landscape and in particular the trains at

Above: *Portrait of Leopold Czihaczek*, 1906. Czihaczek, Schiele's uncle, became his legal guardian after the death of Schiele's father at the beginning of 1905.

Right: *Portrait of Marie Schiele*, 1918. A gentle drawing of Schiele's mother; relations between mother and son were often strained.

his father's station. An early self-portrait in pencil and colored chalk from 1905 and charcoal drawings of his family in 1906 bear testament to the ease and speed with which he handled line and his ability to capture precise likeness. Even in his late, more painterly style, Schiele remained, first and foremost, a proficient draftsman.

Armed with a raw but distinct talent he responded initially to formal artistic training. It was not long, however, before he became bored by the restraints imposed upon the students at the Academy and he began to clash with his austere teacher. 'God has shat you into my class-

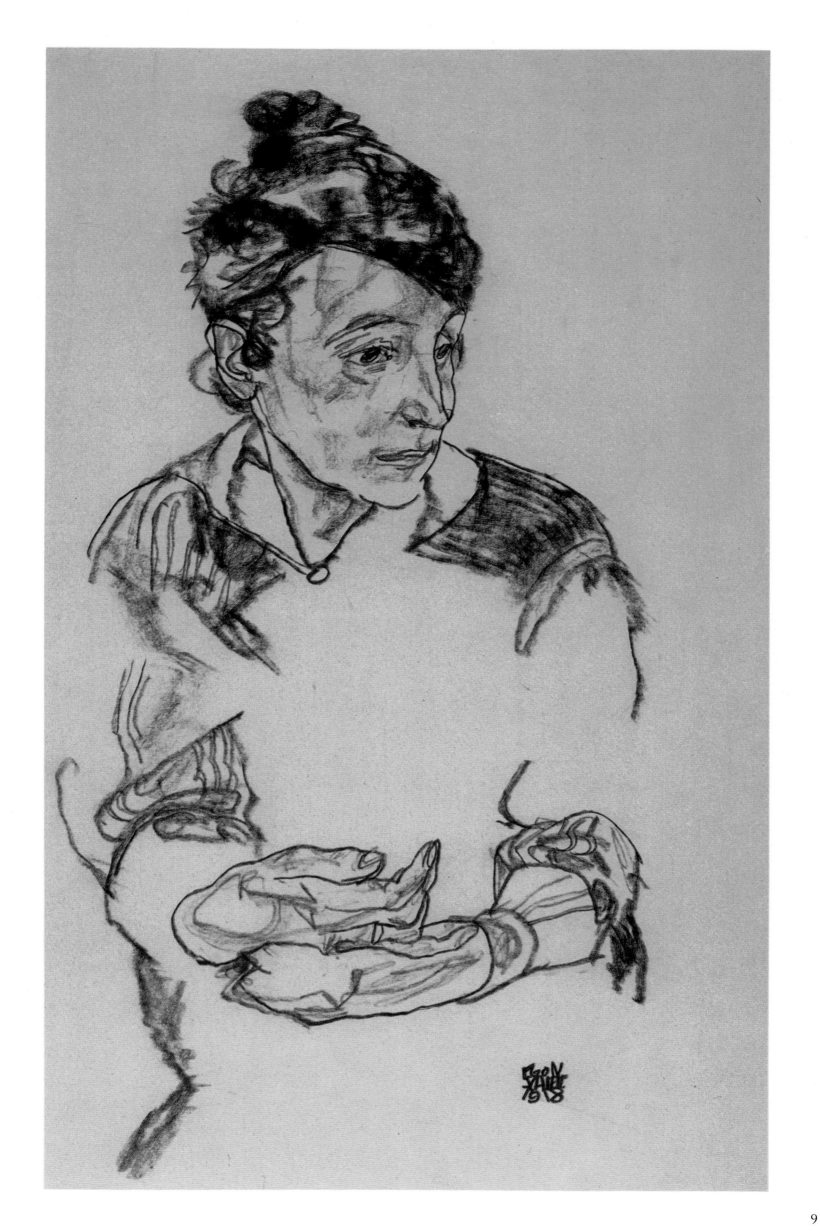

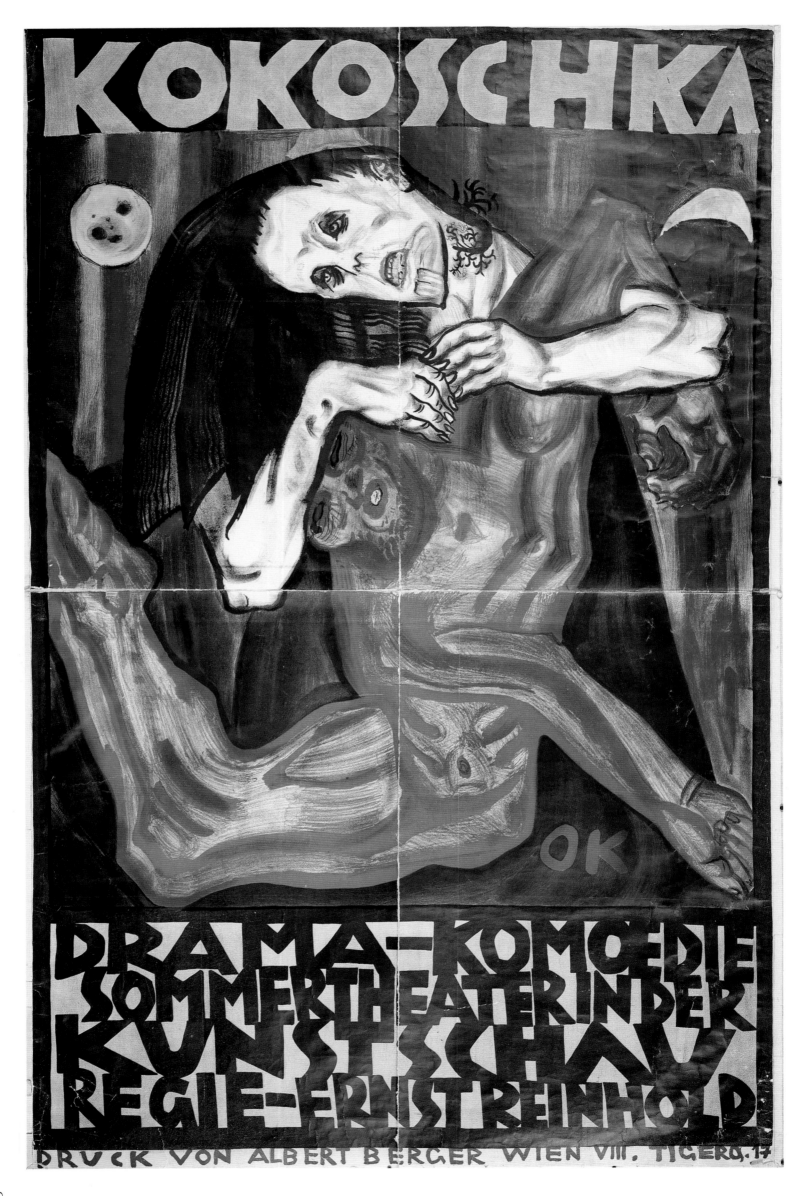

room,' Griepenkerl was reported to have roared at the arrogant young Schiele, and on another occasion demanded: 'For God's sake don't tell anyone that I was your teacher!'

Writing in 1910, Schiele recalled how even during his childhood: 'My loutish teachers were my perpetual enemies. They – and others – did not understand me.' This does not appear to be strictly true, for at high school in Klosterneuburg Schiele had been taught by the sympathetic and encouraging Ludwig Karl Strauch who had suggested, against his mother's wishes, that Schiele apply to art school in Vienna. Schiele's sense of persecution does stem, however, from a traumatic childhood. In January 1905, when Schiele was only fourteen, his father died of progressive paralysis probably brought on by syphilis contracted before marriage. For over a year, Adolf Schiele had become increasingly stricken by mental as well as physical illness, and by the time he died he was clinically insane. It is difficult to understand fully the effects of such a tragedy on an adolescent, but clearly they would be deep and profound. Eight years afterwards Schiele wrote in a letter:

I don't know whether there's anyone else at all who remembers my noble father with such sadness. I don't know who is able to understand why I visit those places where my father used to be and where I can feel the pain . . . I believe in the immortality of all creatures. . . . Why do I paint graves and many similar things? – because this continues to live on in me.

In tone and sentiment, there is something loosely akin to Hamlet in this letter. Schiele's relationship with his mother was frequently strained, as he believed that she neglected the memory of her husband and failed to understand or sympathize with her son:

My mother is a strange woman . . . she doesn't understand me in the least and doesn't love me much, either. If she had either love or understanding she would be prepared to make sacrifices.

Marie Schiele had little money after her husband's death and was forced to 'sacrifice' Schiele to the care of a guardian, his uncle, Leopold Czihaczek. This, and the fact that Czihaczek and Schiele did not get on, compounded the boy's sense of personal tragedy and grief. After 1911 they no longer communicated.

Left: A poster design, *Pietà*, by Oskar Kokoschka for the garden theater at the 1908 Kunstschau in Vienna. Eros and Thanatos were central themes in the art of both Schiele and Kokoschka.

Above right: Edvard Munch, *Puberty*, 1895. The anguished, often sensual, symbolism of the Norwegian artist struck a sympathetic chord with Schiele and his Viennese contemporaries.

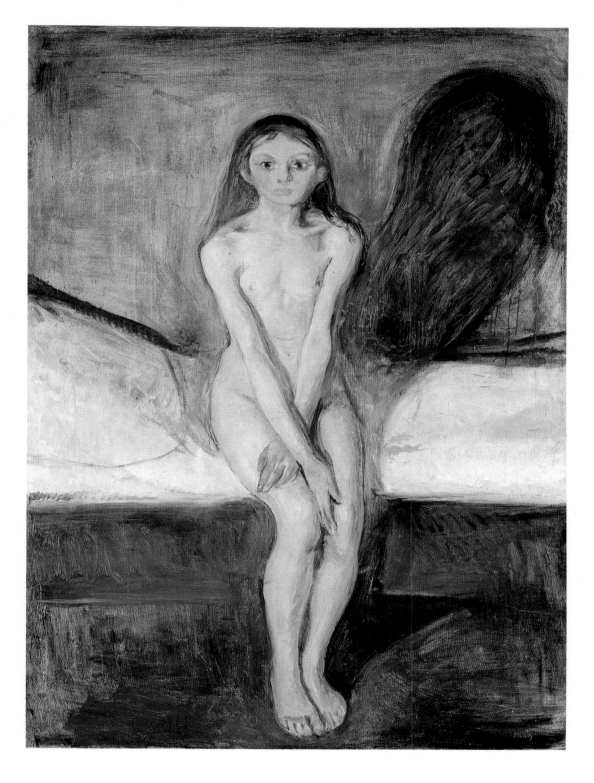

Schiele's clash with authority, with Griepenkerl, had artistic origins. Back in 1898, a group of radical architects, designers, and painters had formed the Austrian Association of Visual Artists, otherwise known as the Vienna Secession, in order to provide an alternative means of exhibiting their art in public. This was in response to the virtual stranglehold exerted on the artistic life of the city by the Genossenschaft bildender Künstler or Association of Visual Artists, formed in 1861, with the only large, public exhibition space in Vienna. Unofficially but effectively allied with the Academy, a conservative conspiracy developed and by the end of the century the opportunity to exhibit 'advanced' art was virtually nil. The Secession set out both to shock and educate a narrow-minded public and to challenge a complacent and insular art establishment. The Secessionists felt an urgent necessity:

to bring artistic life in Vienna into more lively contact with the continuing development of art abroad, and of putting exhibitions on a purely artistic footing, free from any commercial considerations; of thereby awakening in wider circles a purified, modern view of art.

In effect, the Secession formed the basis for a visual artistic assault on Vienna. Josef Maria Olbrich's Secession building, nicknamed the 'Cabbage Head' because of its dramatic, bulbous domed roof, was one of the earliest 'cracks' to appear in the sham façade of nineteenth-century imperialist architecture.

In spite of, or perhaps because of, the variety of international and Viennese artists who were shown annually by the Secession, Griepenkerl actively discouraged his students from visiting Secession exhibitions. This simply made them seem more attractive and incited a greater curiosity among the young artists, not

least of which was Egon Schiele.

Schiele's exposure to contemporary art coincided with and enhanced a desire 'to explore, to invent, to discover,' as he wrote in 1911. The art of his early years in Vienna reflects an awareness of a number of different artists ranging from Ferdinand Hodler and Edvard Munch, Swiss and Norwegian painters respectively, to the Belgian sculptor Georges Minne whose attenuated figures ('fleshless gothic bodies' in the words of Oskar Kokoschka) were to play an important role in Schiele's work after 1909. Most evident initially, however, were the influences of Post-Impressionist artists, notably Van Gogh. In his oil painting of *Trieste Harbor* (page 27), the result of a brief sojourn with his younger sister Gerti in 1907, Schiele echoes both the motif and style of Van Gogh's *Boats on the Beach at Saintes Maries-sur-Mer* (1888; Rijksmuseum Vincent van Gogh, Amsterdam). The bright colors and energetic use of thick pigment owe much to Van Gogh. Likewise, Schiele's first in a series of *Sunflowers*, beginning in 1907 and continuing occasionally up to 1917 (pages 30 and 31), seems to stem from an early appreciation of Van Gogh. The most influential of artists for the young Schiele was, however, undoubtedly Gustav Klimt.

Leading painter of his generation, founder-member and first president of the Secession, Klimt dominated Viennese pictorial art in the two decades either side of 1900. He developed a new style of painting which fused the fluid lines, simplified forms, and abstract patterns of Jugendstil, the German counterpart to Art Nouveau, with more complex Symbolist compositions, epitomized by his murals for Vienna University entitled *Philosophy*, *Medicine*, and *Jurisprudence*, created from 1899 to 1907, whose sensuousness and pessimism had led to uproar and ultimately to rejection. Notwithstanding this controversy Klimt was a cause célèbre in himself through his erotic art and his exotic lifestyle full of widely publicized affairs and casual sexual encounters, often with his models. His behavior and dress were enigmatic. He wore a monk-like habit as photographs illustrate, a conscious if obtuse affront to Viennese conservatism contrasting strongly with the vividness of the richly patterned attire with which he emblazoned his artistic subjects.

In 1907, just as the mural controversy began to rage, Schiele sought out Klimt, doubtless making his first acquaintance with the man who was to be an artistic father-figure for him in the café frequented by Klimt and his artistic circle of friends, the Museum Café or 'Café Nihilism' as it was nicknamed. The story is often told of how Schiele took a portfolio

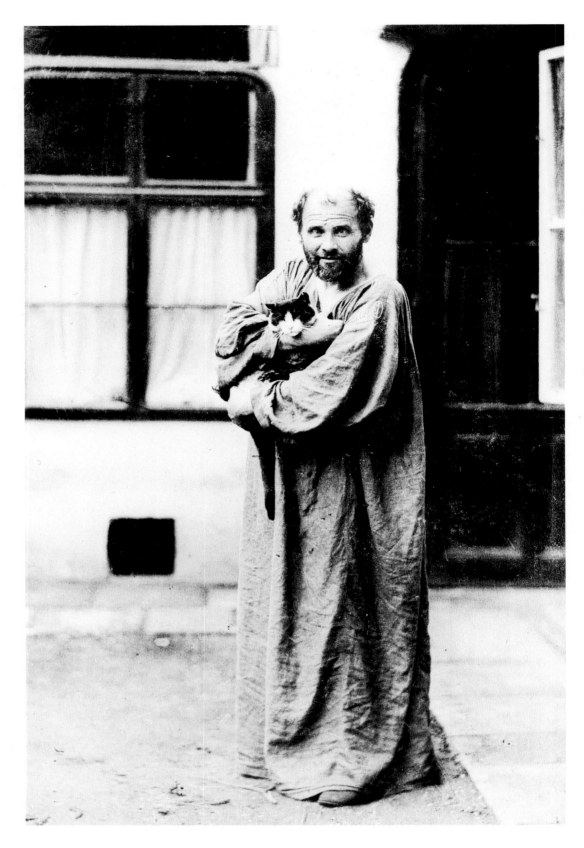

of work to Klimt's studio and asked 'Do I have talent?' to which the older artist replied 'Yes, much too much!'

Klimt did not seek to purge the young artist of his talent nor did he attempt to influence his work directly, but rather as didactic mentor introduced Schiele into advanced artistic circles, including the Wiener Werkstätte (Vienna Workshops), an offshoot of the Secession which designed and produced a range of artifacts, from postcards to clothes, and which Klimt had joined after a widely publicized 'break' with the Secession in 1905. Two paintings in particular illustrate Schiele's immediate response to Klimt: *Watersprites* from 1907 and *Danäe* painted at the end of the year. In both cases Schiele used specific works by Klimt as a starting-point, in terms of subject-matter, style, and even title. Decorative, sensual, and drawing on a similar heritage of mythologically based symbolism, Schiele nevertheless expresses a greater feeling of anxiety and sharpness in his more angular use of line. Similarly, in various decorative flower-paintings of the same period, Schiele used a vertical Jugendstil format of composition together with a Klimtian sense of pessimism, but the preoccupation with death and decay is more striking. But it was only really in 1909 that Schiele entered the battleground on which he was to fight for his own artistic voice.

The *Portrait of Gerti Schiele* (page 40) and *Self-Portrait I* from 1909 only hint at the penetrating analysis of the human

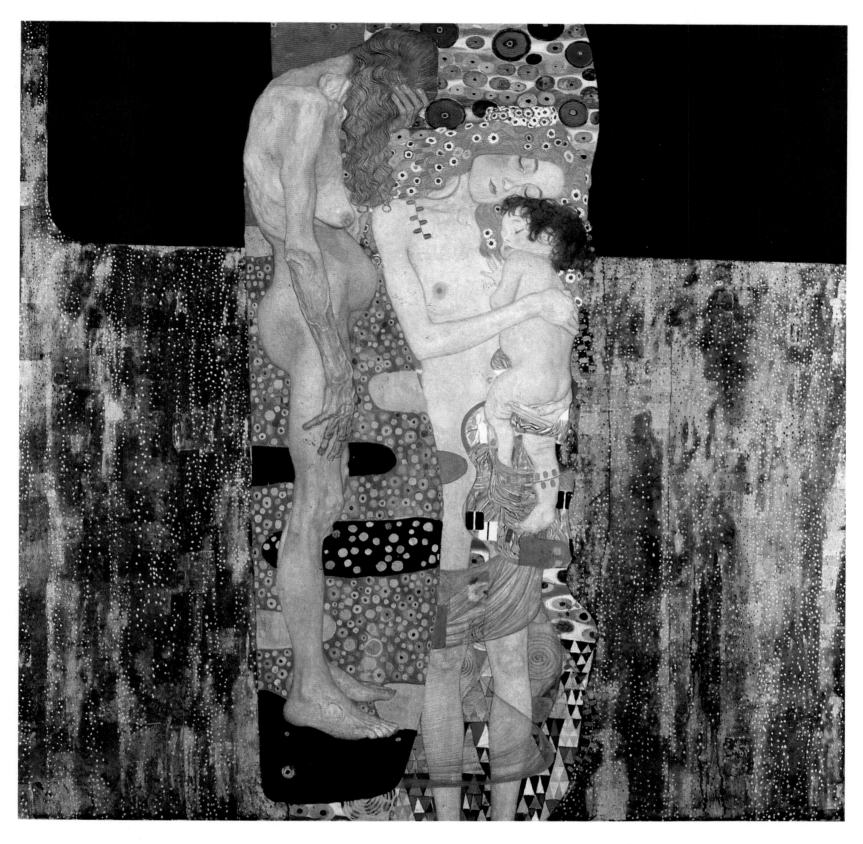

Left: The enigmatic Gustav Klimt, photographed with his cat, c. 1912/14. The monk-like habit seems to have been worn as an obtuse affront to Viennese conservatism and contrasted strikingly with the elaborate attire with which Klimt adorned the figures of his society portraits.

Above: Gustav Klimt, *The Three Ages of Man*, 1905. The painting reaffirms Klimt's preoccupation with decay, mortality, and the cycle of life, concerns which were soon to be taken up by the young Schiele after their first meetings around 1907. Klimt remained an artistic father-figure for Schiele throughout his life. He died in February 1918, a victim of the same influenza epidemic which claimed Schiele's life later that year.

body and psyche which was to follow in a series of radical portraits and self-portraits beginning in 1910. Both share a stylized Klimtian depiction of form, and both use clothes to hide and highlight aspects of nudity and to adorn body and painting with a sense of near-abstract decorative pattern.

The portrait of Gerti has mildly erotic overtones which are confronted explicitly in a fully nude portrayal two years later. Schiele's relationship with his exquisitely pretty sister almost certainly seems to have been sexual on occasion. In 1907 he took her to Trieste, which their parents had visited on their honeymoon, and they stayed in a hotel. More significantly, Gerti and her sister Melanie acknowledged the intense closeness between

brother and sister in interviews with various art historians. Although such biographical detail smacks of salacious gossip, it is an important factor in Schiele's complex sexuality which appears time and again in many aspects of his work and also explains some of the erotic charge in what would otherwise appear to be inexplicably graphic and tense portraits of his sister.

A similar tension and eroticism pervades the self-portrait of 1909, but with greater harshness, conveyed by Schiele's taut, piercing stare. An almost transparent cloth hangs precariously around the body, barely covering the genitals which are grotesquely amplified by a thick black bush of pubic hair which sprouts from beneath the cloth and snakes

13

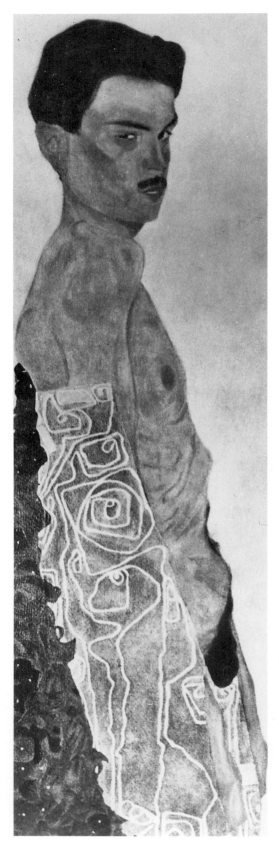

'an isolation cell in which one is not allowed to scream.' In Schiele's *Self-Portrait Screaming* from 1910 (page 57) the isolation cell is both the picture-frame enclosing the nebulous void and his physical body which encases his agonized psyche. The rawness of his anguished gesture is echoed by the red watercolor used. It is this subjectivity and painting embodied with deep feeling which links Schiele's artistic concerns with those of Oskar Kokoschka and Richard Gerstl whose sense of isolation and futility led to his

Left: *Nude Self-Portrait*, 1909. The format of composition, the pronounced flatness, and the decorative use of line owe much to Klimt and to Jugendstil in general. The confronting stare and underlying sexual anguish, however, herald the emergence of Schiele's own artistic voice.

Below: Richard Gerstl, *Self-Portrait Laughing*, 1907. Painted in the year before Gerstl committed suicide, this haunting and disturbed self-image is one of the earliest and most powerful examples of Viennese Expressionism.

suicide in 1908.

In spite of certain shared concerns with other Viennese artists, the closest Schiele came to group identity was around April 1909 when he and several like-minded friends left the academy acrimoniously, having tired of, but completed, the basic three years of study. In December the Neukunstgruppe started an exhibition at the prestigious Pisko gallery. Schiele wrote a manifesto in which he announced: 'Art always remains exactly the same: Art. There is, therefore, no such thing as new art. There are only new artists.' There was no stylistic theorization nor plans to remain as a coherent group. Largely forgotten today, artists such as Anton Peschka (Schiele's future brother-in-law), Anton Faistauer, Paris von Gütersloh and self-styled 'vagabond artist' Erwin Osen were an eclectic bunch of young, vigorous, and, at times, eccentric men whom Schiele painted in the following months in his increasingly individual style. With the notable exception of

its way up to the artist's navel. The cloth or façade which covers the sexual organs, the sexual identity, seems about to fall or be ripped away. On one level, it is a recognizable allusion to Viennese cultural life and on another suggests the artist emerging from a Jugendstil or Klimtian chrysalis.

In both portraits the figures are set against a murky, blank background which conveys an intense feeling of isolation and loneliness. The void becomes the backdrop against which Schiele depicts and analyzes the human form and psyche and, in particular, his own personal angst. The writer Karl Kraus exclaimed at the beginning of the century that Vienna was

the slightly older Kokoschka, who did not associate with the group, Schiele emerges as the leading radical painter.

Whereas Kokoschka had made his major public debut at the Internationale Kunstschau in 1908, organized by Klimt and the Wiener Werkstätte, Schiele's followed a year later at a similar exhibition, likewise organized by, and this time in honor of, Gustav Klimt. Schiele's four paintings did not generate an immediate critical response, but his presence in the show opened up new opportunities. By the end of the year, he had become acquainted with Arthur Roessler, art critic of the *Arbeiter Zeitung* newspaper, the collectors Carl Reininghaus and Dr Oskar Reichel and the publisher Eduard Kosmak. Subsequently Schiele painted their portraits (page 73) and, more importantly, had begun to receive financial and moral support, particularly from Roessler who remained a friend and ally throughout the artist's life.

In 1910 the Wiener Werkstätte published three postcards designed by Schiele, and subsequently Josef Hoffmann arranged for the artist to exhibit with what was labeled the 'Klimt Group' at the International Hunting Exhibition in Vienna. In the fall, work was also shown in Klosterneuburg Abbey – as it had been in 1907 – and consequently, Schiele sold his first painting to Heinrich Benesch, a railway official, soon to become the most extensive collector of the artist's drawings and watercolors. The momentum continued the following year, indeed it escalated after his first one-man show in the Galerie Miethke, when Schiele met the influential Munich art dealer Hans Goltz, who gave a first showing of Schiele's work in Germany. By the end of 1912 Schiele had exhibited at the Munich Secession, with the Hagenbund in Hagen and, most impressively of all, at the major international Sonderbund Exhibition in Cologne. Rapid and increasingly widespread success was tempered with a conservative and hostile critical reception in Vienna. Reference was frequently made to Schiele's 'grotesque depictions' and 'ghostly wraithes' with 'their mutilated, wasted corpses' with the conclusion that 'a genuine talent is in danger of perishing from a thirst for the odd and abstruse.'

Markedly, from 1910 to 1913, to Schiele's art raged with anger and anguish. His anger was vented at the unresponsive or indignant public whom he deliberately set out to shock. Mutilation, death, and decay were fused with explicitly sexual depictions of the human body, which have lost none of their disquieting power eighty years later. His anguish was personal, a mixture of intensity and indulgence, and conveyed in a manner which transcends subjectivity.

Left: *Portrait of Erwin Osen*, 1910. The contorted pose and dramatic hand gestures of Osen, friend and fellow-artist to Schiele, correspond closely to Schiele's self-portraiture which became increasingly anguished and idiosyncratic in 1910.

Below: Moa Mandu and Erwin Osen in performance (exact date unknown). Osen had founded the Neukunstgruppe together with Schiele and other dissatisfied Academy students in the summer of 1909. The following year Osen and his mistress, the exotic and attractive dancer known as Moa, accompanied Schiele to Krumau. The bizarre and often sexually charged gestures which they used in the course of their act seem to have inspired many of the exaggerated theatrical poses adopted by Schiele in his portraiture.

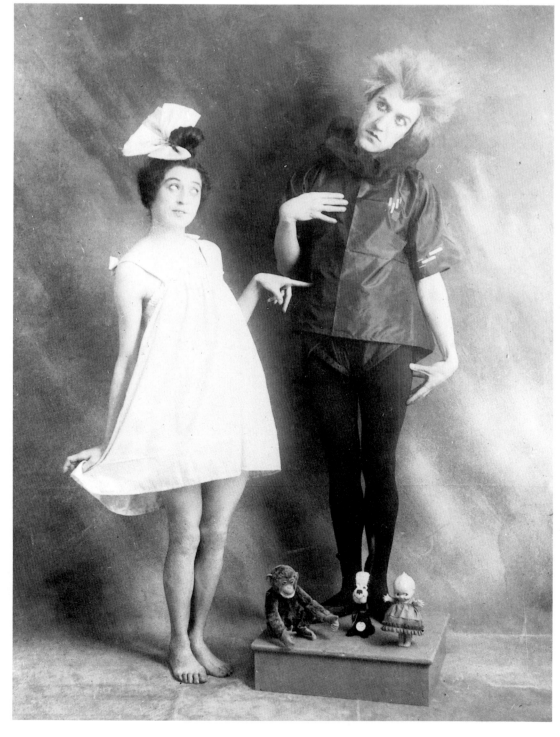

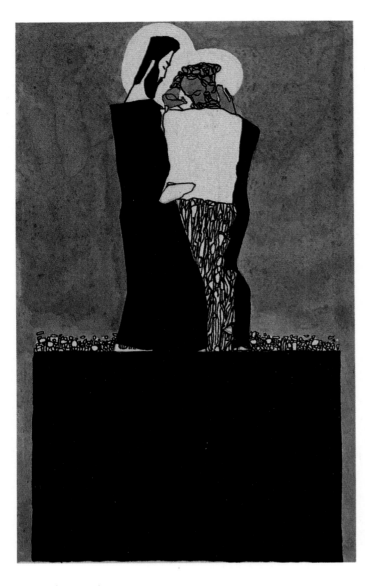

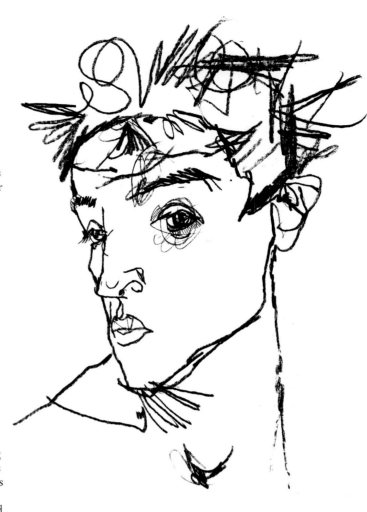

Left: Drawing for a Wiener Werkstätte postcard, 1908. Schiele designed clothes and shoes as well as postcards.

Right: *Self-portrait*, 1913. This rough and almost violent charcoal drawing was made in the year after the artist's imprisonment and the allusion to martyrdom, and to the suffering of Christ in particular, is clearly visible in the rendering of hair as a Crown of Thorns.

Below: *Mother with Child*, 1910. The theme of motherhood in Schiele's work often emphasized the inevitability of death even at the beginning of the life-cycle. This simple line drawing is a rare example of an image of motherhood as fecund, tender, and essentially optimistic.

Underlying everything is a preoccupation with the self.

Schiele produced more self-portraits in his short career than any other artist, Rembrandt included. It is, however, less a matter of quantity and more a matter of intensity, ultimately of self-obsession, which separates Schiele from other self-portraitists. Even in large allegorical compositions and other formal portraits, Schiele appears in various guises. In his 1910 portrait of Arthur Roessler, for example, he presents the critic in an angst-ridden, contorted pose, with hands displayed prominently with long, bony fingers spread open, directly echoing self-portraits from the same period. The self becomes a vehicle for psychological exploration and expression. Painting is both cathartic and narcissistic.

In the nude self-portraits of 1910-11, Schiele exposes himself stripped to the bone: clothes and any trace of ornament have been removed and his gaunt and emaciated body stands alone against a backdrop of nothingness. A sense of theatricality, of exhibitionism, is conveyed via dance-like gestures made with his arms and hands. Often a white halo surrounds his body and radiates energy which contrasts with the withered, decaying flesh. Contorted, grimacing, staring or screaming in front of his studio mirror, Schiele performs while analyzing himself with

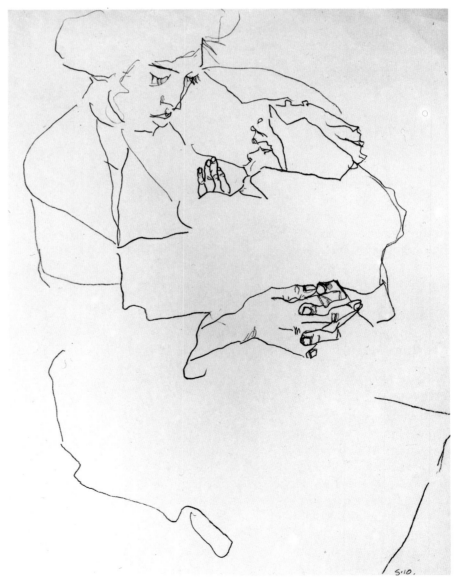

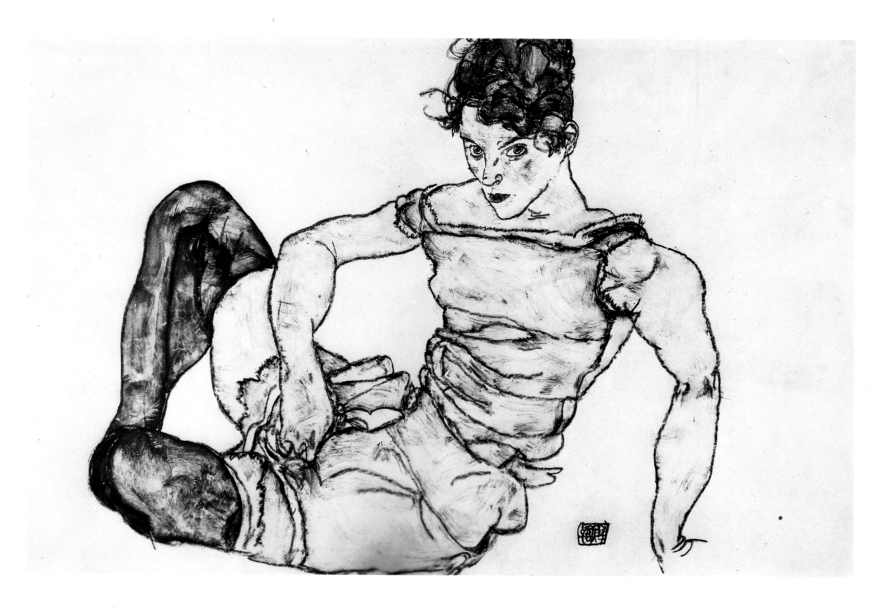

the penetrating vision of an X-ray and then draws and paints with the incisiveness of a surgeon's knife.

Schiele's examination of his own sexuality is equally, if not more, disturbing. Standing in front of his studio mirror, the ubiquitous artistic 'tool' from which Josef Trčka took a double portrait photograph of the artist in 1914, Schiele would masturbate while watching himself intently. In the sketches and watercolors which followed, the physical and mental sensations of auto-eroticism are depicted with an unprecedented explicitness. Clutching and stimulating his rampant phallus in *Eros* from 1911, wracked in the throes of orgasm in a self-portrait from *Nude, Facing Front* 1910 (page 59) or drained after the moment of release in the *Self-Portrait Masturbating* of 1911 (page 61), Schiele revels in the exhibitionism of making public the most private of acts, but at the same time his face always registers an anguish, which implies the triumph of pain over pleasure.

Until he formed his first lasting heterosexual relationship in the fall of 1911 with Wally Neuzil, a model passed on from Klimt, Schiele's developing libido seems to have been satisfied only by masturbation (in spite or perhaps because of early sexual adventures with his sister). That his sexual urges were strong but repressed, even torturous, was made clear in 1913

when Schiele wrote with characteristic candor:

Have adults forgotten how corrupted, that is incited and aroused by the sex impulse, they themselves were as children? Have they forgotten how the frightful passion burned and tortured them while they were still children? I have not forgotten, for I suffered terribly under it. And I believe that man must suffer from sexual torture as long as he is capable of sexual feelings.

A sense of sexual torture and repression underlies many of his female nude portraits. Women and, on occasion, prepubescent girls, are shown as primarily sexual animals and objects of desire with a penetrating visual focus on their often vivid genitalia. Clothes are parted and lifted revealingly from the pudenda in *Black-haired Girl with Skirt Turned Up*; stockings and boots are used fetishistically to heighten a sense of sexual fantasy. Schiele also portrays female masturbation, using young girls – in a line drawing from 1910 – and mature women – in a watercolor of *Seated Woman with Violet Stockings* from 1917 – as models. An intense fascination and power of observation for human activity and the psychic responses are brought into play in these works, with a determination to transcend the physical façade of the body and the moral façade of what was socially permis-

Above: *Seated Woman with Violet Stockings*, 1917. Although late watercolors and drawings such as this were intended primarily as a source of income, they also indicate that Schiele's fascination with female sexuality remained strong and vivid throughout his short life.

sible. While Freud proclaimed the erotic as the all-powerful and much-maligned force behind so many areas of human life, the city remained – superficially, at least – at a respectable distance and with a hypocritical disgust.

Pornography flourished in Vienna and there is no doubt that Schiele cultivated the enormous market. Only in the last year of his life could he sell enough oil paintings to make a living. He relied, in the main, on selling his drawings and in particular his erotic ones. 'No erotic work of art is filth if it is artistically significant; it is only turned to filth through the beholder if he is filthy,' wrote Schiele in 1912. The charge of sexual depravity against Schiele, leading to imprisonment in the same year, was denied by artist and friend alike. Roessler refutes it most eloquently suggesting that, above all, Schiele's eroticism was the result of loneliness and, in effect, a cry for help:

In spite of his 'eroticism,' Schiele was not depraved. His friends did not know him as a

Left: *Dead Mother I*, 1910. This small oil painting on wood, the first of two sharing the same title and subject matter, heralded a series of large and important allegorical works by Schiele which centered around the themes of procreation, birth, and death.

Right: *The Self-Seers*, 1911. There are three versions of this oil painting which is a double self-portrait of Schiele, stemming from the idea of the Doppelganger which came, in turn, from German Romanticism. In effect it is a three-way confrontation between the artist, his image on canvas, and the haunting presence of death.

Below right: *Fall Trees*, 1911. 'I find fall much more beautiful than every other season . . . not only as a season but as a condition of man and things,' wrote Schiele. The painting exudes the melancholic sense of decay which the artist found so poignant in the fall. The trees have an anthropomorphic quality while at the same time they are reminiscent of the three crosses on the hilltop of Calvary.

practising eroticist. . . . What drove him to depict erotic scenes from time to time was perhaps the mystery of sex . . . and the fear of loneliness which grew to terrifying proportions. The feeling of loneliness, for him a loneliness that was totally chilling, was in him from childhood onward – in spite of his family, in spite of his gaiety when he was among friends.

Although it was denied that Schiele actively indulged in sexual depravity, he certainly portrayed the darker side of sexual life. In his studies of pre-pubescent girls, who were often from the slums of the city, for example *Standing Nude Girl* (page 44) or *Seated Young Girl* (page 45) from 1910, the sickly almost putrid yellow/green color of the flesh alludes to the disease and death which sexual promiscuity could bring, as it did on a large scale in Vienna. Sex and Death were themes in many of the large allegorical oil paintings which began also around 1910.

In scale and approach, Schiele's allegor-

ical paintings draw on a long European tradition of symbolism. In style, they are among the first of his grandiose statements made in oil in an Expressionist idiom wherein a loose and expressive brushwork is combined with Schiele's draftsmanship. The works revolve around an equally traditional theme, that of life-cycle, from birth to death, but tainted with the now-characteristic obsession with self. The paintings *Dead Mother, Dead Mother I* and *II* from 1910 and 1911 respectively herald the birth of the series and contrast new life within the womb with the gaunt, death-like mask of the mother's face. The second work was subtitled *Birth of a Genius* and made subtle narcissistic autobiographical allusions. Schiele wrote to his mother:

Without doubt I shall be the greatest, the most beautiful, the most valuable, the purest and the most precious fruit. Through my independent will, all beautiful and noble effects are united in me. . . . I shall be the fruit which

after its decay will still leave behind eternal life; therefore how great must have been your joy to have borne me?

The joy of motherhood was expressed later in Schiele's life after his marriage in 1915, but back in 1911 the link with pain is maintained in a work entitled *Pregnant Woman and Death* (page 89). Here, Schiele quite literally fuses birth and death with two merging figures, both of whom have the face of the artist. Schiele identifies with both the monk, representing death, and the pregnant mother, and so ultimately posits himself as life-giver and taker.

The double self-portrait also featured in three paintings entitled *Self-Seers* wherein death looms, skeletal and specter-like, behind the artist. The works allude to symbolic self-confrontation drawing on the Romantic theme of the Doppelgänger which involved a chilling encounter with a mirror-image of the self just before the moment of death. Schiele's

idiosyncratic and theatrical gestures with his arms and hands add an air of mystery to the double image of what might be described as that of a stylized schizophrenic.

Some time in the spring of 1911, just after he had met Wally Neuzil, Schiele decided to leave Vienna and spend some time in Krumau (now Český Krumlov in Czechoslovakia). Krumau was his mother's home-town, picturesque and situated on a sharp bend on the River Moldau. The paintings of town and surrounding landscape reflect the calm contentment which Schiele found in retreating from the city and returning to the natural surroundings similar to those which he had experienced in his childhood:

The impressions of my childhood which clearly remained with me afterward were of flat landscapes with rows of trees in spring and of raging storms. In those first days it was as though I heard and smelled the miraculous flowers, the mute gardens, the birds in whose blank eyes I saw myself pinkly mirrored. I often wept through half-closed eyes when fall came. When spring arrived I dreamt of the universal music of life and then exulted in the glorious summer and laughed when I painted the white winter.

In works like *Houses and Roofs in Krumau* painted on wooden boards, or Bretterl, as Schiele called them, the complex geometrical structure illustrates how far beyond *Jugendstil* Schiele had moved. The shallow space and vertical format still echo his earlier style but these paintings can also be seen loosely to approximate to a cubist grid-structure. The mood of the work is distinctly melancholic, with titles such as *Dead City* (page 34) or *Dead Town* which convey what Schiele saw as 'the sadness and destitution of dying towns and landscapes.' Schiele also confronted these images with 'a happy heart' because, as he wrote at the time: 'I am conscious of my humanity' and 'because I know that there is so much misery in our existence and because I find fall much more beautiful than any other season . . . not only as a season but also as a condition of man and things – and therefore of towns also.' In his pictures of sunflowers and *Fall Trees* (1911), portrayed with almost human characteristics, the sense of decay, of the approaching end to a natural life-cycle, is powerful. As Schiele wrote in a poem entitled *Pine Forest* around 1910: 'How good! Everything is living dead.'

The melancholic contentment of life in Krumau was undermined rapidly by the petit-bourgeois indignation of the townsfolk, both at his 'living in sin' with Wally and at his hiring of young local girls to pose for nude studies. Though forced back to Vienna, Schiele still needed to live and paint away from the confines of the

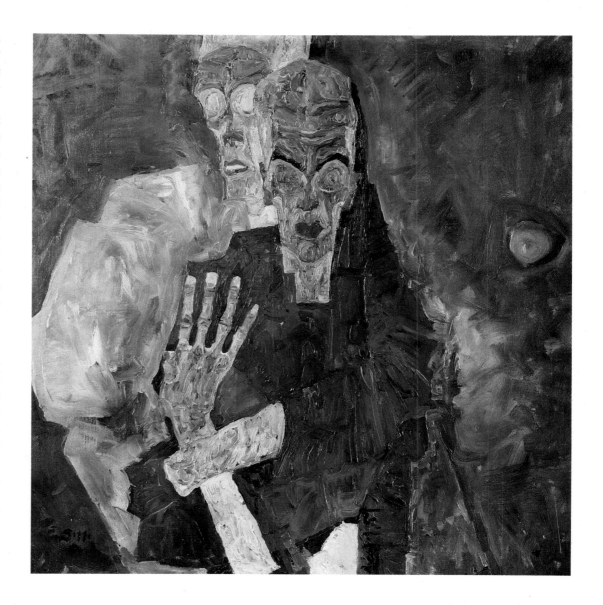

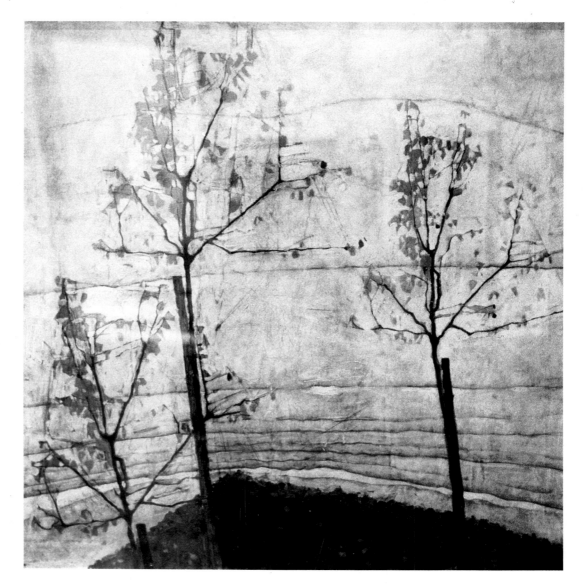

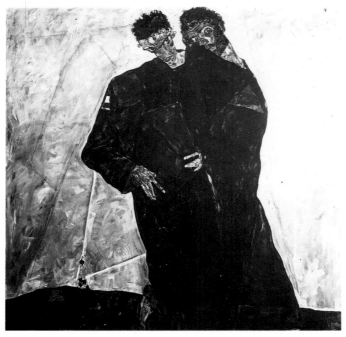

Left: *The Hermits*, 1912. This double-portrait of Schiele and Gustav Klimt clad in monks' habits was painted in the months after Schiele's imprisonment and expressed the bitter sense of artistic and social alienation which he felt.

Below: Gustav Klimt, *The Kiss*, 1907-8. This elaborate and sensual painting was the culmination of Klimt's mosaic style, an icon of Viennese decorative painting.

Right; *Portrait of Erich Lederer*, 1912-3. This is perhaps the most elegant of all Schiele's portraits. Erich was the 15-year-old son of the industrialist August Lederer.

city and so by the end of 1911 he and Wally were happily settled in a house in Neulengbach, twenty miles or so to the west of Vienna.

The months spent in Neulengbach up to the summer of 1912 were ones of renewed contentment and artistic fecundity. 'I have become aware; earth, weather, smells, history, feels in all its parts' wrote Schiele to one of his patrons, Oskar Reichel, concluding his letter ecstatically, 'I am so rich that I must give myself away.' Schiele's belief in himself as visionary artist is affirmed with a rare sense of optimism.

The gloom and doom of his allegorical oils was maintained in two masterpieces which were produced in sequence over a period of months in 1912. The *Hermits* portrays two men, clearly recognizable as

Schiele and Klimt, attired in monks' habits; ascetics alienated from the world. Schiele, in the foreground, wears a crown of thorns and stares at an uncomprehending world with the pathos of a martyr. Klimt holds on to the younger artist and rests his head, with eyes closed, on Schiele's shoulder. Although interpreted by some as an homage to Klimt, the image seems to imply that Schiele is guiding or leading the ageing Klimt, whose physical and artistic powers are diminishing as those of his son or protegé increase. The theme of separation is continued enhanced in *Agony*, wherein Schiele lies with hands on heart, his eyes closed as if resigned to suffering while Klimt kneels by his side, holding and watching over his young companion. The composition is created from a rich, semi-geometric patchwork of colored shapes which move beyond Klimtian decoration, unifying figures and background while at the same time energizing the inevitable void. These are among the most powerful of all Schiele's oil paintings and were created either side of a period of genuine and almost ascetic alienation, a period of imprisonment, no less.

In some respects the effects of Schiele's 24 days in prison are over-emphasized in biographies of the artist, doubtless because they make for good reading, but also because the artist's sense of outrage and persecution were loud and strong and recounted in a *Prison Diary* published by Roessler in 1922. Without undermining the drama, and indeed the traumas of the occasion, the circumstances surrounding Schiele's arrest and captivity and the artistic products of his time in jail are dealt with at greater length below (pages 64 and 67). In summary, Schiele was charged with seduction and corruption of a minor, a charge which was dropped, and of 'immorality' and 'publishing indecent drawings' for which he received a sentence of three days imprisonment in addition to the 21 days he had spent in custody before the trial. His reactions were complex and confused but ranged from extreme suffering to a sense of sublime catharsis: *For My Art and My Loved Ones, I will Gladly Endure to the End* (page 67) and *I Feel Not Punished But Purified!* (page 65) are two of the titles given to works made in prison.

After his release, Schiele returned to Vienna with Wally and lived in embittered seclusion. His anger and determination to fight back against the hypocritical society which was ultimately responsible for his imprisonment is indicated in his art: a pencil and gouache self-portrait entitled *Fighter* presents an image of powerful defiance; a major oil painting entitled *Cardinal and Nun* presents two figures, moral symbols of Catholic Vienna, interlocked in a sexual embrace. Deliberately

parodying Klimt's celebrated *Kiss*, itself an icon of late Viennese Jugendstil portraiture, Schiele launches a blasphemous and satirical attack on the sham morality of his homeland.

The sense of martyrdom, so strong in the *Hermits* and *Agony*, was developed by Schiele, most notably in a poster for an important retrospective exhibition at the end of 1914 at the Arnot Gallery, entitled *Self-Portrait as St Sebastian* (page 70). Schiele's body hangs limply, pierced by arrows ('of outrageous fortune'?) and with arms outstretched as though crucified. The identification with Christ is subtle but the pervading theme is sainthood, as though the artist has been purified or sanctified through his suffering. This vision of redemption is among the

Right: *Portrait of Friederike Maria Beer*, 1914. This wealthy, young society figure also commissioned Klimt to paint her portrait.

Below: Oskar Kokoschka, *The Tempest*, 1914.

Far right: Schiele photographed by Anton Trčka in 1914, over-painted to frame and exaggerate the unusual pose. It is signed twice by Schiele.

last of the self-portraits which proclaim Schiele's life of angst-ridden adversity.

Schiele's post-prison dejection worried his close friends who rallied in support. Klimt introduced him to the wealthy industrialist August Lederer who became an avid collector of Schiele's work. Schiele was invited to spend Christmas with the Lederers at their villa near Györ in Hungary at the end of 1912 and he stayed on into the New Year, painting a sympathetic and powerful portrait of Erich, the 15-year-old son of the magnate, who became Schiele's pupil. 'He has a long aristocratic face' wrote Schiele 'and is a born painter and draws also, like Beardsley.' Schiele had a copy of Erwin Osen's monograph on Beardsley, whom he greatly admired, and the linear quality of whose work had definite affinities with Schiele's own.

Schiele resumed portrait-painting with renewed vigor, producing a masterful *Double Portrait, (Otto and Heinrich Benesch)*, in 1913 (page 78), with a characteristically perceptive analysis of the father/son relationship, and a decorative, but equally idiosyncratic *Portrait of Friederike Maria Beer* in 1914. Friederike Beer

was a wealthy young society figure dedicated to the arts and to the Weiner Werkstätte in particular which designed, she recorded, 'every stitch of clothing that I owned.' Klimt was to paint her portrait in 1916 and did so in a highly decorative manner, positioning her standing against a rich backdrop of swirling patterned imagery. Schiele painted her wearing an ornate robe, but from an ambiguous viewpoint, either standing or lying down, her arms curled above her head, with only a nebulous background.

The outbreak of the war had little immediate effect on Schiele's career. Indeed, 1914 witnessed a further expansion of Schiele's reputation, when his art was exhibited for the first time outside Germany and the Austro-Hungarian Empire, in Rome, Brussels, and Paris. On 16 February 1915, shortly after his successful retrospective at the Arnot Gallery, he wrote to Roessler that he had 'been to the recruiting office today and was sent home (in)definitely' on the grounds of fragile health. If the possibility of mobilization seemed remote however, a change in his life seemed more immediate for, as he continued in the letter, 'I am contemplating getting married – most advantageously, perhaps not Wally.'

Schiele's chosen bride was Edith Harms, youngest daughter of a middle-class family whose father had been a railway official and who had lived opposite Schiele's studio with her mother and older sister Adele from the beginning of 1914. Schiele's 'courtship' had begun with a series of almost comical self-portraits which he displayed from his window. The shy admiration of both girls presented Schiele with a number of choices, such as which girl to marry, though that was resolved when Adele declared her intentions, spurious in the event, to become a nun and indeed, and whether or not to marry into a bourgeois family and therefore resume the bourgeois lifestyle of his childhood. The decision to marry Edith on 17 June 1915, his parents' wedding anniversary, was thus a major turning-point in his life. Three days later, after the briefest of honeymoons spent in his studio, he was called up for military service. His return to conventional society was thereby completed.

The complexities of choice and the sense of breaking away from old to new life are expressed inevitably in Schiele's art in two large allegorical oils from 1915. *Death and the Maiden* (page 92) is essentially a farewell portrait to Wally who kneels, clutching at Schiele who embraces her with sympathetic detachment. Compositionally it owes much to Kokoschka's *Tempest* from 1914 which had portrayed Kokoschka and Alma Mahler in passionate embrace. *Soaring*, the final major double self-portrait (now lost), seems

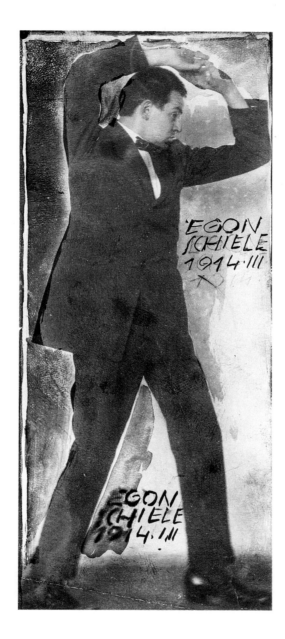

more complicated, but Alessandra Comini has argued eloquently that the image of Schiele floating upward and away from himself portrays the choice between the narcissistic self-sufficiency of the celibate monk (both 'figures' are clad in a brown habit), and the greater social integration of the artist. The war forced many other Expressionist artists to make peace with society and, as Comini argues, 'the Expressionist psyche, full of Angst, naked and revealed to the new world, now became ... Man's new façade.'

Although aware of the horrors and carnage of World War I, Schiele saw no active service. After his initial posting to Prague, Schiele returned to Vienna where he was assigned to guard duty, often escorting Russian prisoners-of-war, of whom he made a number of sketches. The following year, in May 1916, he was posted to a prisoner-of-war camp in Mühling in Lower Austria where he worked as a clerk and thanks to one of the officers, Karl Moser, 'had a store room ... converted into a studio.' 'When the weather was good,' Moser recalled 'he painted there for a few hours every day.' The watercolor portraits which he made of various Austrian and Russian officers are assured and poignant human studies, but even in *Sick Russian Soldier* there is a

far greater gentleness than in the pathological studies made in the Viennese slums back in 1910 and 1911. Likewise, the *Ruined Mill at Mühling* (page 36) and *View of Krumau* from 1916, the latter painted from sketches and memories from 1911, affirm a sense of joy and hope through their bright colors and uncomplicated rural motifs which contrast markedly with the decayed and pessimistic towns and landscapes of earlier work.

In January 1917 Schiele returned to Vienna, this time posted to the Konsumanstalt, effectively a PX (NAAFI) or supply-depot for serving members of the forces. His commanding officer, Lieutenant Dr Hans Rose, commissioned him to make drawings of the Konsumanstalt headquarters and also of its various branches throughout the Empire for a souvenir brochure, whose publication was ultimately thwarted by the end of the war. In the spring and summer of 1917 Schiele traveled and produced in addition to his army work, a series of Tyrolean sketches. Although the war had curtailed his artistic output its effect was only marginal. At least eight oil paintings were produced in 1916, some thirteen resulted in 1917 together with numerous sketches and watercolors. In the middle of 1917 Schiele was invited to take part in and to help select other work for the Kriegsausstellung or War Exhibition in Vienna.

If not traumatic, Schiele's first year or so of marriage appears to have been frustrating, at least from his point of view. Edith, dutiful and very much in love, followed him out to Prague and remained at her husband's side throughout most of the war, even in Mühling where she joined him for what was, in effect, a vacation. Schiele's *Portrait of Edith Standing* (page 98) from mid-1915 depicts her as an innocent if tense, virginal young bride, but with none of the emotional or psychological force of other portraits. The distinct lack of sexual power conveyed reflects the physical frustration of their marriage in its infancy. This idea is enhanced by, and finally depicted in a state of apparent resolution, in a series of three double-portraits entitled *Embrace*, whose tone changes from one of gentle persuasion on Schiele's part to one of mutual, ecstatic abandonment. The third *Embrace* from 1917 (page 102), 'remains,' in the words of Simon Wilson, 'one of the great images in art of human sexual love.'

Schiele's increasing marital contentment finds fullest expression in his last major allegorical oil, *The Family*, painted in 1918 (page 108). It is worth interjecting that Schiele still needed and apparently found sexual fulfilment elsewhere, with his models to be more precise, as the vividly erotic *Reclining Woman* (page 100) helps to suggest. It is also worth adding, however, that the explicit and

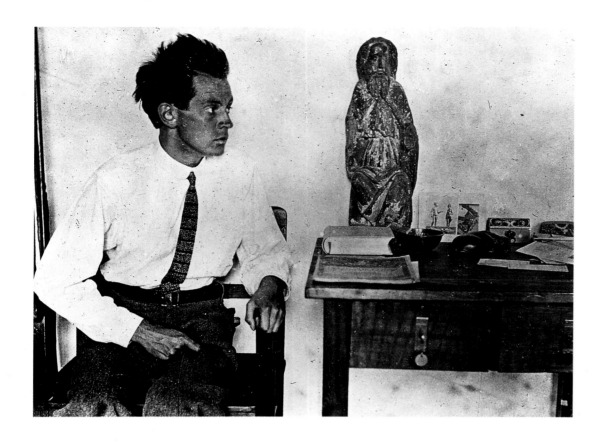

shocking nature of many of Schiele's nude female portraits has been radically tempered. The woman, posing invitingly with legs apart, has her genitalia covered, albeit provocatively, by a sheet; the background is less void-like and more integrated, more harmonious with the image. *The Family*, initially called *Squatting Couple* until a child was added in the foreground, is also the culmination of a number of oil paintings dealing with parenthood and the family unit. Both *Mother with Two Children* (page 95) from 1915 and *The Family* have a tenderness and a pathos indicative of Schiele's own personal transformation to that of a tamed and increasingly mature adult. Although Edith is not used directly as the model for *The Family* – Schiele deemed her too plump by this stage, and besides, she had a natural reticence to posing in the nude – the compositional unity of the painting suggests an integrated family unit.

Above: Schiele photographed in his studio by Johannes Fischer in 1916. The artist is seated in stylized pose in a chair which he had made himself. To his left are a variety of artifacts and objects which he loved to collect.

Below: Front cover of *Die Aktion*, 1916. This radical Expressionist journal, published in Berlin by Franz Pfemfert, dedicated its September issue of 1916 to Schiele who designed the cover and had five other drawings, a poem, and a woodcut published.

Right: Schiele photographed in front of his beloved studio mirror by Johannes Fischer in 1915. Clearly visible on the left is part of the recently completed painting, *Death and the Maiden* (page 92).

Far right: *Crouching Nude*, 1918. A soft and fluid line drawing which epitomizes Schiele's later, more gentle graphic style.

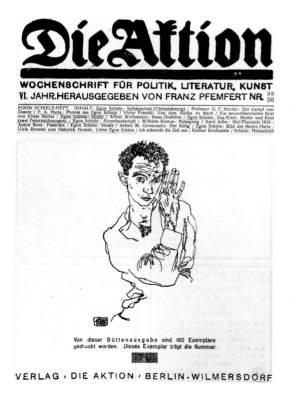

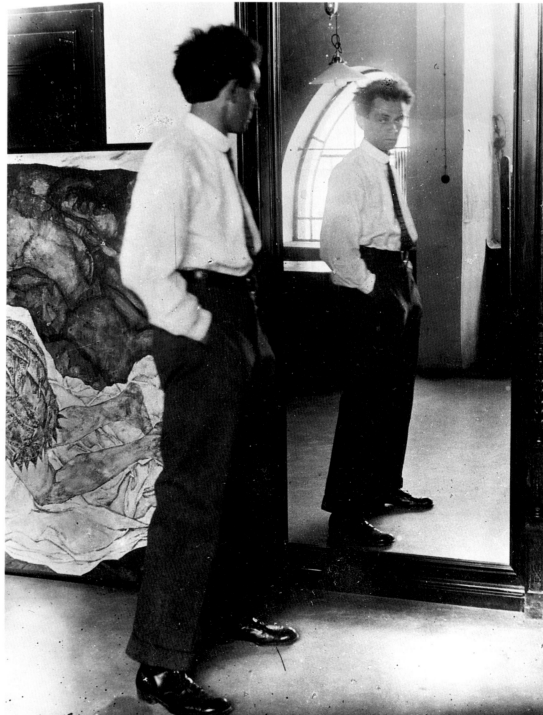

Edith announced that she was pregnant some time in mid-1918, but the child was never born because Edith died of influenza on 28 October 1918. Schiele used Toni, the young son of his sister Gerti and Anton Peschka, as a model, and painted his portrait earlier in 1918. It is a charming, accomplished, but essentially sentimental work, with a painterliness and harmony which characterize his later portrait style, which had been developed the previous year.

One of the officers Schiele had met at the Konsumanstalt in Vienna was Karl Grünwald, former cloth merchant and continuing art enthusiast. As the result of a number of meetings involving painters, poets, and musicians, an ambitious attempt was made by Grunwald to form a new group. The Kunsthalle, as it was called, sought to lay the foundations for a rebirth of cultural life after the war. In the event it never got off the ground but it triggered off a series of commissioned portraits for Schiele, including those of the bibliophile and gallery-owner Guido Arnot and the composer Arnold Schoenberg. These portraits together with the more tender *Portrait of Edith, Sitting* (page 104) from 1918 illustrate Schiele's gradual but marked interest in form rather than content wherein compositional harmony is merged with a descriptive and objective approach to subject matter, a move from, to cite Comini's arguments once again, the existential to the environmental, 'in short a return from the void.'

At the risk of over-simplification with the benefit of hindsight, Schiele's *Portrait of Paris von Gütersloh* (page 85) can be seen as both the culmination of the series of late portraits and, in effect, as a state-of-the-art, or Schiele's art, at the time of his death. It was his last major oil, masterful but full of contradictions, often contrived, from the painterliness of background and bodily form to the draftsman-like exactness of hands and face. There is a hint of self-portrait, even self-caricature, in the gestures made with arms and hands which corresponds with the crooked nose which Schiele gives to his friend who had twisted Schiele's nose in a reciprocal portrait also in 1918. Von Gütersloh's eyes stare piercingly at the viewer while presenting focal points for the penetration of his psyche, in other words 'windows to the soul.' This and the black halo (as opposed to white and therefore negative or inverted 'body-glow') which surrounds the body, link the work with the more radical portraits of 1910-12, but at the same time the vivid almost lush background is integrated totally with the figure and effectively neutralizes it. The portrait remained unfinished, thwarted by death as was Schiele's career, but has a sense of completeness nevertheless.

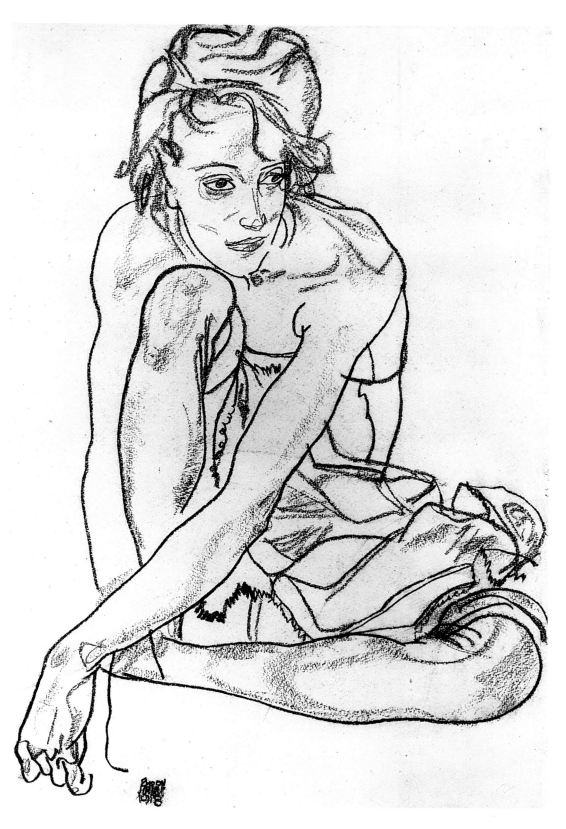

In March 1918 Schiele was invited to be the major participant in the 49th Secession Exhibition. 19 oils and 29 drawings were shown and many were sold at prices previously unknown for Schiele's work. His poster for the Secession Exhibition depicted a Last Supper with Schiele at the head of the table (page 86). The allusion to Christ shows characteristic conceit but there is an equally poignant aspect to the image, for opposite Schiele, at the foot of the table, there is a chair and a place set but no one there. This refers to Klimt who featured in early sketches but who had died on 6 February of influenza.

After Klimt's death, Schiele was without a serious rival as the leading painter in Vienna. (Kokoschka was recovering from a serious war wound in Dresden at the time.) The critical response to Schiele's work had changed dramatically and the artist was even described as 'a moralist to the extent that he has never depicted sin as something beautiful.' Commissions for portraits flooded in together with a project to decorate the Burgtheater. In May Schiele had an exhibition of his graphic work at the Arnot gallery and the price of his drawings trebled. Acclaimed and prosperous, he and Edith were able to move into a house with a large studio in the garden in the suburb of Hietzing, where Klimt had lived and worked.

The influenza epidemic which raged through Europe in 1918 was responsible for almost as many deaths as World War I. The virus which claimed the lives of both his artistic mentor and his wife finally struck Egon Schiele. Three days after Edith, on 31 October 1918, he died.

The Artist's Guardian (Leopold Czihaczek), 1907

Oil on canvas
24⅝×18¾ inches (62.7×47.2 cm)
Private Collection

This, one of Schiele's earliest surviving works, illustrates in the speed and fluidity of line and the dramatic contrast of dark and shade, the precocity of his talent. But it also reveals the limitations of his early efforts. The melodramatic intensity of the sitter's gaze over-emphasizes the force and authority of his model, namely Leopold Czihaczek, his godfather, guardian, and father-figure after 1905.

Compounding his feelings of rejection and injustice, Schiele was sent to live with Czihaczek, a railway engineer, soon after the death of his father. His guardian was vehemently opposed to Schiele's attending art school but permitted his nephew to live in a room in his house in the Zirkusgasse, one of the better streets in the ghetto-like Leopoldstadt district of the city, and within walking distance of the Academy. Although Professor Griepenkerl forbade his students to draw from life in the first year, Schiele had little problem persuading his uncle to sit for him, and in 1907 produced six portraits of the old man, seated, standing, and playing the piano. The works are striking in their analytical visual perception but contain little or no affection for the subject-matter, rendered in a simple graphic manner.

An early portrait of Czihaczek was one of the works in Schiele's portfolio at the time of his application to the Academy. These 'satisfactory' drawings would have been viewed in competition a few months earlier in 1906 with some work deemed to be 'unsatisfactory' by an unsuccessful applicant named Adolf Hitler.

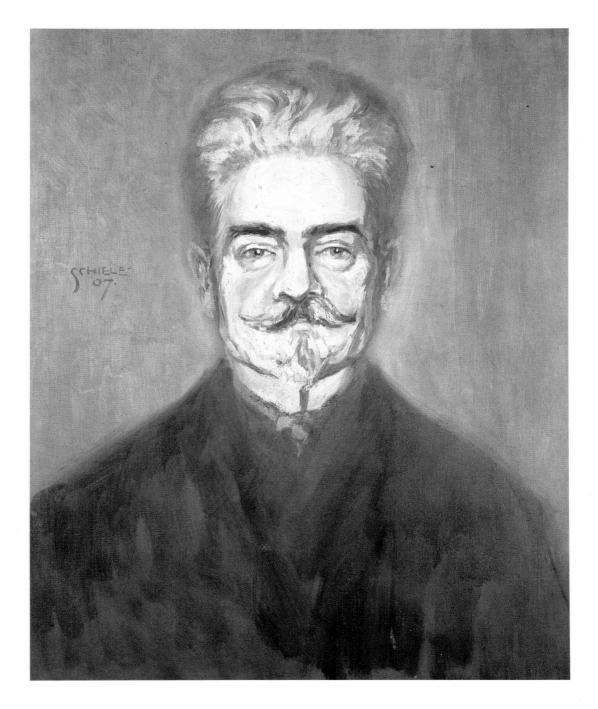

Trieste Harbor, 1907

Oil on cardboard
9¾×7¼ inches (25×18 cm)
Neue Galerie am Landesmuseum
Joanneum, Graz

This early oil painting originates from a creative period in Schiele's burgeoning career and corresponds with his own artistic, emotional, and sexual awakening. It was during a visit to Trieste with his younger sister Gerti that Schiele made his first acquaintance with the female body, which remained a lifelong fascination.

Compositionally and thematically this work owes a great deal to the early work of Vincent van Gogh and the motif echoes that of the proto-expressionist's work at Saintes Maries-sur-Mer. Stylistically the thick pigment and paint surface scratched with the pointed handle of the brush, follow in the rich and tactile tradition which Van Gogh helped to re-establish in European art. Likewise the shimmering surface and luminous paint owe a great deal to this forerunner of modern painting.

The series of *Sunflowers* (pages 30-31) can be traced to this time and this recurrent motif in Schiele's work can equally be deemed to have begun from an early exposure to one of late nineteenth-century Europe's first martyr-artists.

The relationship between Schiele and Van Gogh influenced much of the Austrian's mature style: pioneering and energetic while cast in the same egocentric genre. The pictorial stress is vertical, the mood is calm, the complexities of Van Gogh's character and creative drive are echoed in the work of one of his earliest disciples, stylized and stylish but fundamentally unique. From this source, but with his own sense of adventure, Schiele rapidly discovered his own artistic vision.

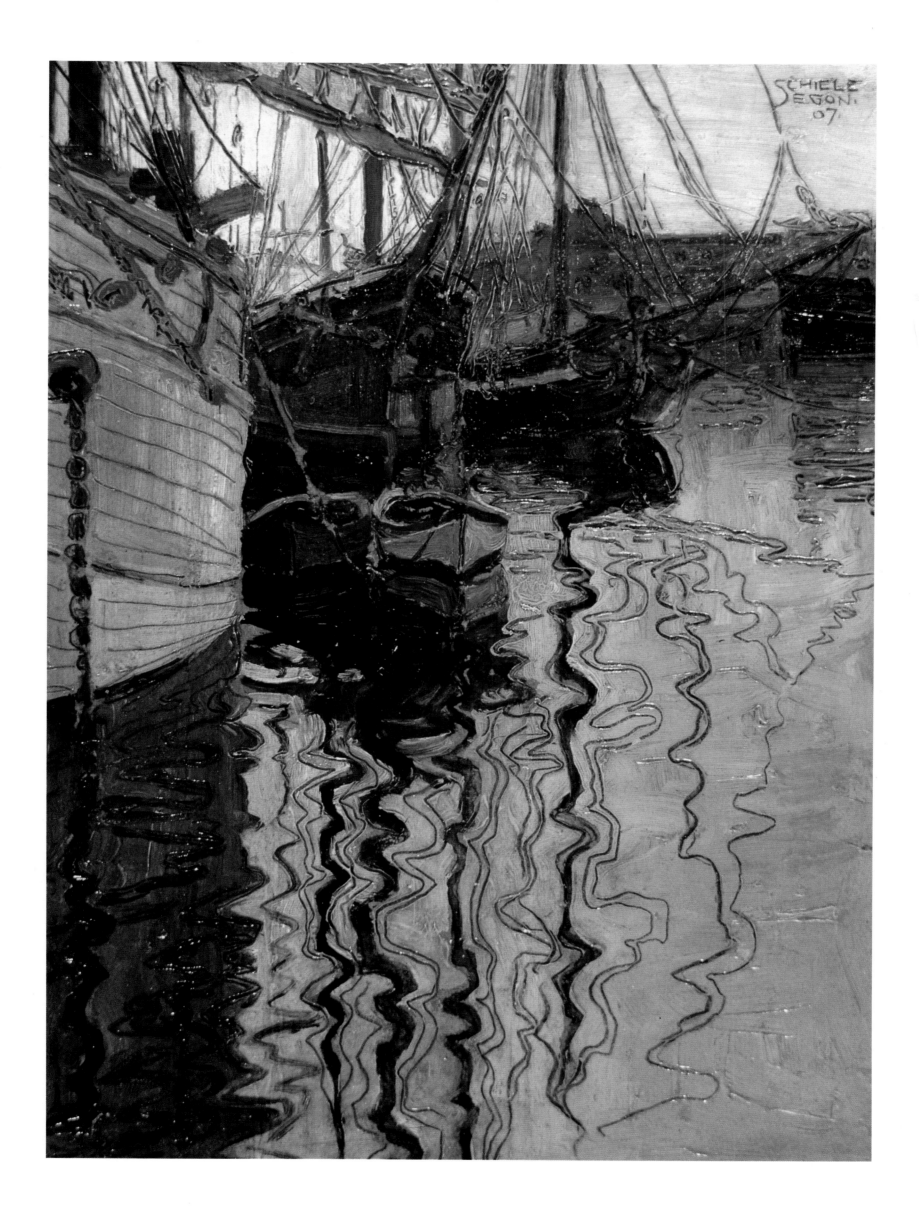

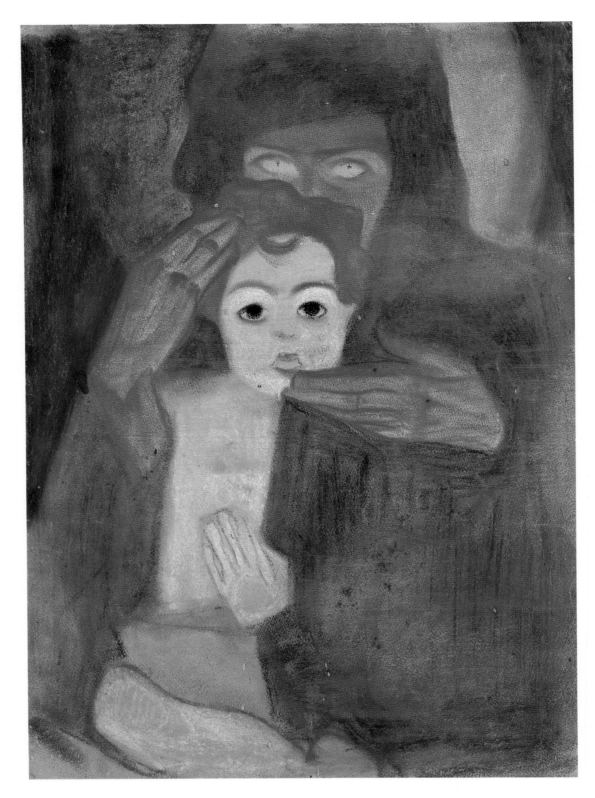

Madonna and Child, 1906-08
Colored chalks
23½×17 inches (60×43.5 cm)
Niederösterreichisches Landesmuseum,
Vienna

This elaborate chalk drawing, among the earliest in Schiele's oeuvre, is an early rendering of a Secessionstil motif fused with the mesmerist faces of Fernand Khnopff. In style and subject-matter, it anticipates the later concerns of Schiele: motherhood, life-cycle, Madonna and child, and the beginning of a creative cycle which culminates in death.

The piercing, mask-like faces of mother and child allude to the impending, looming presence of death in all life and art. The halo becomes at once a meaningless void and the faces of the sitters become increasingly unsentimental, drawing on a tradition of passive and menacing prototypes which allude to the demonic death threatening life from the outset. Even at the beginning of his career, Schiele used sickly, yellow and palid hues to depict enigmatic hand-gestures which threaten decapitation and dismemberment, rather than the unified growth and life more traditionally associated with the subject-matter.

This was one of the few early examples of Schiele's work displayed at the Abbey of Klosterneuburg and was among those which brought artistic recognition from Heinrich Benesch, an executive of the Imperial Railways and a pioneering patron of Schiele.

Just after Schiele painted *Madonna and Child* he and a group of like-minded artists from the Academy began to question many of the underlying assumptions on which their course of study was founded: 'Is nature only that which the professor recognizes as such?' Schiele asked of his Professor Griepenkerl in one of thirteen questions which were raised by the Neukunstgruppe in Vienna in April 1910. By the end of the year, Schiele had established himself as the most forthright figure in the emerging avant-garde.

Plum Tree with Fuchsias,

c. 1909

Oil on canvas
35½×35½ inches (90.5×90.5 cm)
Hessisches Landesmuseum, Darmstadt

From the stylized contour-lines of both plum tree and fuchsias and the off-center compositional format of the painting, it can be inferred that this oil painting was made around 1909. The central focus of the work is the thinly painted void which is fragmented by the horizontal and vertical lines of tree trunk and branches. The painting has a compositional and emo-tional unity, however, which stems totally from the symbolism inherent in the motif.

Traditionally fuchsias were sweet-smelling flowers which lost their perfume on Mount Calvary; where the blood from Christ's wounds fell, there sprang red and purple blooms, heads hung in grief and emitting no fragrance. Schiele depicts his fuchsias dripping with blood-colored paint. The purple and red heads droop with shame and sadness echoing the colors in the plum tree above, but also en-acting the roles of the Virgin and St John at the foot of the cross. The plum tree manifests itself as a wooden cross or even as a crucified figure which hangs limply, withering away in death, but with an allu-sion to eternal life burgeoning from its branches. Martyrdom, the mortality of mankind, and the continual decay inhe-rent in nature, are the central themes of this early masterpiece.

The work anticipates Schiele's develop-ing a fully-fledged Expressionist style. This can be seen loosely in his expressive handling of paint and more strikingly in his unifying thematic approach which embodies nature, and more specifically the plum tree, with quasi-human charact-eristics. Here Kandinsky's conception of 'psychic states disguised in the forms of nature' merges with Schiele's poetic dic-tum that 'all is living dead.'

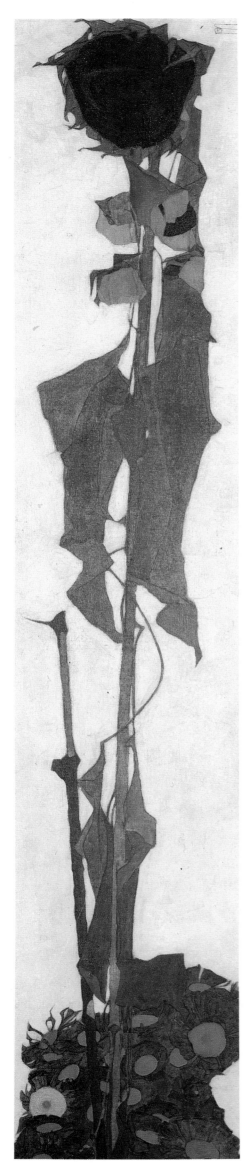

Sunflower, 1909
Oil on canvas
59×31½ inches (150×80 cm)
Graphische Sammlung Albertina,
Vienna

Right:
Sunflower, 1911
Watercolor on paper
Graphische Sammlung Albertina,
Vienna

Sunflowers were motifs favored by Schiele for two main reasons: first, they echoed the powerful subject-matter of Van Gogh, an early influence on Schiele's work, though more in terms of theme than style in Schiele's depictions of the flowers; second, as emblems of the life-cycle central to much of Schiele's allegorical oil painting with connotations of impending decay and death, even at the height of life in glorious bloom.

The earliest *Sunflower,* from 1909, contrasts with Klimt's approach to natural phenomena which sought to express the decorative and beautiful aspects of life in art. Schiele, conversely, uses the flower to suggest mood – in German, Stimmung – and notably, in this instance, the human-sized sunflower assumes many of the qualities of figurative portraiture ranging from scale to the almost melancholic 'expressions' conveyed by the posture of body and head. Whereas Klimt's flowers and landscapes may be said to be biomorphic, Schiele's are fundamentally anthropomorphic.

Standing tall, the once-proud sunflower has already begun to decay. The leaves are turning brown and the head begins to hang. The gloominess of the motif contrasts with the richly patterned bed of flowers from which it has sprung, painted in Jugendstil vein but metaphorically and actually transcending that decorative and stylized approach to painting.

In *Sunflowers* from 1911, and indeed in later paintings of the same motif, the Jugendstil silhouette of the flower, particularly its leaves, has been replaced by more jagged edges and the entire motif is painted in a rougher and more expressive manner. Both plants are portrayed against an isolating background, but the later work stands in total seclusion with no base, decorative or otherwise.

Although the human analogy is less obvious in the later works, there are no figurative connotations, the mood of the work is perceivable in terms of the vulnerability of the natural life-cycle with all its attendant joys and problems and with the sunflowers themselves expressing or even 'feeling' these emotions.

Schiele's evocation of mood through nature has parallels with a number of his contemporaries in Vienna, from Carl Moll and Anton Kollig to his friend Anton Faistauer. In his almost psychological expression of human characteristics in nature, however, he stands alone with only Kokoschka and Gerstl distantly approaching him.

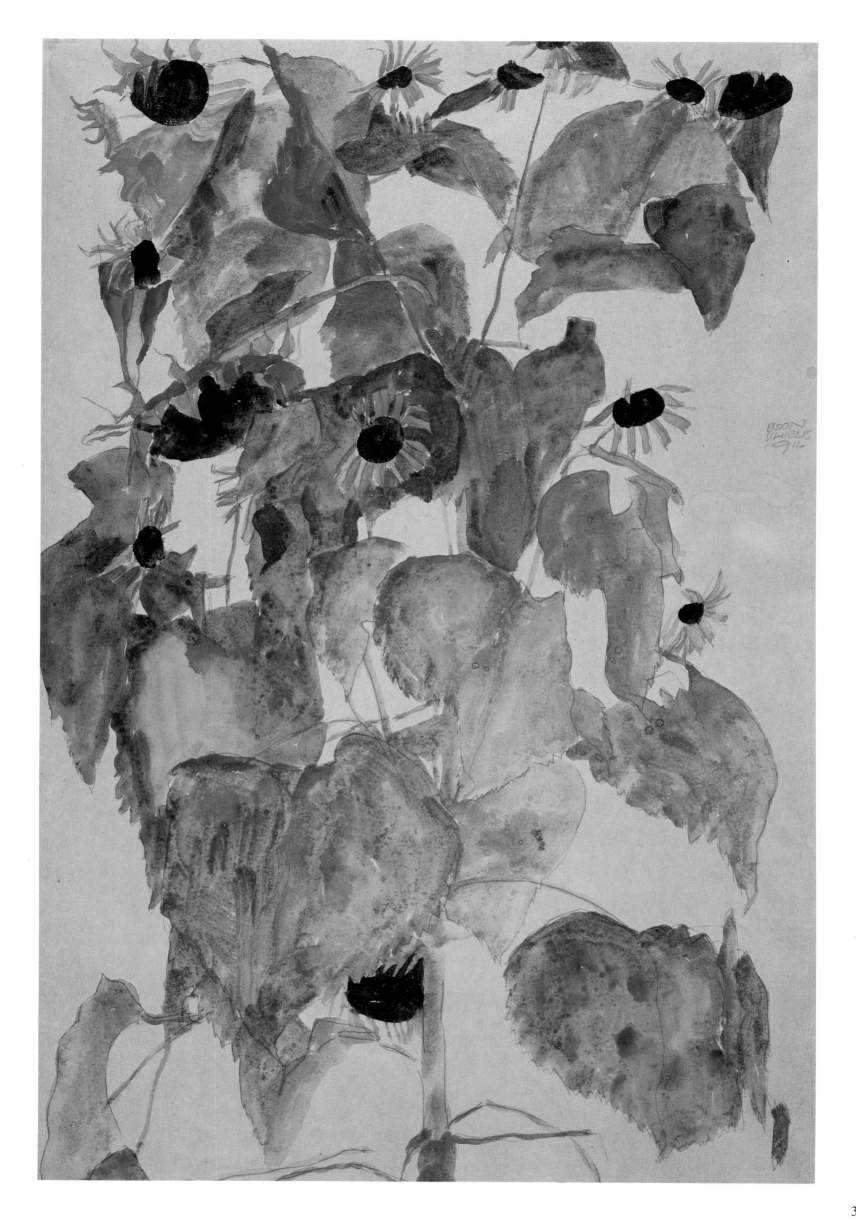

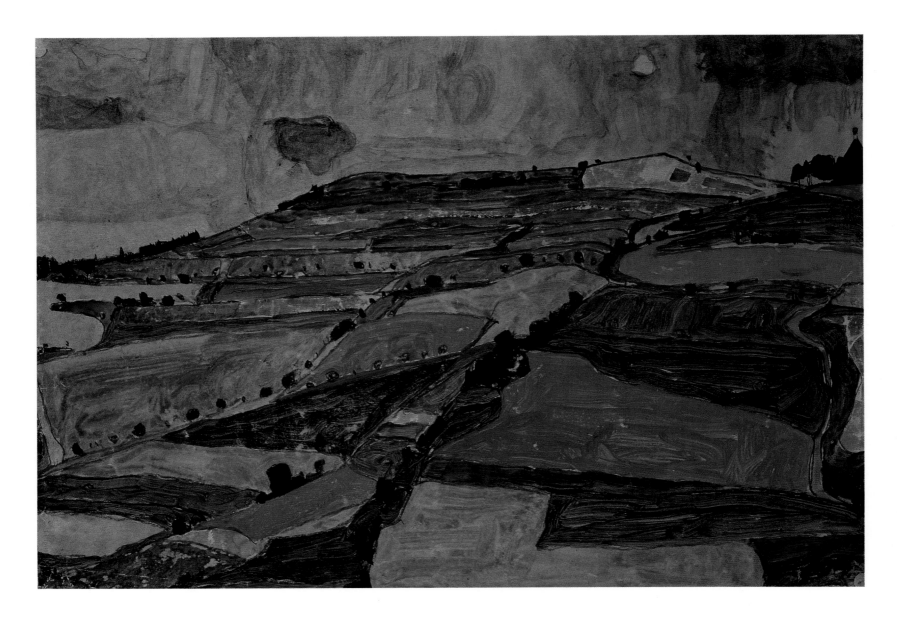

Hill near Krumau, 1910

Watercolor
12⅙×17⅓ inches (30.9×44 cm)
Graphische Sammlung Albertina,
Vienna

Houses and Roofs near Krumau, 1911

Gouache and oil on canvas
14⅝×11½ inches (37.2×29.3 cm)
National Gallery, Prague

Five works spanning seven years of Schiele's artistic maturity should suffice to indicate his response to nature and the surrounding towns and cities which encircled Vienna, tantamount to a rural Ringstrasse.

The *Hill near Krumau,* one of Schiele's earliest escapes to nature made at the beginning of the radical period in 1910 illustrates how far from Vienna he had moved but essentially how limited were his stylistic developments. Writing in a letter from Krumau to his friend Anton Peschka in 1910, Schiele lamented his predicament:

I want to leave Vienna very soon. How hideous it is here! Everyone envies me and conspires against me. Former colleagues regard me with malevolent eyes. In Vienna there are shadows. The city is black and everything is done by rote. I want to be alone. I want to

go to the Bohemian Forest. May, June, July, August, September, October. I must see new things and investigate them. I want to taste dark water and see crackling trees and wild winds. I want to experience them all, to hear young birch plantations and trembling leaves, to see light and sun, enjoy wet, green-blue valleys in the evening, sense goldfish glinting, see white clouds building up in the sky, to speak to flowers.

The thin washes of watercolor whose effect is strikingly close to that of the *Bretterl* made in 1911, create a patchwork of quilted color receding gently up the undulating hillside and are still versed in Wiener Werkstätte rhetoric. The clouds on the horizon, increasingly murky, still give a wide vista of endless space. The tiny trees dotted over the landscape give the motif a sparsely populated feel but the absence of human life is deafening.

Schiele's escape to his mother's home town in Bohemia in 1910 with Wally and his two friends, Erwin Osen, a painter and theatrical performer, and his girlfriend, the beautiful and exotic dancer Moa, corresponds with an increasingly productive period in Schiele's life.

The patchwork of color in the rural motif is neutralized in this urban oil painting and the houses are stacked much more steeply into the hillside and obliquely on to the surface of the canvas, fusing the tilted perspective of Cézanne with a more radical cubist building-up and interlocking of pictorial space and form. The overbearing darkness and melancholy is a theme which contrasts markedly with the exuberance of Schiele's *View of Krumau* from 1916 but which is continued sharply in a painting made from sketches, memory, and a grid-like postcard in 1912, namely *Dead City.*

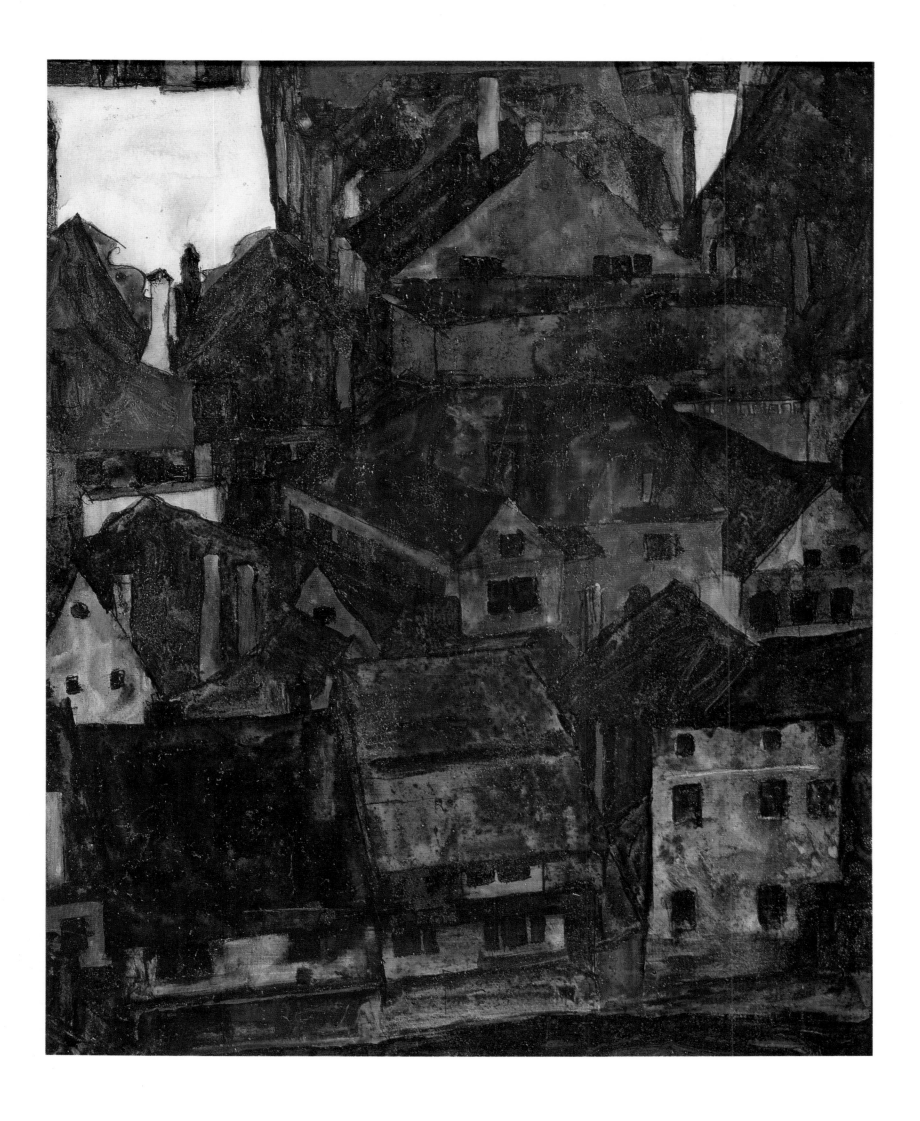

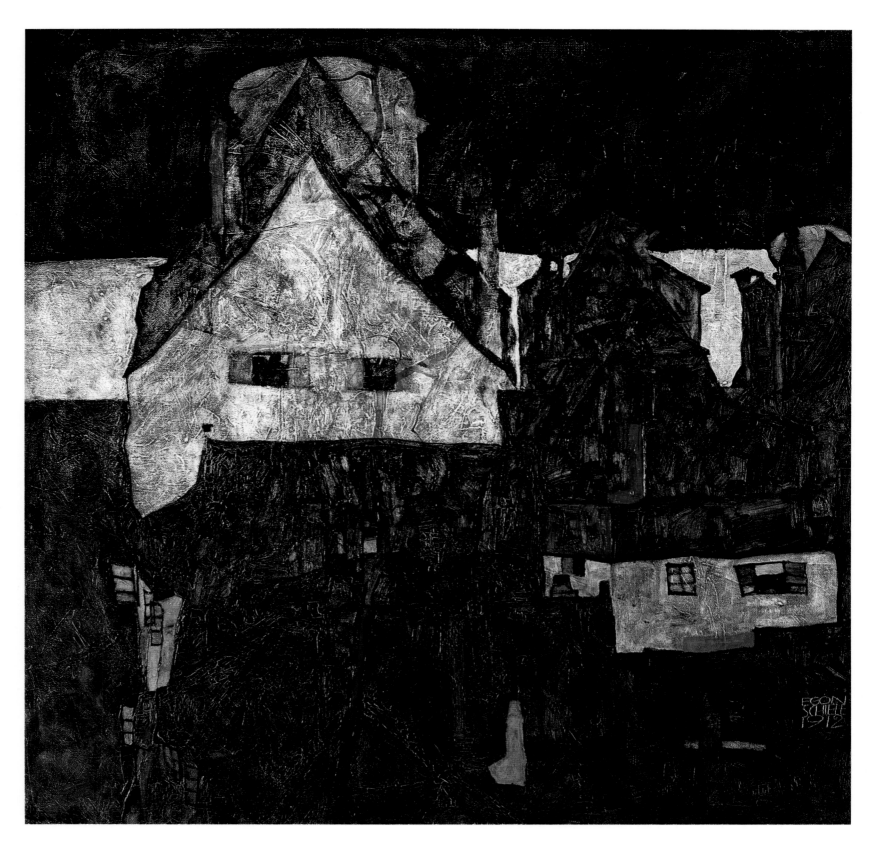

Dead City, 1912
Oil on canvas
31½×31½ inches (80×80 cm)
Kunsthaus, Zurich

In this townscape both the mood, metaphorically, and the three-dimensional pictorial illusionism are flattened into a two-dimensional, factured weave of abject despair. The anthropomorphic quality of the buildings, particularly the Swiss-style mountain hut in the foreground, is made more haunting by the lack of actual bodily human presence. The reference to death in the title is apt for there is no sign of life in the painting.

Significantly, Schiele never painted the streets or buildings of Vienna unless this is the exception which proves the rule. More likely is that 'City' is used in the title to differentiate between Krumau and other smaller towns like Moldau, Stein or Mühling depicted by Schiele at this time. The lime green house in the foreground and striped blue and black background heighten the compositional tension and melancholic mood. It was this kind of painting which Schiele used as a backdrop for one of his large self-portraits in oil, entitled *Melancholia* from 1910, now lost, but recorded in a photograph.

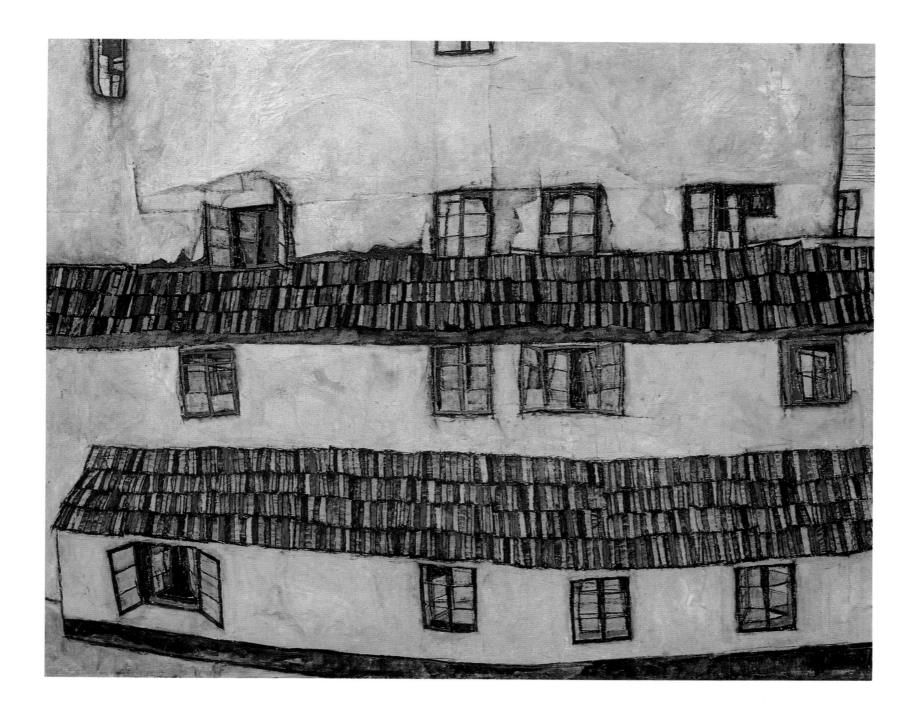

Window Wall, 1914

Oil on canvas
43½×55⅛ inches (110×140 cm)
Österreichische Galerie, Vienna

Schiele's developing insistence on a more abstract and horizontal linear format of composition received fullest attention in an oil from 1914 entitled *Window Wall* or *Façade with Windows* which also seems to stem from somewhere in Krumau. The two-storied building is an impenetrable façade which is quaint and ornate but with little artistic appeal.

Schiele perceived in the two-terraced roofs a vertical stacking of colored tiles loosely akin to books and book-shelves, thus presenting an interior view from the outside, the closest the viewer will ever get to the inside in effect. The white wall confronts us directly and all space and volume are negated in this the flattest of all Schiele's paintings. The abstract qualities of design, in perfect broad horizontal bands in the brightest of color tones stand out like beacons of light and contrasting shade. This was one of the paintings exhibited at the successful retrospective at the Arnot Gallery in 1914.

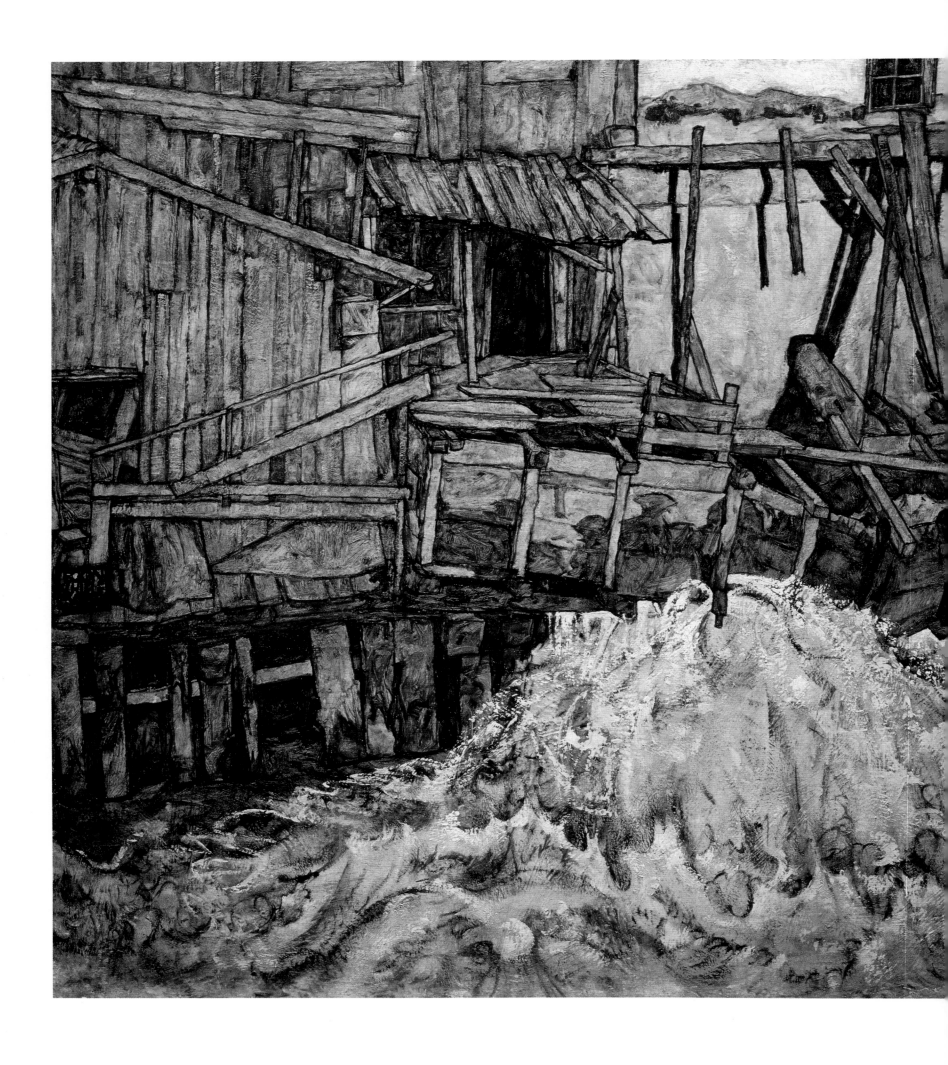

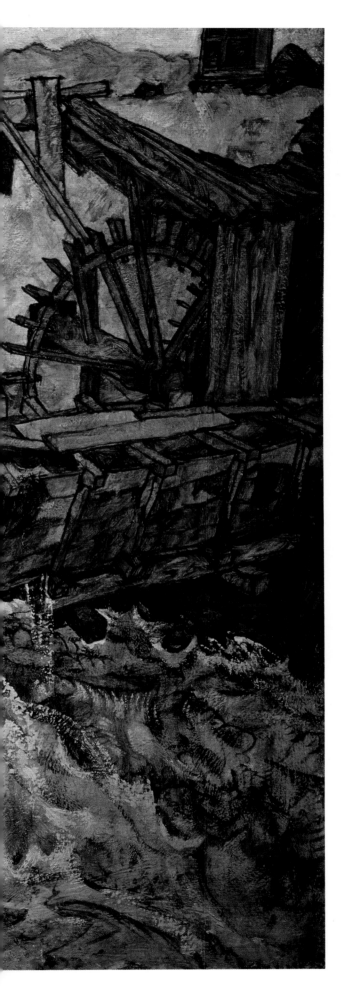

Ruined Mill at Mühling, 1916
Oil on canvas
43×55 inches (109×140 cm)
Niederösterreichisches Landesmuseum,
Vienna

Overleaf:
View of Krumau, 1916
Oil on canvas
39½×55½ inches (100.5×141 cm)
Neue Galerie der Stadt Linz
Wolfgang Gurlitt Museum

In May 1916 Schiele was posted to Mühling in lower Austria as a clerk in a Prisoner-of-War camp for Russian officers (apparently on account of his exquisite hand-writing). It was here that he continued to produce portraits of Russian soldiers. It was here also, in the natural surroundings of his childhood, that he returned briefly to painting in oil.

Both the *Ruined Mill at Mühling* and the *View of Krumau* exude a sense of exuberant optimism from the lighter, brighter palette which Schiele used, and also from the fluid, Expressionist style of the works. This belies Schiele's declared intention 'to create the most important works about the war,' but at the same time it demonstrates his increasingly balanced and hopeful view of the world around him. His wife, Edith, joined him at Mühling and the two of them spent long and happy afternoons scrambling through the beautiful scenery, eulogized in Schiele's diary.

The *View of Krumau* was painted from sketches and drawings made back in 1911 and is, therefore, a reinterpretation of a motif from memory. The painting both recalls and fulfills a yearning expressed by Schiele in his prison diary in 1912. Riding on a slow train en route to the court at St Polten, he had expressed a desire 'to see ... beautiful things: sky, cloud, flying birds, growing trees, and quiet houses with cushion-soft roofs.' The 'cushion-softness' of the houses and trees is blended with an exaggerated cubist geometry enhanced by the unusually high vantage point from which the painting appears to have been made.

The town, stacked up and into the hillside, is the central image and is flanked on either side by rich green fields and trees. The murky sky seems less a backdrop of nothingness or negative void and more an endless space which liberates the town and painter from metaphysical and physical constraints. In this work and in the *Ruined Mill* the quasi-metaphysical state of melancholy and evocation of death and decay so strong in earlier town- and landscapes have totally disappeared.

The *Ruined Mill at Mühling*, painted from sketches, but effectively from his immediate surroundings and experiences, is an equally joyful counterpart to the *View of Krumau*. Beneath a ramshackle old wooden mill, the cascading water bubbles and swirls with an energy mirrored in Schiele's vigorous, painterly style. Compositionally, the painting is layered in horizontal bands from the expressively painted water to the more graphic depiction of the mill above. Whatever the intention, a deeper sense of space pervades the painting and with a corresponding feeling of freedom.

Although painted two years before Schiele's death, these works are among his last depictions of rural subject-matter.

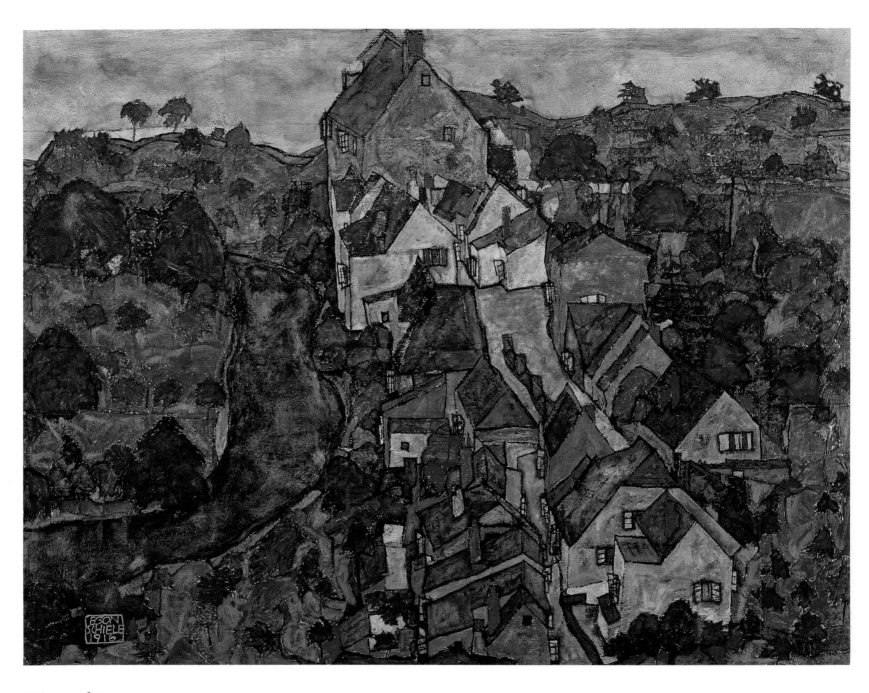

View of Krumau, 1916
Oil on canvas
39½×55½ inches (100.5×141 cm)
Neue Galerie der Stadt Linz
Wolfgang Gurlitt Museum

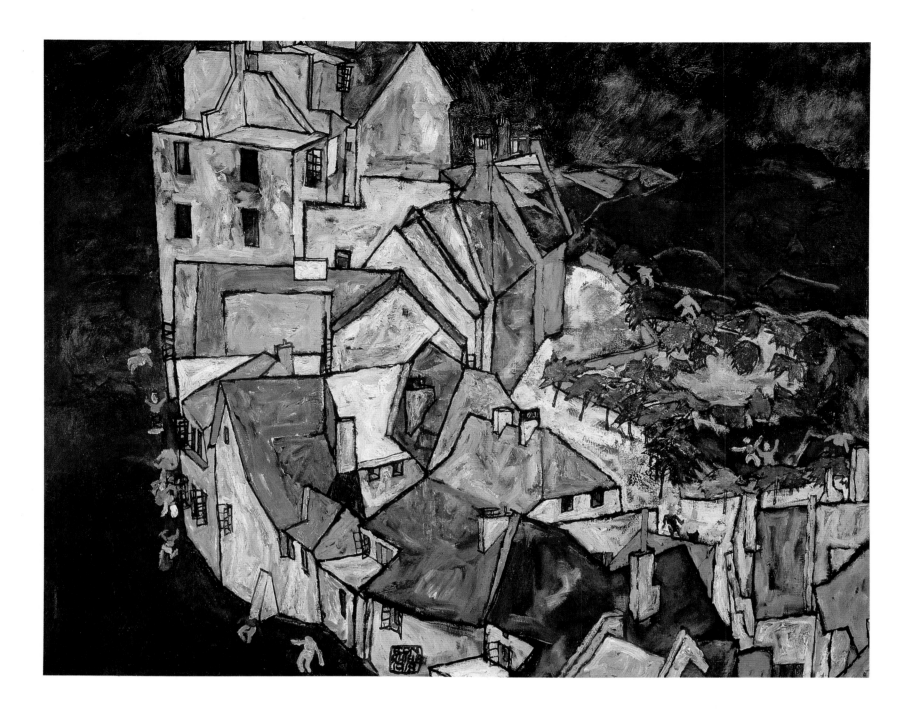

Edge of Town, 1917

Oil on canvas
43 1/10 × 54 9/10 inches (109.5×139.5 cm)
Landesmuseum Joanneum, Graz

At the end of his career and in what turned out to be his last urban landscape, Schiele fused the concerns of earlier work into one final lasting image of a town snaking its way up into the hillside, curved, and colorfully expressive. It has steep cubist grid and a bright colorful pattern, flanked by trees and an encroaching but richly painted darkness against which the town stands.

The painting has a curiously sentimental feel to it, as if designed for a Christmas card, and perhaps what gives it this sense of joy and certainly what separates it from earlier work is the presence of human figures who play, stroll, talk, and simply go about their business in the streets of the small isolated town.

Unique in his oeuvre, and with a corresponding affirmation of life, Schiele finally transcends the melancholic emptiness of his former work and leaves a lasting image of human presence and activity. Finally, his towns have real inhabitants; nature is utilized by man and the artist can at last cope with its infinite variety.

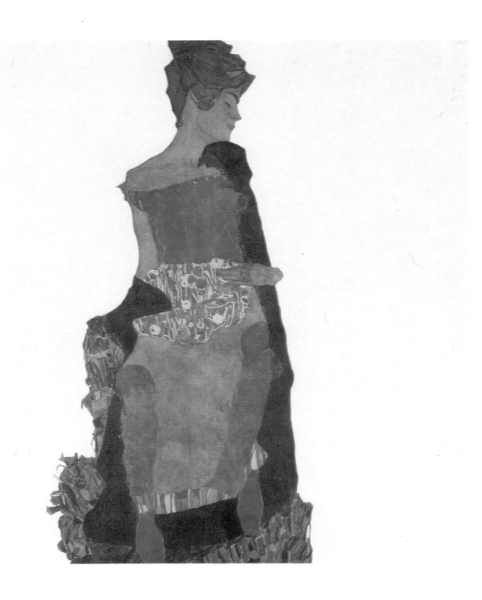

Nude Girl with Crossed Arms (Gerti), 1910

Black chalk and watercolor
18×11 inches (45×28 cm)
Graphische Sammlung Albertina,
Vienna

Gerti stands before the viewer, fully un-dressed for the first time. She turns her head away from us, folds her arms protec-tively across her breasts in a manner which suggests both vulnerability and embarrassment. Her lower torso remains unprotected and her delicate black shock of pubic hair and swollen vulva become the focal point of the composition. Her thin, boyish body is over-painted with washes of orange and red watercolor, linking the portrait to self-portraits of Schiele screaming and with hand pulling cheek, also from 1910. The backdrop too is tinted with a hint of orange which has the disquieting effect of integrating as well as isolating the figure.

The erotic charge which emanates from the girl's body, inviting and repelling the viewer's attention, seems to stem from Schiele's likely erotic relationship with his sister. Comini has pointed out that it is only in portraits of Gerti and his mistress Wally Neuzil that Schiele ever analyzes the psyche of his female subjects, the rest being presented either as purely sexual animals or, in the case of his wife Edith, virginal façades. Even though her eyes are averted and potential windows to the soul are closed off, there is quite evidently a look of distant sadness. Furthermore, her vulnerable body is covered with patches of yellow and green suggesting sickness. This was not the case. Gerti remained, as far as is known, in perfect health, but the appearance of her portrait serves to link the portrait with Schiele's pathological depictions of young girls, particularly from the slums of Vienna from around 1910.

Portrait of Gerti Schiele, 1909

Pencil, oil, silver and gold paint on
canvas
55×51½ inches (139.5×140.5 cm)
Private Collection

This life-sized portrait of Schiele's sister Gertrud, or Gerti, was, in 1909, the artist's largest and most ambitious work to date. Through his use of oil and silver and gold paint, Schiele fuses Klimt's dec-orative approach with Jugendstil con-tourline, and his own isolating backdrop, in a work which signals the beginning of his more individual style.

The central placement of the figure shifts the emphasis of composition from that favored by Jugendstil artists. It con-trasts with an earlier *Portrait of Gerti with a Black Hat* in which the figure inclines toward the left side of the square canvas. Although her torso is fully frontal, Ger-ti's shoulder and head are turned, giving the outline of the silhouette a series of in-dentations which, as Comini has com-mented, effectively transpose Klimt's 'spiral stream.' The decorative patterned cloth, which acts as base and surrounds the lower part of the figure, is repeated in the muff which Gerti clutches to her midriff, and is turned inside out and made up of red and silver orbs. Schiele styled himself 'the silver Klimt' around this time, in reference to his particular use of that metallic paint.

The richness of pattern contrasts mark-edly with major areas of dark and red-dish-brown oil which are essentially low-key or austere. These enhance the with-drawn expression on Gerti's face, eyes closed, gently relaxed; the fragile, day-dreaming young coquette.

The stylish contour-lines, which out-line both the ornamental and figurative elements, stand out so clearly against the marbled void and give this portrait a character of great elegance. Indeed it ranks among the most elegant of all Schiele's works, and represents a remarkable tour-de-force of portraiture for a 19-year-old.

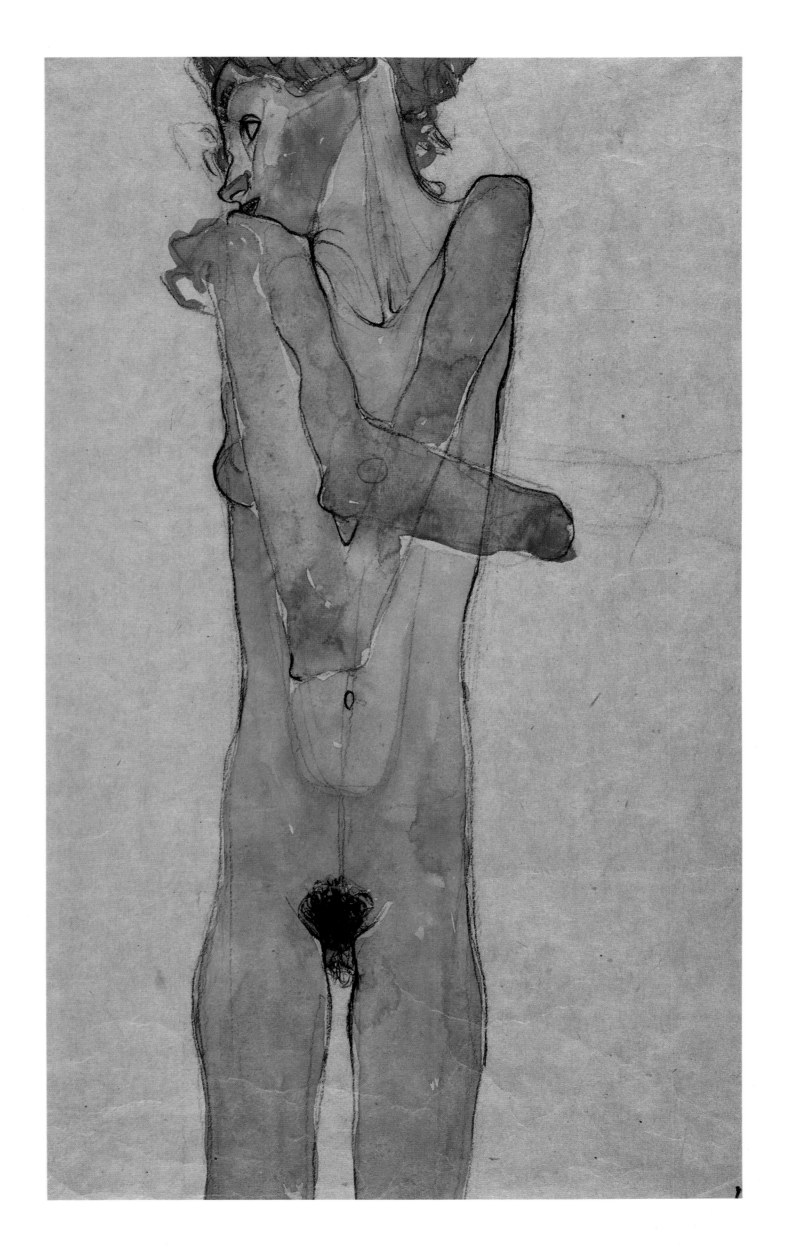

Self-Portrait Drawing a Nude Model in Front of a Mirror,

1910
Pencil
20×12¾ inches (51×32.5 cm)
Graphische Sammlung Albertina,
Vienna

In many ways this simple but highly effective line drawing is a manifesto for Schiele's art in the period around 1910, fusing as it does his self-portraits with an analysis of the nude female body.

Schiele's favorite studio prop, his mirror, makes a rare but significant appearance in his art. Although we have been aware of his performances in front of a mirror, it had never been depicted so explicitly before, and would not be so again. For once, the self is marginalized, compositionally and thematically. Schiele presents himself to the left of his model, sitting with rapt concentration on his face, eyes boring into the image which he confronts and with which he is confronted.

The viewer sees the pert and pretty model from both a front and rear perspective as she flaunts her body in front of the artist and his mirror. The implication is that we are invited to join in; to empathize with the artist and to indulge in the delights of the lithe flesh on offer. Schiele's dark eyes confront everything. Those of his model, however, alluringly made-up and framed by the jaunty hat which she wears, avoid a direct stare, so

engrossed in her own image does she appear to be. Her pubic hair demands similar attention, framed this time by the tops of her stockings but with legs closed, ultimately repelling sexual advance while seductively provoking sexual reaction. The drawing recalls an explanation of his approach to self-portraiture and the female nude made contemporaneously by Gustav Klimt.

No self-portraits by me exist. I am not interested in myself on the 'subject of a picture'; what interests me is other people, females in particular, and above all, other phenomena. I am convinced that as a person I am not particularly interesting. I am nothing special to look at. . . . The world will have to do without my artistic or literary self-portrait. Which is not a matter for regret. Anyone who wants to know about me – as an artist, which is the only interesting aspect – will have to take a close look at my pictures and to work out from them what I am and what I want.

All this is a far cry from Schiele's self obsession. It is, however, a view which, in common with some of Schiele's art, raises other fundamental questions transcending mere subjectivity.

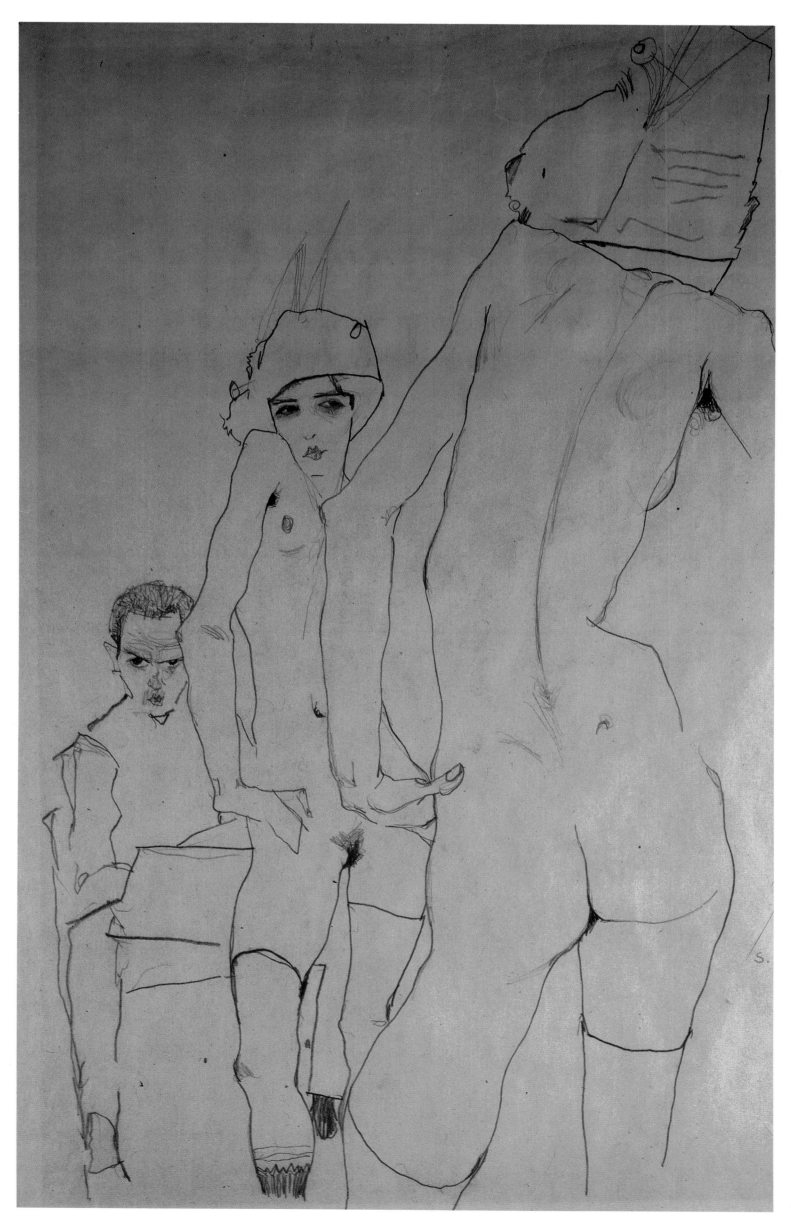

43

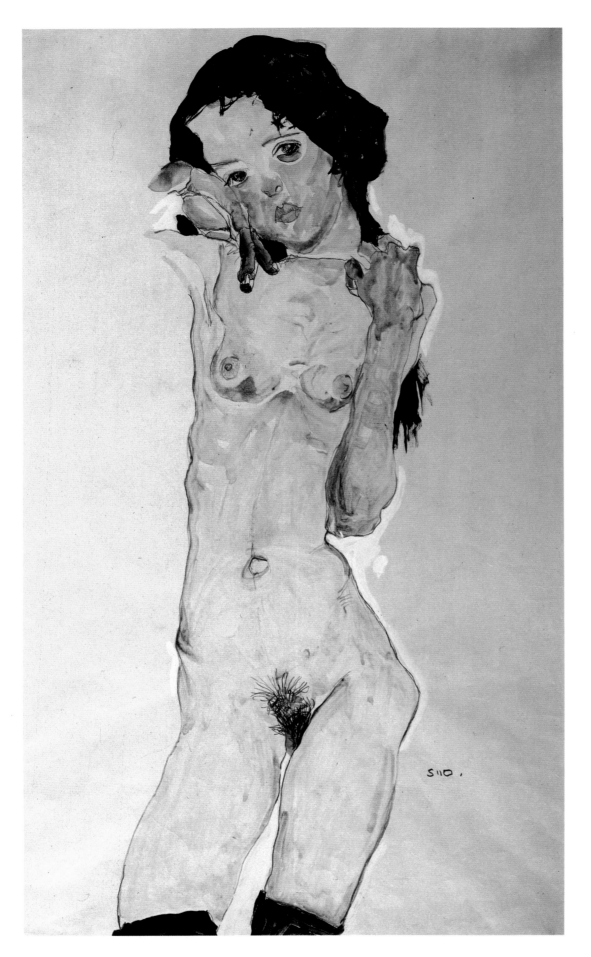

Standing Nude Girl, 1910
Pencil and watercolor
21¼×12 inches (54×30 cm)
Graphische Sammlung Albertina,
Vienna

Seated Young Girl, 1910
Watercolor and gouache
21¼×12 inches (54×30 cm)
Graphische Sammlung Albertina,
Vienna

These two watercolor studies of young girls are of similar size and central compositional format and confront similar themes. The fleshless young Gothic bodies which Oskar Kokoschka had discovered in the work of the Belgian sculptor Georges Minne, who showed extensively at the 1909 International Kunstschau, appealed to Schiele's artistic concerns in 1910. Drawing also from Edvard Munch's rendition of *Puberty*, the pose of which he had used in his *Portrait of Edvard Kosmak* in 1910, Schiele set out to re-examine the awakening sexuality in pre-pubescent girls. The unself-conscious, nude posturing of his models who were often from the city's slums, caused scandal in subsequent years. Evidence of Schiele's active interest in young girls is sparse and indeed his paintings and drawings are made from a detached voyeuristic standpoint, rather than hinting at any physical communion with his models.

Both girls, standing and sitting, have vacant expressions on their faces; the standing model gazes with an independent belligerence, and her friend sitting stares with a sense of abandonment combined with her attempt to seduce.

Both bodies are tinged faintly with red and green washes giving their young skin an overriding feeling of decay and disease. Child prostitution was rife in Vienna and sexual disease among young and old was a widespread problem. Schiele seems to warn viewer and model of the dangers of sex while at the same time, suggesting its irresistible allure.

'The erotic work of art has a sanctity all

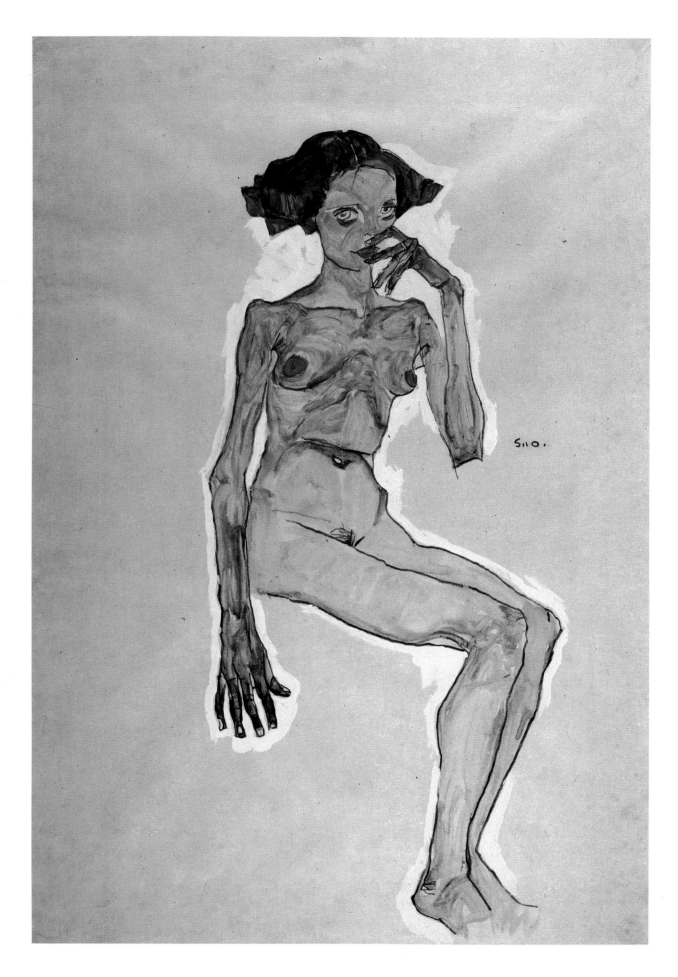

of its own,' Schiele pronounced to his godfather, Leopold Czihaczek, in 1911. This is defined by the white haloes which surround the figures of his young models. 'I paint the light which comes out of all bodies,' he wrote in the same year, an approach which reduces these sketches to the level of analytical. The sexual charge of the works is heightened by the blazing red lips, nipples, and vulva of the standing girl, together with her fetishistic stocking-tops which seek to frame the pudenda. The seated model, isolated and without an actual chair, has the long, bony hands and fingers of the artist who identifies, in part, with her depravity, but who also tries to present her innocence by means of mitigation.

Schiele produces work which in its explicitness and shocking simplicity still has the power to disturb eighty years later, recalling the artist Alfred Kubin's words written in 1923: 'Yes, our age is forced to distill its beauty out of terror.'

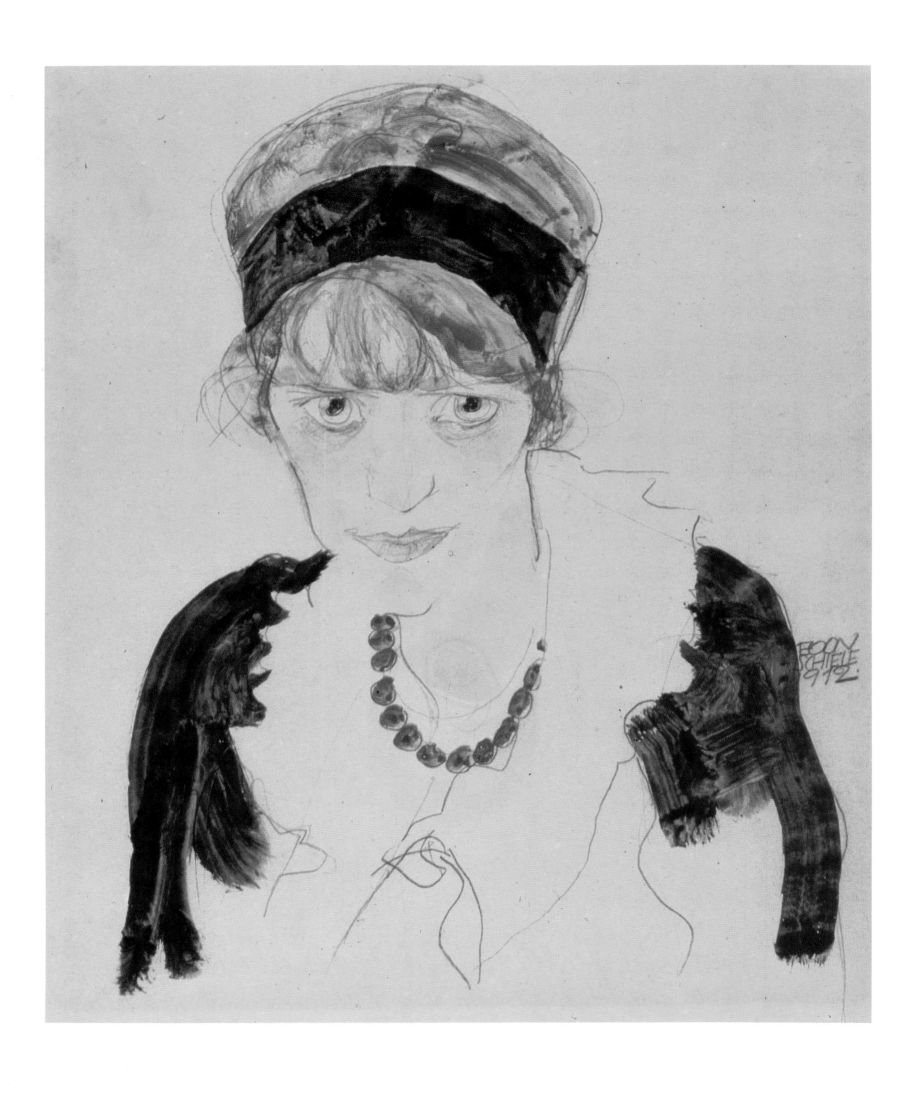

Wally, 1912
Pencil and gouache
11½×10½ inches (29.2×26.7 cm)
Private Collection
Photograph Galerie Im Griechenbeisl,
Vienna

In 1911 Schiele had met the woman who was to rejuvenate his sexual, emotional and artistic powers, a 17-year-old model who had earlier associated with Klimt but who sexually and professionally had been passed on to the younger artist in the summer of 1911 and remained with him until the summer of 1915. Her devotion to Schiele is almost legendary, ranging from posing for him to doing the household chores, and even delivering erotic drawings of herself and other models to various clients. So lewd were some of these images that the young girl was often reduced to tears by the vulgar suggestions made by certain male clients.

She proved to be an object of fantasy and desire as well as one of tenderness for Schiele throughout their relationship, right up to 1915 when he decided that he must return to his bourgeois roots and marry 'advantageously.' So powerful was their union that he proposed to continue by holidaying together annually but Wally refused and left her former lover to serve as a nurse in World War I. She died in the course of this work some time in 1917.

It was the 'noble' Wally who stuck by her man, imprisoned at Neulengbach, and brought spiritual and artistic inspiration in the form of paint and brushes in his darkest hour. Posing seductively and without inhibition for the artist throughout the period from 1911 to 1914, and inspiring a series of devoted images rarely surpassed in terms of the intensity of interaction between model and artist, Schiele and Wally worked together in artistic and emotional harmony in the prewar years. Her green eyes and red hair feature regularly in Schiele's work: either fetishistically clad or respectably clad she shocked and captivated the inhabitants on the fringes of Vienna with her doleful eyes and fashionable attire.

Nude Against a Colored Background, 1911
Pencil, watercolor, and gouache
19×12½ inches (49×31 cm)
Neue Galerie der Stadt, Graz

Lovers, 1911
Pencil, watercolor, and gouache
19×12 inches (48.3×30.5 cm)
Private Collection

Overleaf:
Two Girls Lying Entwined, 1915
Pencil, watercolor, and gouache
13×20 inches (32.5×50 cm)
Graphische Sammlung Albertina,
Vienna

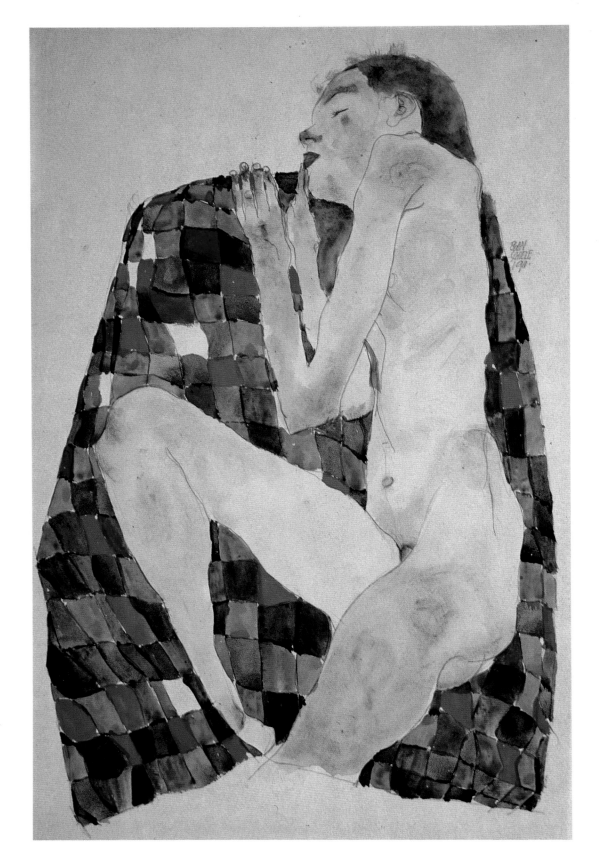

A year after painting his harrowing and sexually explicit portraits of female nudes, Schiele began a new series of watercolor portraits of young girls. In these the girls are shown either alone or together and against a variety of different backdrops which enhance the decorative quality perceived by the artist in the female figure. Initially, at least. In this series, the raw, sexual power which is inherent in his other studies of women is numbed.

The Nude Against a Colored Background from 1911 shows a young, almost odalisque-like girl cocooned in a Wiener Werkstätte patchwork quilt whose blazing reds enhance the delicacy of the young girls' lips and discreetly suggestive pudenda. Once again the model came from the working-class district of the city and seems utterly at home in the studio of a celebrated artist, away from the restraints of domestic life yet protected from the outside world by her blanket. Her natural exuberance, suggested by the color of the blanket, is tempered by the self-awareness of her facial expression relaxed in restful sleep.

The poise, gestures, and contour lines articulate the expressive compositions of Ferdinand Hodler, the Swiss Symbolist painter. From the fact that Hodler had a large retrospective at the Secession in 1903/04 and subsequently sold seven pictures to Carl Reininghaus, a patron of Schiele, it can be inferred that Schiele was familiar with his work. In turn, the color harmonies bear faint analogy with that of musical harmony, prevalent in the Swiss artist's work, but also predominant in the work of Wassily Kandinsky with which Schiele became familiar around 1910.

This balance and harmonious interaction is made manifest in a watercolor which followed soon after, entitled *Lovers*, in which two girls lie fused in relaxed but sexual embrace, this time against an orange, blue and brown tartan, or 'Scottish-style,' blanket, a cocoon which reflects their closeness.

Lesbianism had always fascinated the male voyeur and artists from the Renaissance to Rodin had engaged themselves in analyzing, depicting and doubtless titilating themselves, and their predominantly male audience, by the subject. The calm and affection of *Lovers* foreshadows the allusion to more frenetic activity in female love-making which is confronted in a watercolor from 1915, *Two Girls Lying Entwined.*

This work, the culmination of the sequence currently under analysis, portrays two women lying doll-like across each other in drained and post-orgasmic pose. Colored backdrop and sexual object are combined in the partially clothed figures which reassert the libinous instinct of woman. The triangle of limbs and torsoes, clothed and unclothed, with various patterned backgrounds, seems to have been inspired by Japanese *Shunga*, or erotic pictures, as pointed out by Simon Wilson, presenting a further source of inspiration for Schiele's work, both thematic and compositional, hitherto neglected.

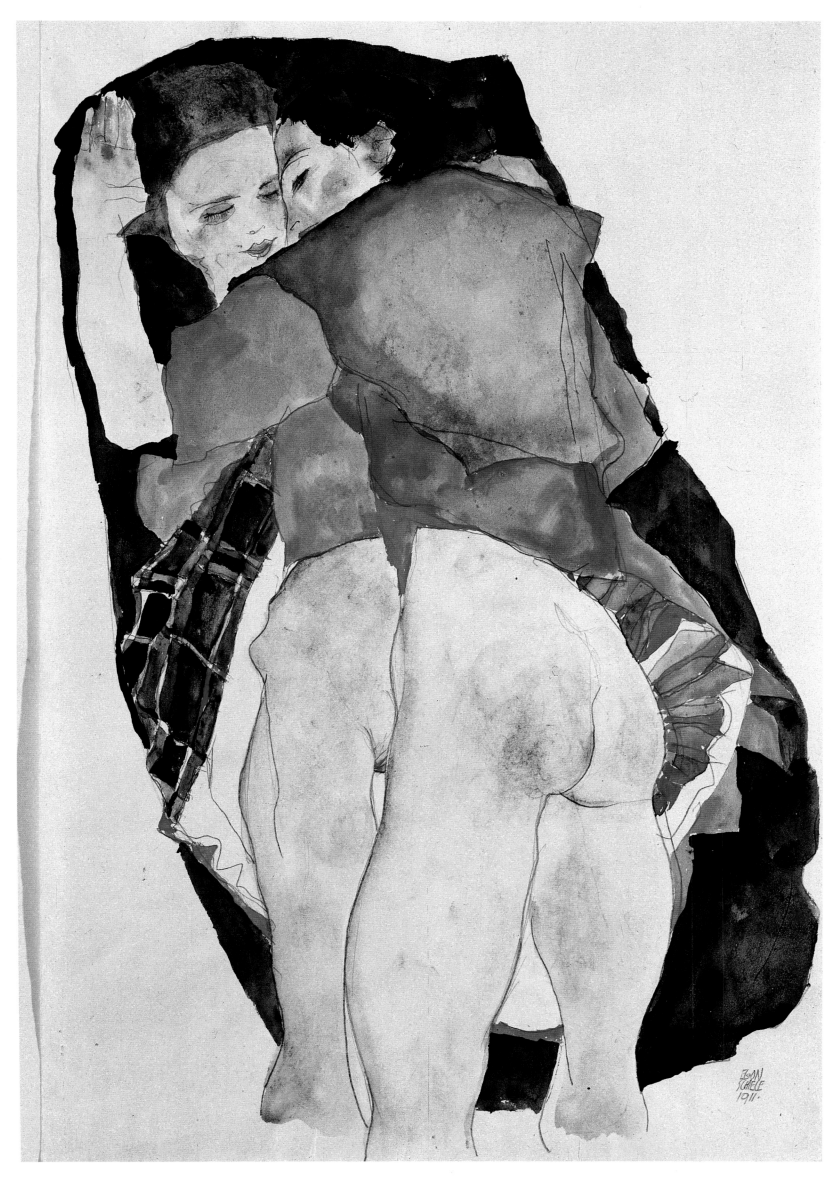

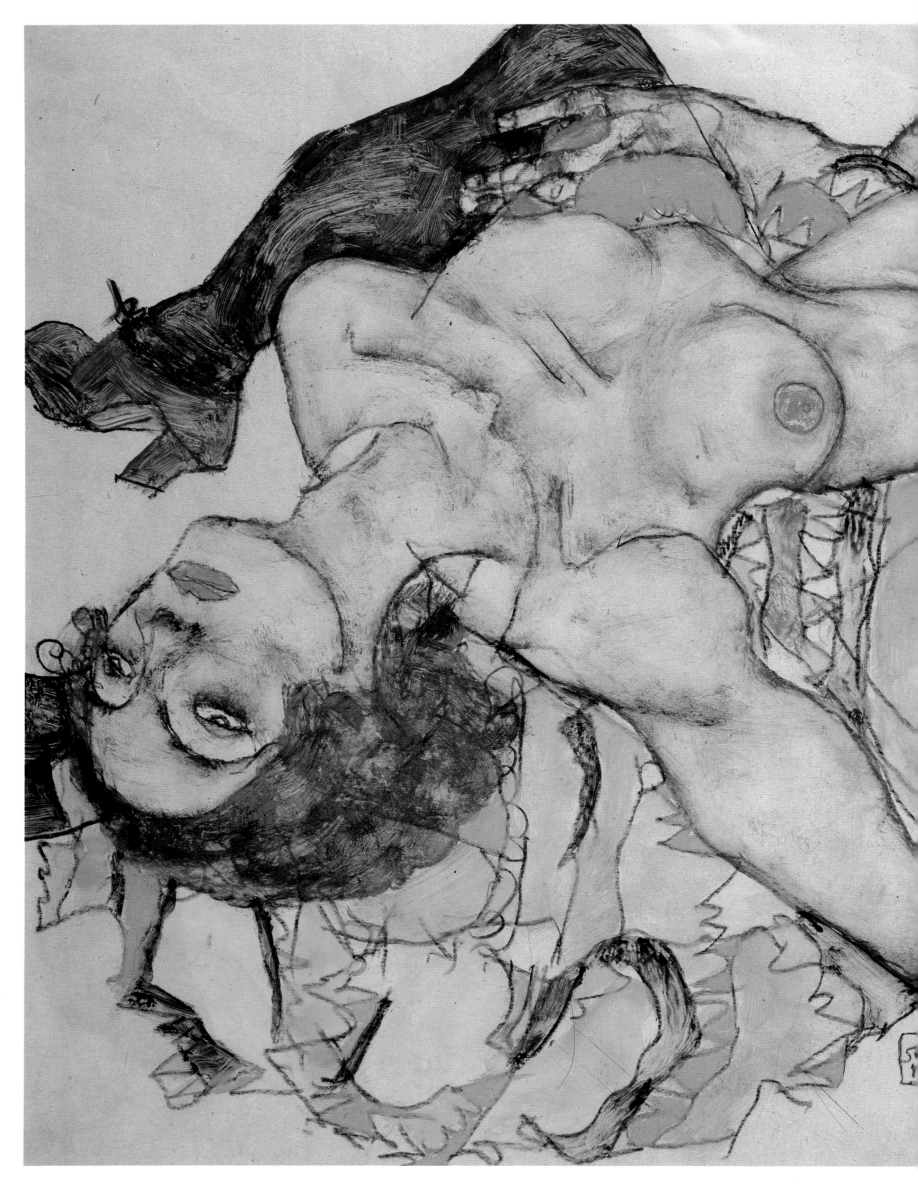

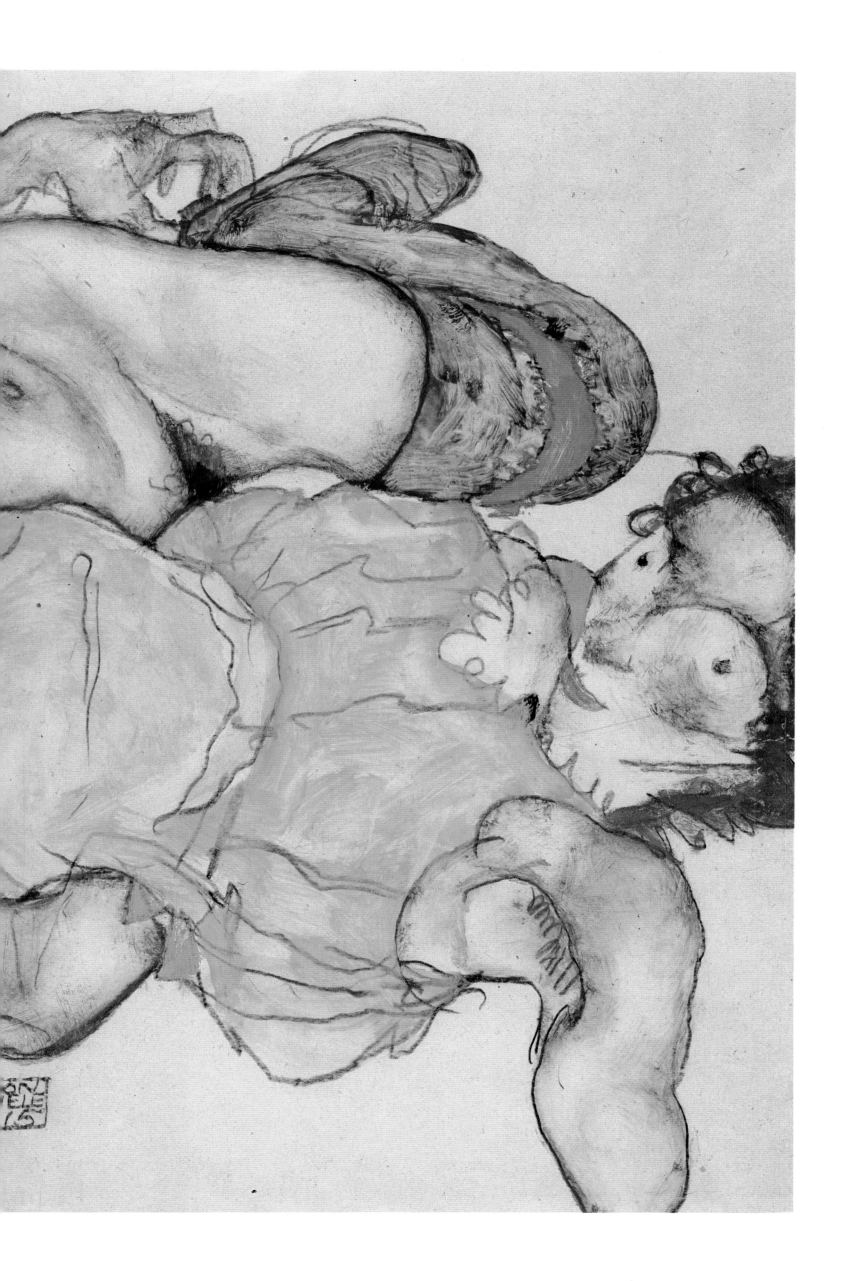

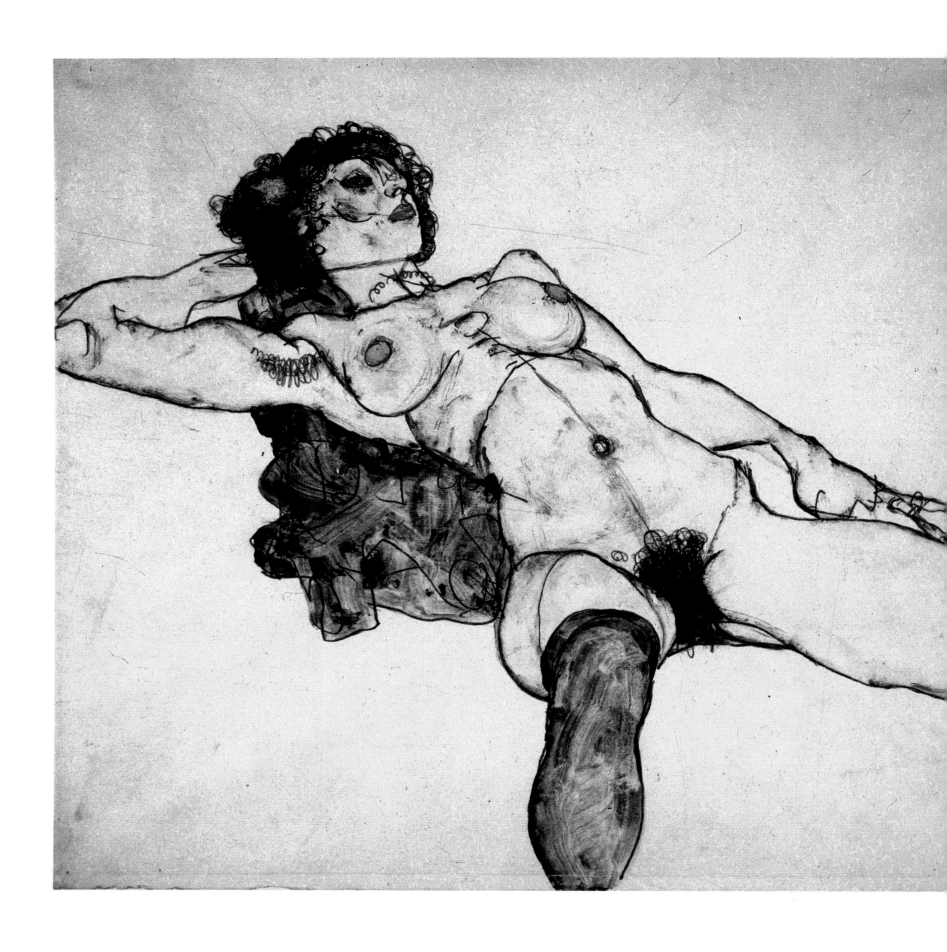

Nude, Lying, 1914

Pencil, watercolor, and gouache
11¾×18½ inches (30.4×47.2 cm)
Graphische Sammlung Albertina,
Vienna

Schiele's graphic watercolor of a reclining nude painted in 1914 suggests a variation in theme and purpose which belies its straightforward and explicit appearance. First and foremost it is an image of raw unadulterated sex. The woman lies, legs apart, in a passive pose whose invitation to sexual communion is tempered only by the fact that the pulpy red vulva, a feature so often depicted by Schiele, is absent. Even in a wary, post-prison mood, Schiele seems determined to produce work tantamount to pornography and, in spite of his disclaimers, many works were produced for that end, as a means of making a living. One could add that as a consequence of his imprisonment, Schiele's intention is to shock.

From 1911, when he began his affair and working relationship with Wally Neuzil, Schiele had tended to use only her as his model. The reclining nude is not Wally but another woman. Whether or not Schiele's relationship went beyond the merely professional, the fact that he looks elsewhere for inspiration and subject-matter has some significance in terms of his personal life and eventual break-up with Wally to marry Edith Harms.

Some time in 1910 Schiele made the acquaintance of a gynaecologist called Erwin von Graff and consequently was able to make drawings in the Women's Hospital in Vienna. The use of sick and pregnant women as models in his allegorical oils from 1910 was the main result of this new situation, but the resulting imagery is made plain enough in other work. The *Nude, Lying* has the passive pose of a woman awaiting medical examination and, although this is not to underplay the more obvious sexuality in the watercolor, it does add a further, valid dimension to Schiele's erotic work.

Self-Portrait Pulling Cheek,

1910
Black chalk, watercolor, and gouache
17½×12 inches (44.5×30.5 cm)
Graphische Sammlung Albertina,
Vienna

This *Self-Portrait Pulling Cheek* is the same size and is rendered in similar red/orange watercolor washes as the *Self-Portrait Screaming* (page 57) to which it relates closely. The iconography and effect of the works, however, differ markedly.

Recent scholarship has paid much attention to this work in which Schiele stands in full frontal pose, one hand clasped across his stomach, the other pulling down on his right cheek, opening up his right eye in distorted gaze. Alessandra Comini has interpreted the portrait in terms of Schiele's self-awareness and the parodying of his own name. In German *schielen* is the verb 'to squint' and the effect of his quixotic hand gesture causes his left eye to appear to be doing just that.

In a recent catalogue essay, and doubtless drawing on the work of Erwin Mitsch in his 1974 monograph on Schiele, Klaus Albrecht Schroder has traced the stomach-clutching gesture and the sorrowful expression on the face, caused by the distortive effect of the hand on his cheek, to a lay tradition of self-portraiture as the 'man of sorrows.' This stems from the Renaissance, particularly Albrecht Dürer's identification with Christ, through nineteenth-century Romanticism up to and including early twentieth-century Viennese self-portraiture, notably in the work of Richard Gerstl and Egon Schiele. It was a tradition from which the latter was to continue to draw in the self-portraits made immediately after his imprisonment.

The doleful mood and inherent sadness of the work was to be the central theme of a large oil painting entitled *Melancholia*, now lost, for which it was initially a preparatory study.

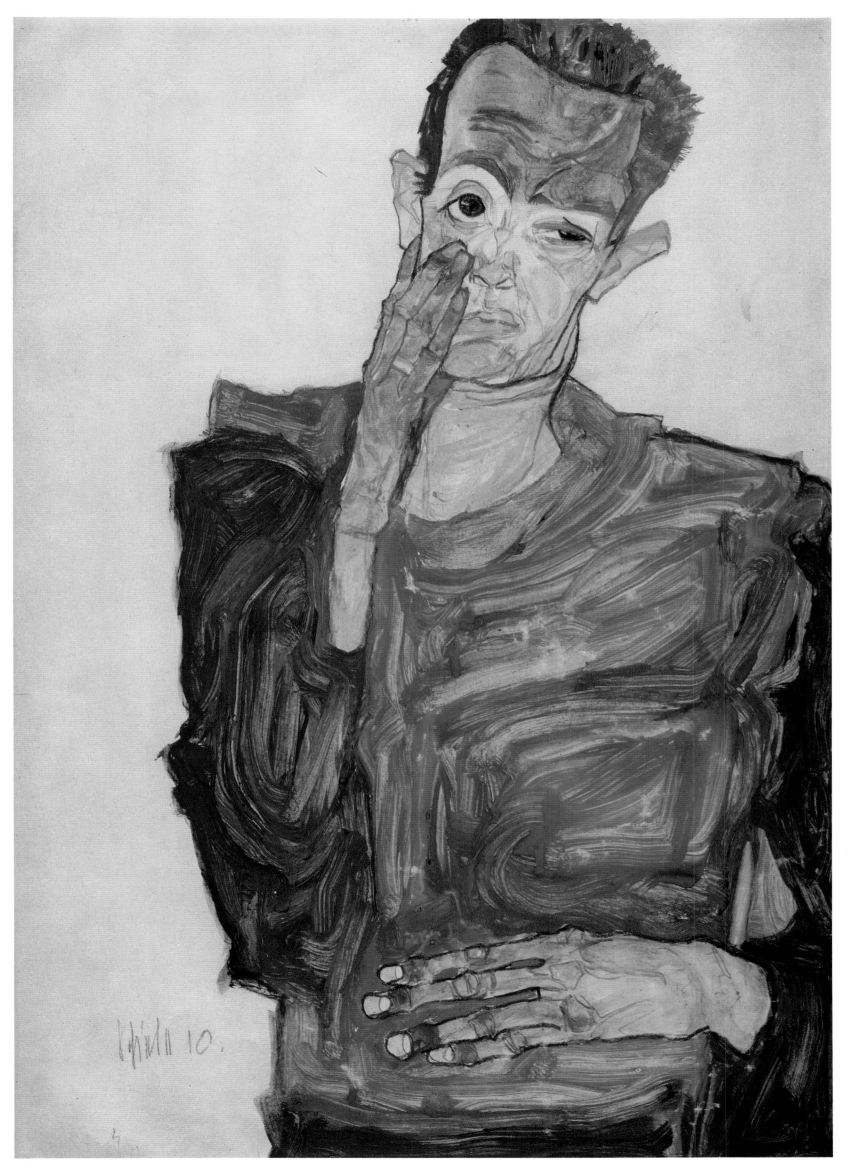

Self-Portrait Screaming, 1910

Pencil, watercolor, and gouache
17½×12 inches (44.5×30.5 cm)
Graphische Sammlung Albertina,
Vienna

This and the three self-portraits which follow are among the earliest and most harrowing of all Schiele's depictions of self, signaling the beginning of a series now known as the radical portraits.

The painting has an angry red/orange watercolor wash all over it which amplifies Schiele's paroxysmal and frustrated outburst. His face is pulled so taut that the skin is strained across his high cheekbones. His mouth is flung wide open and emits a piercing scream as his eyes tighten up in a fearful grimace. Recalling Kraus's dictum about Vienna and isolation cells in which one can or must scream, as so much of his work at this time seems to do, the portrait also draws on Expressionist iconography, not least on Edvard Munch's celebrated depiction of *The Scream*.

Schiele locates himself within an imprisoning picture-frame which echoes rather than absorbs the outburst, whereas Munch uses the Northern European landscape as a backdrop and sounding-box in his work. The result is that Schiele induces a greater intensity of 'sound' and 'image' in his painting together with a characteristic sense of alienation.

The isolated white tooth which contrasts so sharply with the rawness of the red mouth heightens the already tense mood of the painting. The effect of the work is both cathartic – an attempted purging of all his pent-up frustrations by Schiele – but also exudes a feeling of nemesis – Schiele's indignation and anger at the world as a whole and his attempt to invoke a semblance of retributive justice.

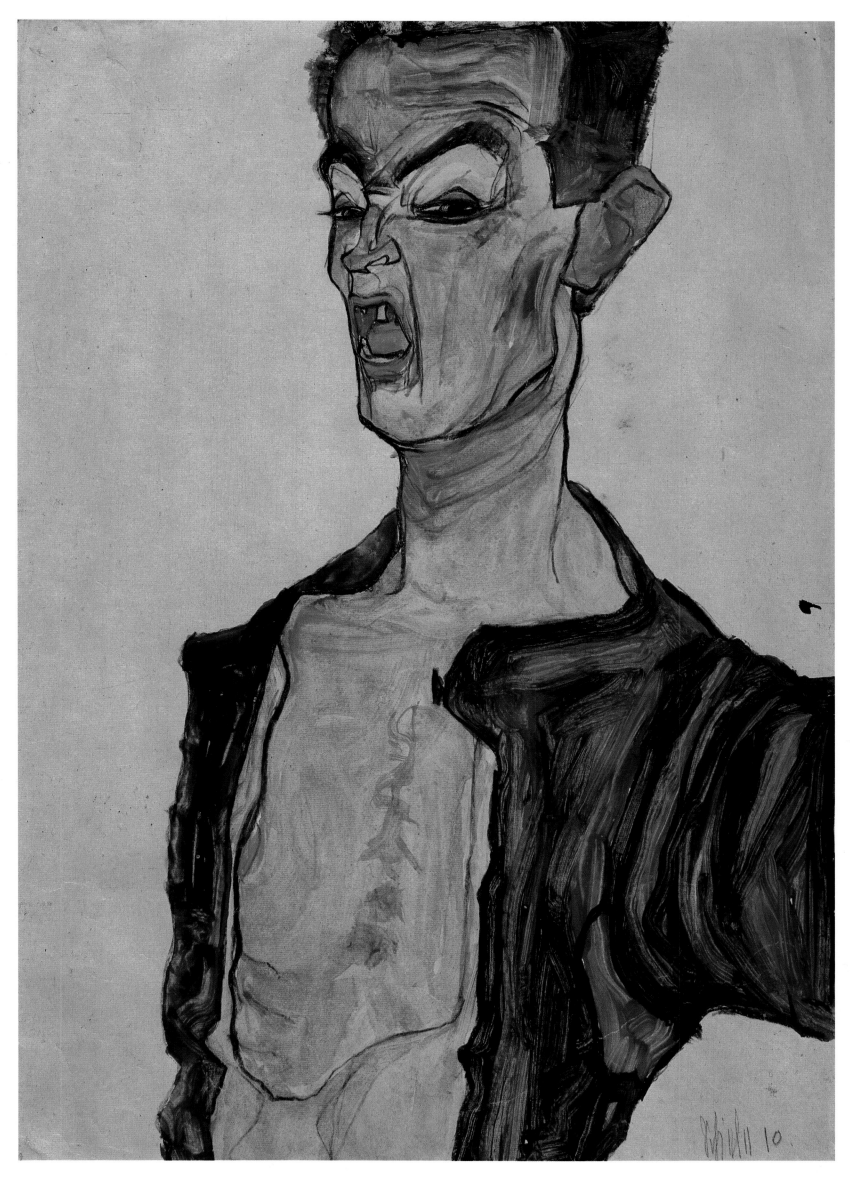

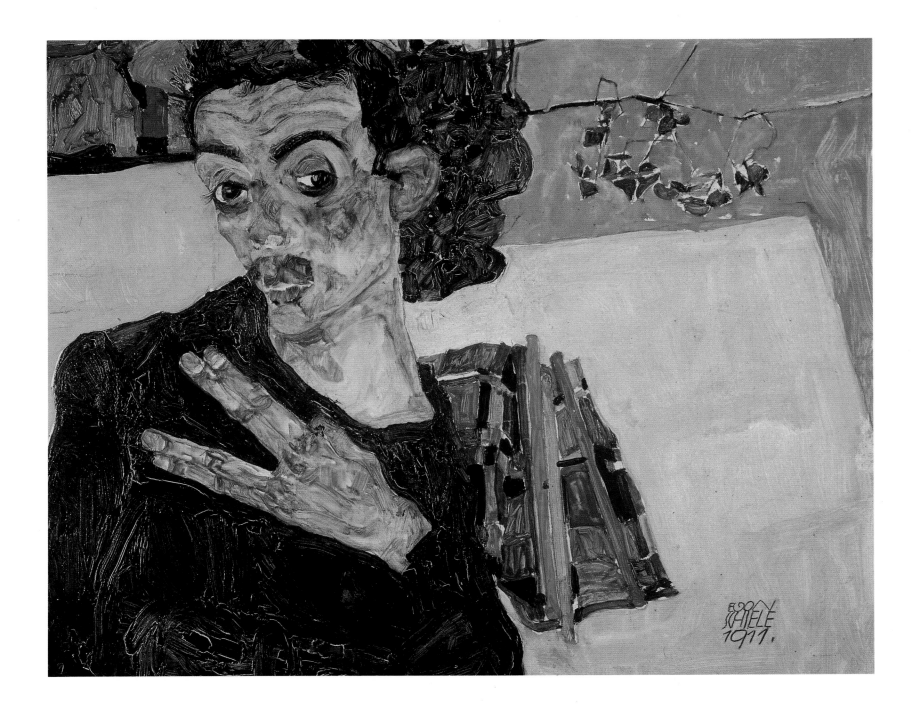

Self-Portrait with Black Clay Vase, 1911

Oil on wooden panel
10⅞×13⅜ inches (27.5×34 cm)
Historisches Museum der Stadt Wien, Vienna

Painted in similar circumstances and with the same technique as the *Artist's Bedroom in Neulengbach* (page 62) on wooden board or Bretterl, this self-portrait nevertheless illustrates that Schiele's feelings of vulnerability and confusion were still strong and the painting has the feel of a premonition.

Schiele's wide-eyed stare gives him the look of a trapped animal. He appears cornered and stands amid what seems to be a collection of objects on a table against a backdrop loosely evoking his fall trees and plant paintings also from 1911. The brightly colored Wiener Werkstätte cloth lying on the uptilted tabletop recalls a phase of Schiele's career from which he had recently emerged while at the same

time adds an air of frivolity to an otherwise curiously confused mood.

A gesture of Schiele's hand, only possible, according to Frank Whitford, if one were double-jointed, fuses medieval religious imagery with the artist's own brand of idiosyncratic and enigmatic personal coding. The hands slapped across the chest can be read in a number of ways: from a gesture of self-admission, 'mea culpa,' to a sign of peace or even, with his parted fingers, as conveying a readiness to give blessing. In the late twentieth century the gesture reads as a silent attempt to tell the world where it can go.

The most curious and ultimately significant aspect of the painting is found in

the black clay vase which seems to emerge from the back of Schiele's head, but which in fact stands on the table, and whose profile echoes that of the artist. It has been ascertained that Schiele owned a similar black vase, multi-faced and known as 'janus-faced.' The conception of a 'janus-vase' is central to this work and indeed to much of Schiele's art in general.

The painting both looks back to Schiele's early career and heralds later events and styles; the artist looks inwardly at himself while gazing outwardly at the viewer and beyond. The range of iconographical gesture spans from the medieval to the existentialist modern period, creating an image rich with alternative meanings.

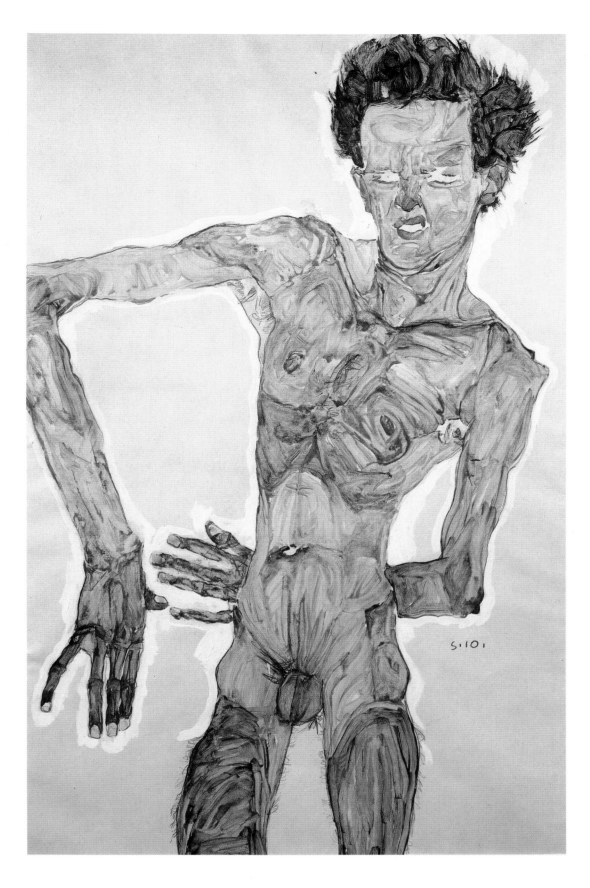

Self-Portrait Nude, Facing Front, 1910

Pencil, watercolor, gouache, and glue
21⅞×14⅓ inches (55.5×36.5 cm)
Graphische Sammlung Albertina,
Vienna

In this self-portrait riddled with contrast and paradoxical confusion, Schiele's gaunt and ageing body belies the physical exuberance of the dance-like physical contortion.

The patchy application of watercolor, gouache, and glue gives his skin a diseased look and his grimacing facial expression seems to baulk at the putrid smell which his body emits. The pose seems to stem from contemporary Expressionist dance as practiced by Mary Wigman and others in fin-de-siècle Vienna. In fact, Schiele's body is convulsed and in the throes of orgasm, his penis hanging limply with post-orgasmic flaccidity almost denying the artist's sexual identity while his body retains an electric sexual charge. This is amplified by the white body halo, or 'astral glow' which outlines the form of the figure. This is a feature which has religious connotations of sanctity, scientific connotations of radiating energy, Freudian allusions to the impulses of the libido, and finally can be read as a theosophic aureole, stemming from a fashionable ideology widespread among artists from Kandinsky to Piet Mondrian.

The self-portrait was used as a poster to advertise lectures by Egon Friedell on 'George Bernard Shaw and Shakespeare,' as well as on hand-bills to publicize musical concerts by the Rose Quartet who performed works by contemporary Austrian composers such as Anton von Webern and Arnold Schoenberg. Finally, it appeared on the cover of Robert Muller's militant magazine *Der Ruf*, published in 1912 and lasting four issues.

Self-Portrait Masturbating,

1911

Pencil and watercolor
18½×12½ inches (47×31 cm)
Graphische Sammlung Albertina,
Vienna

Beginning with an earlier self-portrait with trousers pulled down from 1909-10, Schiele explores the whole spectrum of physical and emotional sensations which the body and mind undergo during masturbation and sexual release.

Ecstacy, abandonment, release, and the guilt-ridden angst and post-orgasmic depression are all analyzed and explored with an equal intensity by Schiele in his studies of this most intimate of private acts, here made public.

The subject of masturbation had become more acceptable in artistic circles at the end of the nineteenth century, notably in the work of Rodin. In his bronze tribute to Balzac, an equation was made between masturbation and orgasm on the one hand and artistic creativity and genius on the other. This allusion is covertly rendered with the writer clearly masturbating beneath his thick overcoat. Likewise, Wedekind's depiction of young boys masturbating in the lavatory, stimulating themselves with an image of Palma Vecchio's 'Venus' had shocked, but had helped to legitimize an essentially taboo area of human activity. Taking this into account, and even considering Freud's treatment of the subject, Schiele still manages to transcend the threshold of public embarrassment. Indeed, the renowned critic of the *Neue Freie Presse*, A F Seligmann wrote in response to Schiele's graphic self-portraits that 'persons of taste are liable to suffer from a nervous shock.'

In the *Self-Portrait Masturbating* Schiele equates pain with pleasure by the agonized expression on his face, a sensation of release and hollow guilt. He holds his genitals in a manner which not only denies his own sexuality but, moreover, in its triangular finger formation, conveys a vulval effect and alludes to sexual ambiguity and a negation of self.

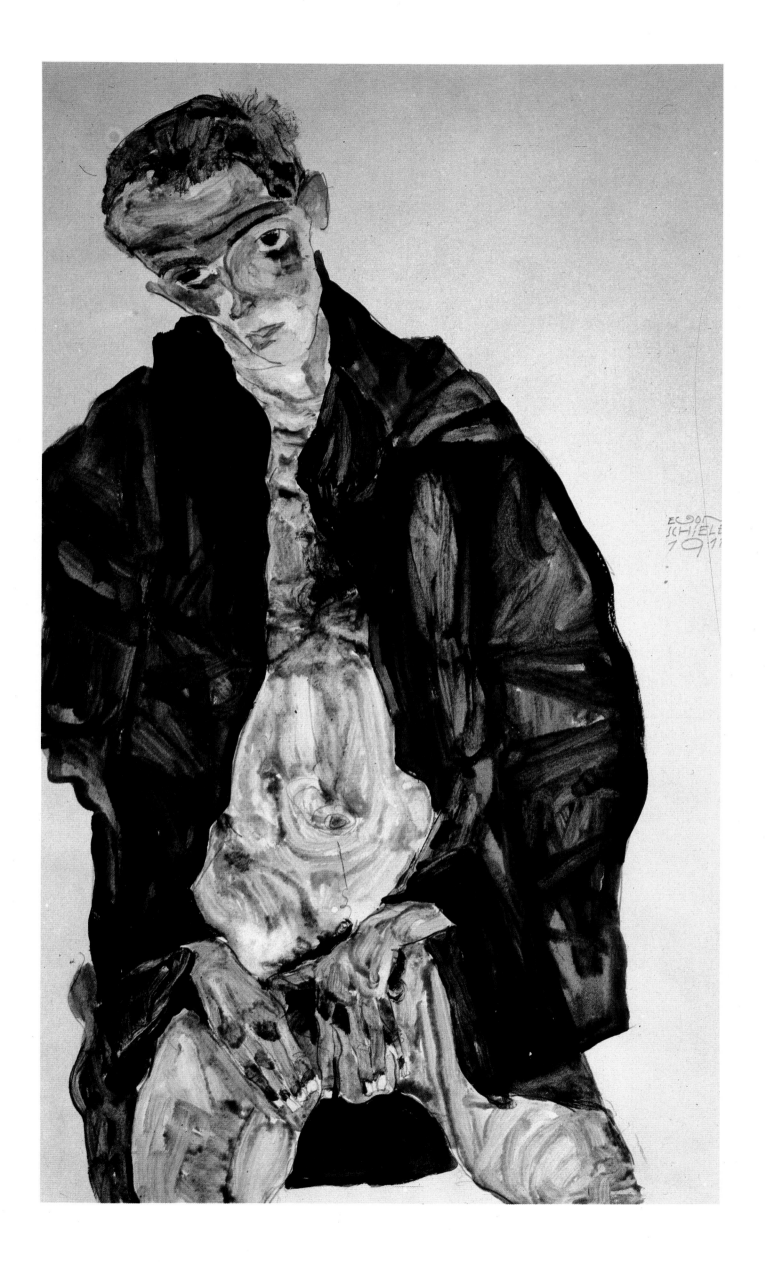

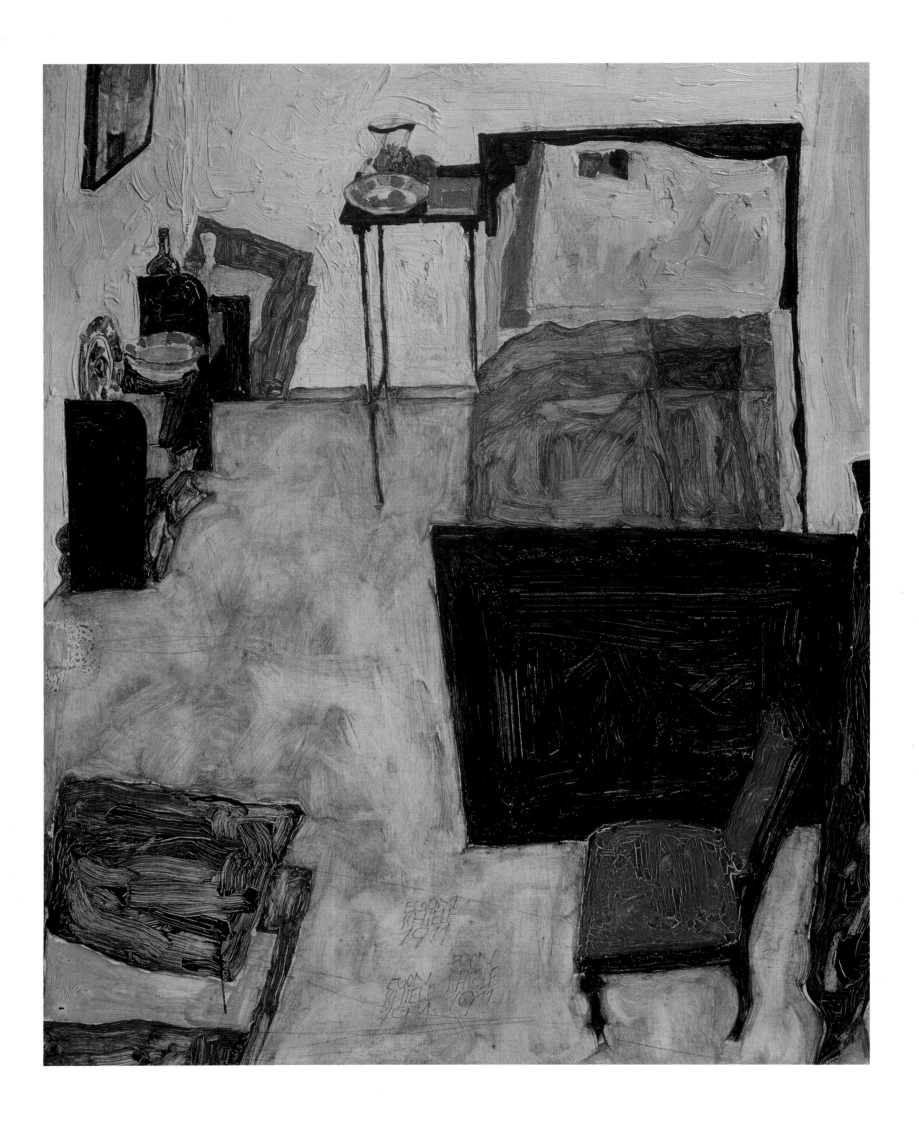

62

The Artist's Bedroom in Neulengbach, 1911

Oil on board
15¾×12½ inches (40×31.7 cm)
Historisches Museum der Stadt Wien

Painted at a time of contentment and fecundity for the artist just prior to his imprisonment, *The Artist's Bedroom in Neulengbach* is Schiele's most overt homage to Vincent van Gogh, from the subject-matter itself to the distorted perspective from which the work is made.

Schiele had seen Van Gogh's *Bedroom at Arles* on exhibition in 1909 at the Kunstschau in Vienna and subsequently at the home of his patron Carl Reininghaus, who owned it.

The work was executed on a piece of wooden board and was part of a series made in 1911, known affectionately by Schiele as *Bretterl* or 'little boards.' The effect of the oil, applied in smooth, thin layers is like that of glazed enamel, and the luminous colors echo those of the Dutch Master, but without the rich effect of his thick impasto.

Peter Selz has noted how Schiele's room has no windows or doors, and as such is an isolated cell (recalling Karl Kraus's dictum about Vienna: 'an isolation cell in which one is allowed to scream'). Van Gogh's bedroom has two doors and a window, thus imbuing the work with a greater sense of liberation and light.

Schiele's fondly painted room focuses more strongly on the bed, viewed from a raised viewpoint and with the pillow predominant. This is a symbolic representation of the artist's head, a cerebral self-reference which hints at the artist's need to control his impulses via his intellect. Self-affirmation is enhanced by Schiele's signing of his name, not once, but three times on the floor in front of his bed.

Schiele's sister Melanie recalled that her brother was fond of pointing out that Van Gogh died in 1890, the year that he was born. This brings to mind the adage of another underrated twentieth-century master, Giorgio de Chirico, who frequently pointed out that when the philosopher Friedrich Nietzsche was certified as clinically insane in 1888 in Turin, he too was born in the same year and subsequently claimed that a metempsychosis or transmutation of Nietzsche's soul had taken place and that he, de Chirico, embodied the philosopher's soul.

Prison Watercolors

There is both an irony and a virtual inevitability about Schiele's imprisonment from 13 April to 7 May 1912: the irony is multiple for at the time of his arrest in Neulengbach, Schiele was in the midst of one of the most contented and fecund periods of his life. Furthermore, although his sentence might have been a good deal more stringent, the judge who sentenced him was himself a collector of pornographic pictures. The sense of inevitability stems from Schiele's arrogance and sense of rebelliousness in an essentially puritanical, yet hypocritical, society in which pornography flourished. In spite of frequent warnings from various friends, Schiele injudiciously left his erotic drawings on display in his studio, even when children came to pose for him. On 13 April 1912, two policemen came to his studio and arrested Schiele, apparently without informing him of the charges for a week.

The charges were of 'immorality' and 'seduction of a minor.' The former was upheld and on top of the 24 days in prison, Schiele had one 'immoral' drawing burnt by the judge, Dr Stouel. Prior to their meeting, Schiele wrote indignantly about him in his diary on 24 April:

Not very far from me, so near that he would have to hear my voice if I were to shout, there sits – in his magistrates office – a judge, or whatever he is. A man, that is, who believes that he is something special, who has studied, who has lived in the city, who has visited churches, visited museums, theaters, concerts, yes, probably even art exhibitions. A man who consequently is numbered among the educated class which has read or at least heard of the life of the artist. And this man can permit me to be locked up in a cage! Hours, yes, days, he leaves me in here and does not bother himself about me at all. What is he thinking? What kind of conscience does this man have?

The second charge of 'seducing a minor,' relates to a 13-year-old girl who had, by all accounts, fled to Schiele and Wally Neuzil's house to escape from home for a while and doubtless to be near the handsome 'celebrity' whose dandy-like dress and bohemian lifestyle had caused quite a stir in the small provincial town.

The account of Schiele's period of imprisonment stems from a prison diary made by the artist and published by Arthur Roessler in 1922. There is strong evidence to suggest however, that Roessler's 'editing' of the diary was at best forgetful and at worst calculatingly self-aggrandizing. Roessler was away in Italy during Schiele's imprisonment and it seems clear that Heinrich Benesch, in visiting the artist three times, played the father-figure during this period. No mention of Benesch's visits was made in the published diary and in spite of his complete absence at the time Roessler records Schiele as having written 'of all my friends AR loves me the most strongly and the most purely because he understands me the most deeply, with his heart.' This has led scholars, most notably Alessandra Comini in her comprehensive study, *Schiele in Prison* (1973), to conclude that Roessler's editing seriously compromises the accuracy of the diary.

Schiele's estimated 13 watercolors – 12 are dated and signed for certain – do provide a relatively untampered account of the artist's range of emotions and, in turn, correspond with specific and personal entries in the diary which, at least, vindicate Schiele's attitude toward himself and his situation, if not his friends.

Left:
The Single Orange Was the Only Light, 19 April 1912
Pencil and watercolor
12½×18⅞ inches (31.9×48 cm)
Graphische Sammlung Albertina,
Vienna

The first watercolor to be painted by Schiele in prison exudes a paradoxical sense of joy in captivity as the result of his receiving artist's materials from Wally and consequently being able to paint and draw:

At last! At last! At last! At last alleviation of pain! At last paper, pencils, colors for drawing and writing. Excruciating were those wild, confused, crude, those unchanging, unformed, monotonous gray, gray hours which I had to pass – robbed, naked, between cold, bare walls – like an animal.

He exclaimed on 16 April and three days later wrote:

I have painted the cot in my cell. In the middle of the dirty gray of the blankets a glowing orange, which V [Vally/Wally] brought me, as the single shining light in the room. The little colorful spot did me unspeakable good.

The watercolor drawing is a detailed rendition of his cell and shows a simple bed made from wooden planks and a makeshift mattress covered by a rough blanket with Schiele's coat folded up to make a pillow. Both cell and composition are dominated by a vivid, luminous orange which sits amid the browns, blues, and grays of the bed linen, a thoughtful present from Wally.

On the wall above the bed, faint lines depict a landscape which Schiele had made with his own spittle. Above this, Schiele has signed his name: the artist's mark and a corresponding piece of graffiti to the initials of a previous prisoner, 'MH' carved in the wood above the door.

I Feel Not Punished, But Purified!, 20 April 1912
Pencil and watercolor
19×12½ inches (48.4×31.6 cm)
Graphische Sammlung Albertina,
Vienna

The title of this watercolor, superficially melodramatic in tone, only hints at the intended sarcasm which underlies the work. Having been made to scrub the floor of his cell, a task which gave Schiele a temporary sense of purpose, Schiele then drew the corridor outside the cell, his door ajar, all described ironically in his diary on 24 April:

Drew the corridor before the cells, with the rubbish that lies in the corners and the equipment used by the prisoners to clean their cells. Fine. Gave me equilibrium. I feel not punished, but purified!

Comini has testified to the accuracy of Schiele's imagery, with its sparse but striking use of yellow. This gives the mops an organic feel loosely akin to Schiele's isolated, fall trees, but in this instance the dominant yellow conveys a summer mood, hinting at his hope for freedom.

The image and composition have parallels with Van Gogh's *Hospital Corridor at Saint-Rémy* painted in gouache and watercolor in 1889. In a later diary entry Schiele wrote:

A walk in the prison courtyard. Roller is surely a great artist, but his prison yard in Fidelio is still only theater, whereas the painting of the prison courtyard by Van Gogh is the most stirring truth, great art.

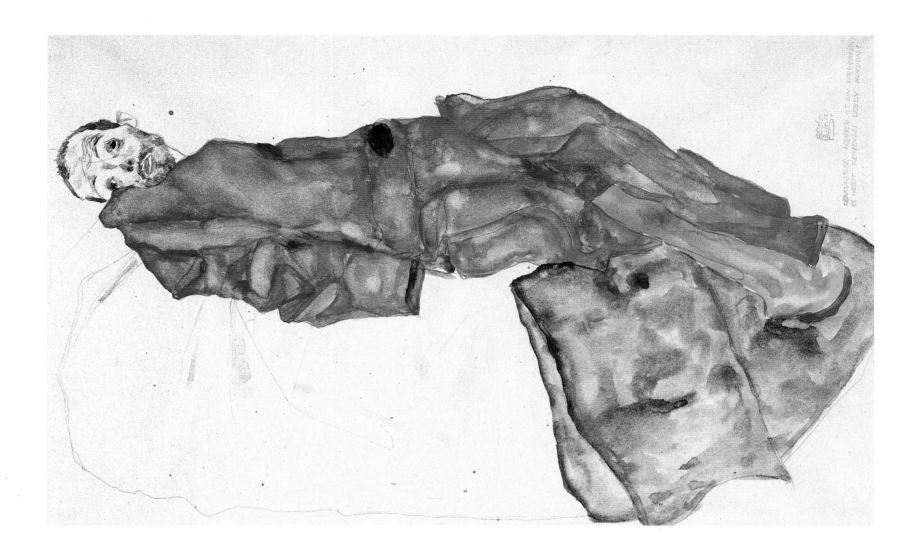

Prisoner, 24th April 1912
Pencil and watercolor
12½×18¾ inches (31.8×48.2 cm)
Graphische Sammlung Albertina,
Vienna

**For My Art and My Loved
Ones, I Will Gladly Endure to
the End!,** 25 April 1912
Pencil and watercolor
15⅛×12½ inches (38.2×31.7 cm)
Graphische Sammlung Albertina,
Vienna

Schiele was able to express in his diary the cathartic benefits of being able to paint and draw.

The imprisonment has become more bearable since I have been able to work. I have drawn the organic movement of the primitive chair and water pitcher, and lightly applied colors to the drawing. I also drew two of my colored handkerchiefs in combination with the chair.
21 April 1912

His situation however, became increasingly desperate and he reverted to angst-ridden self-portraiture of which the third and fourth in the series rank among the most poignant. Curled up tightly in his coat to relieve the cold, yet as if desiring a return to the womb, Schiele is unshaven and unkempt, the tortured *Prisoner*. He looks as if he has just cried out in pain and his body is left limp and lifeless.

A day later, he becomes determined to fight again: His beard is shaven; his hair trimmed and his hands reach out, fingers outstretched in claw-like posture as if ready to fight. In spite of his continued agony he will survive. The theatrical title says it all: *For My Art and My Loved Ones, I Will Gladly Endure to the End!*

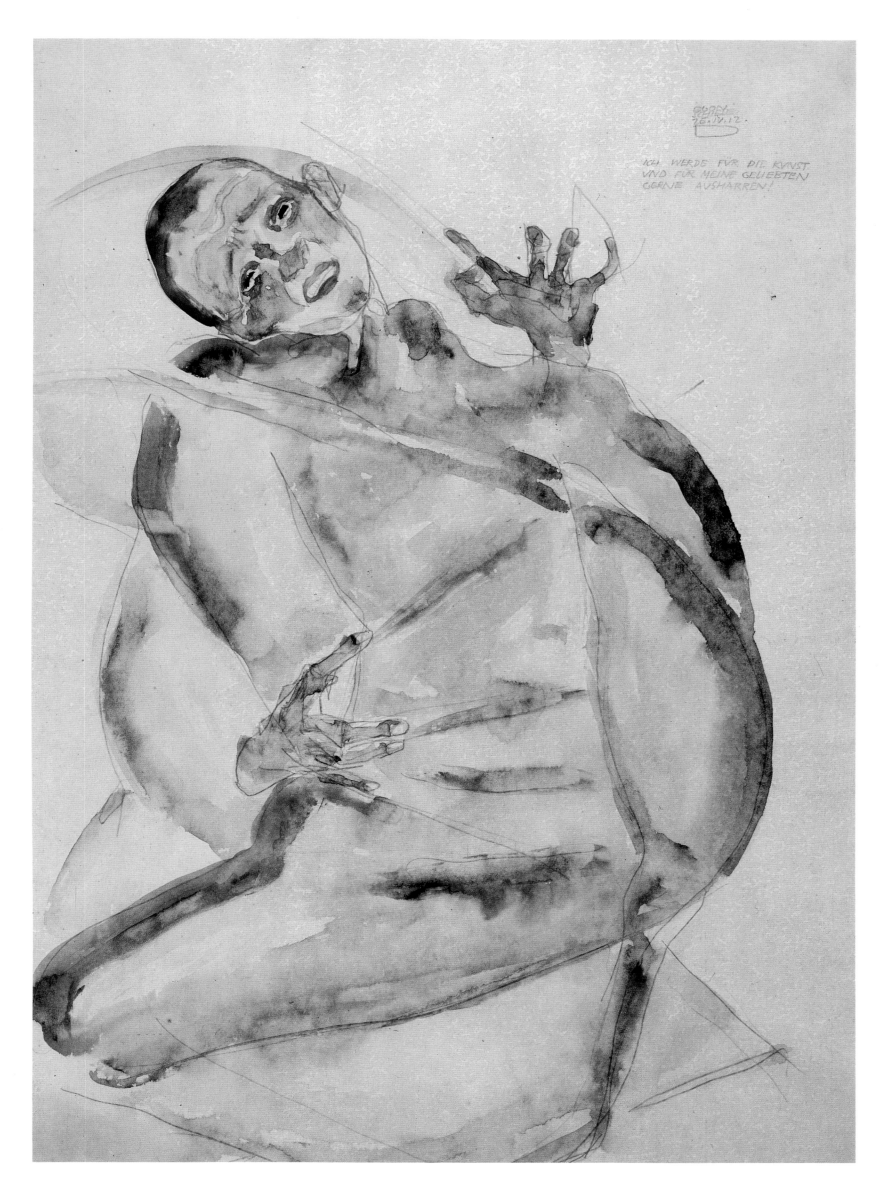

ICH WERDE FÜR DIE KUNST
UND FÜR MEINE GELIEBTEN
GERNE AUSHARREN!

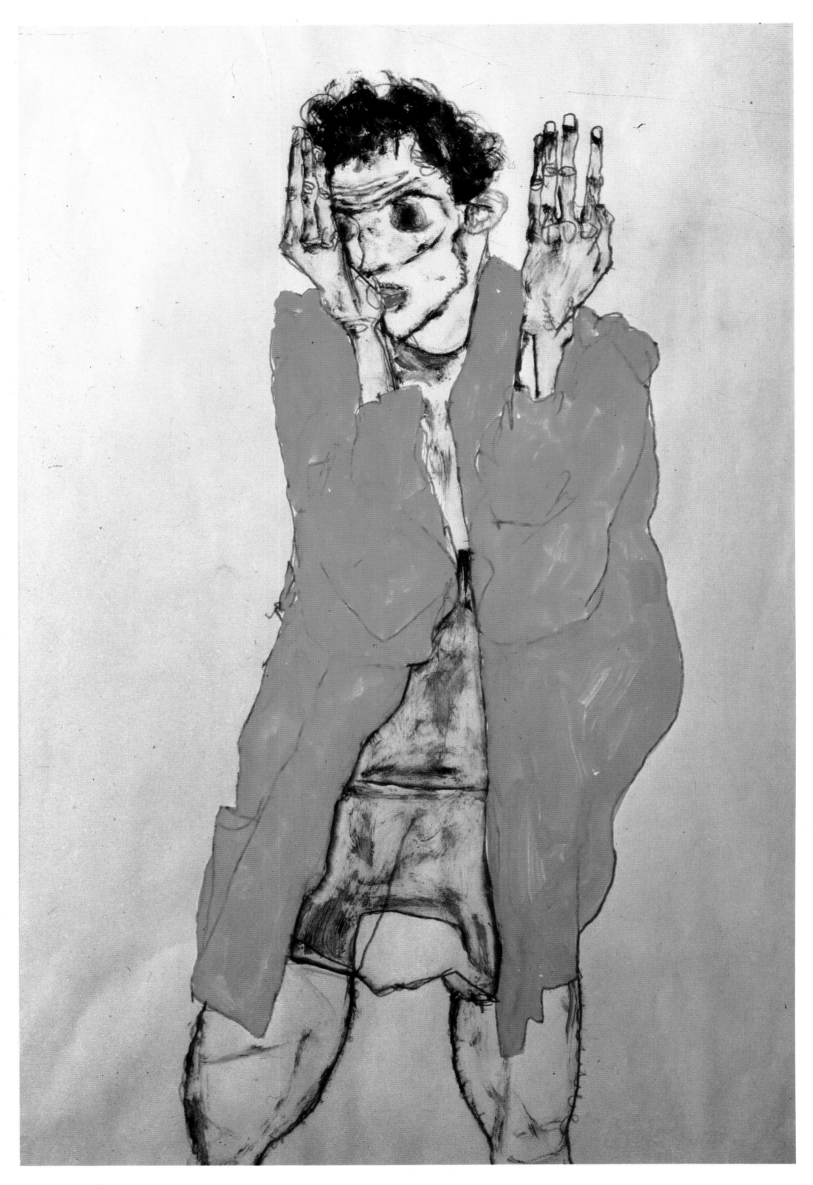

Self-Portrait with Raised Arms, 1913-14

Black chalk and gouache
19¼×12½ inches (49×31.5 cm)
Private Collection

This is one of the earliest self-portraits used by Schiele in a quest to publicize himself from the window of his studio at 10 Hietzinger Hauptstrasse by waving images of himself across the street to two young girls; Adele and Edith Harms, who giggled shyly at the eccentric antics of the crazy artist.

The portraits are poster-like in their simplicity and clarity: flecked with dry smudges of bright color that are easy on the eye but striking at the same time; encased within fluid and easily legible lines. The flamboyant posture draws on a tradition of expressionist dance in contemporary Vienna, a tradition familiar to Schiele from his attendance of Mary Wigman's risqué performances together with his own vacations with Erwin Osen and the dancer Moa in 1910 in Krumau.

The brittle angularity of line is not sub-ordinated to Schiele's fundamentally organic structure. The caricatured eyes, hair, and hands are fused together with a new, exaggerated hardness of image which further abstracts the figure-style. The intention of the work was vindicated by the visual success which it achieved: Adele and Edith were captivated by the artistic and actual persona projected.

These self-portraits were among the last in Schiele's cathartic transformations from monk to saint to socially integrated artist but there is a semblance of pathos, particularly in his sad eyes, which remains unpurged in his later figures. In contrast, however, there is something comical in intent in the visual manifestations of the human form, a fact doubtless acknowledged by Schiele in spite of the relatively serious aims which underlie the the majority of his auto-portraits.

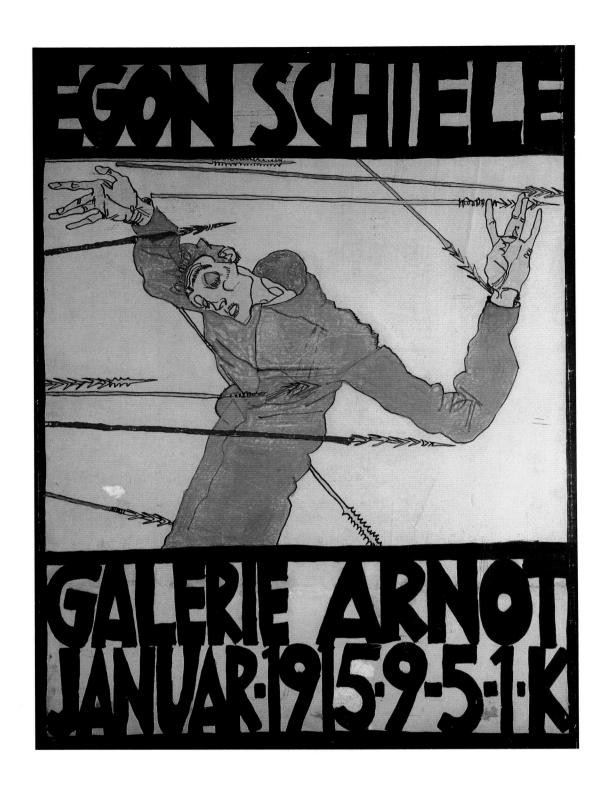

Self-Portrait as Saint Sebastian, 1914-15

Indian ink and gouache
26⅓×19¹¹⁄₁₆ inches (67×50 cm)
Historisches Museum der Stadt Wien,
Vienna

This is the final, harrowed image of the persecuted artist. The Renaissance 'Man of Sorrows' is now isolated. He is a modern-day primitive, a hunted captive suffering 'the slings and arrows of outrageous fortune.' His body is pierced and broken, a crucified man mirroring the persecution of Christ and following in the martyred tradition of St Sebastian.

Sebastian was a Roman martyr who suffered under Diocletian in the late third century, and who is buried in a basilica which bears his name on the Appian Way. Among the earliest representations of Sebastian are the mosaics in San Pietro in Vincoli in Rome, which show him elderly and bearded, wearing a crown. The piercing arrows originate from a fifteenth-century tradition popularized during the Renaissance because of the opportunities offered to portray a delicate young man, nude and helpless, a mirror image for the isolated and weary young artist.

The poster followed closely after Schiele's imprisonment and registered as an attack on the sham morality of the Catholic society which he felt had been responsible for his unjust captivity. It is the first image which portrays the artist emerging from the shackles of asceticism and into the martyred cause of art. The concept of the suffering artist was rejuvenated in the nineteenth-century and remained a legacy from which many artists continued to draw well into the twentieth century.

Although first and foremost an image which identifies Schiele with the martyrdom of St Sebastian, this self-portrait can still be perceived in terms of Schiele's identifications with the suffering of Christ Crucified through metaphysical and public torture forced upon him after his public humiliation at the hands of the State. At his death, he was taken to the home of his mother-in-law, the Harms residence on the Hauptstrasse, like Christ finding no refuge in his own home.

The visual impact of the image seems to have been powerful: The Arnot Gallery retrospective for which the poster was created was Schiele's first successful artistic assault on Vienna, a harbinger of things to come.

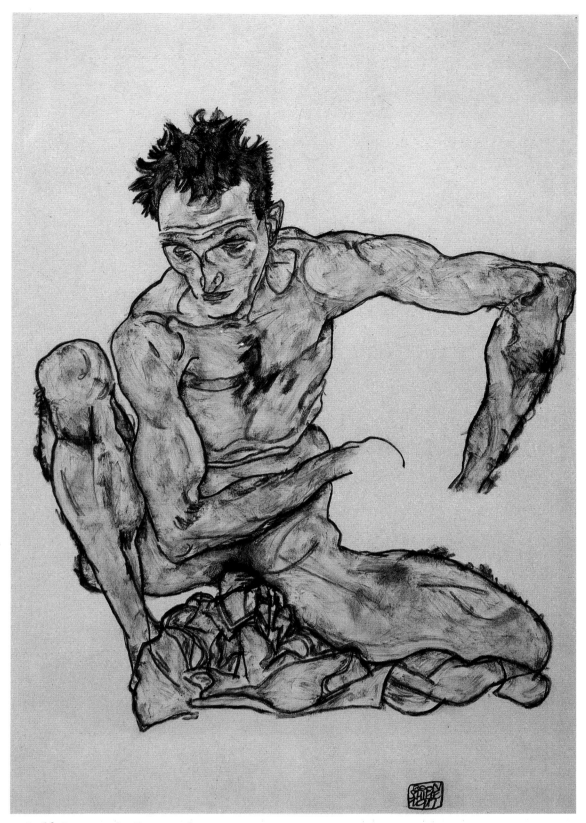

Self-Portrait Squatting, 1916
Chalk and watercolor
Graphische Sammlung Albertina,
Vienna

This small chalk and watercolor self-portrait is one of a series of studies in which Schiele searches for a unique signature-pose for inclusion in later, major works. The graphic precision of the head stems in part from the self-portrait for the cover of *Die Aktion* (page 24) but the pose, rendered by a fluid line flecked with color, is unique.

Schiele's body is lithe, not emaciated. The flesh still has a hint of sickness but in succeeding watercolors of Schiele squatting, his flesh assumes a healthy appearance.

The 'amputated' hands and ambiguous genitalia are not self-mutilation or violent denials of self and sexuality, more a case of an abbreviated sketch in the artist's quest for a signature-pose. No longer is the body a prison from which Schiele seeks release, but more a haven for an increasingly calmed psyche and a potential vehicle for a grandiose artistic statement. From this pose, Schiele was able to develop this image of himself, squatting, resigned but ultimately at ease, and fuses it with the subject of *Mother with Two Children* (page 95) to form his last great allegorical masterpiece, entitled *The Family* (page 108).

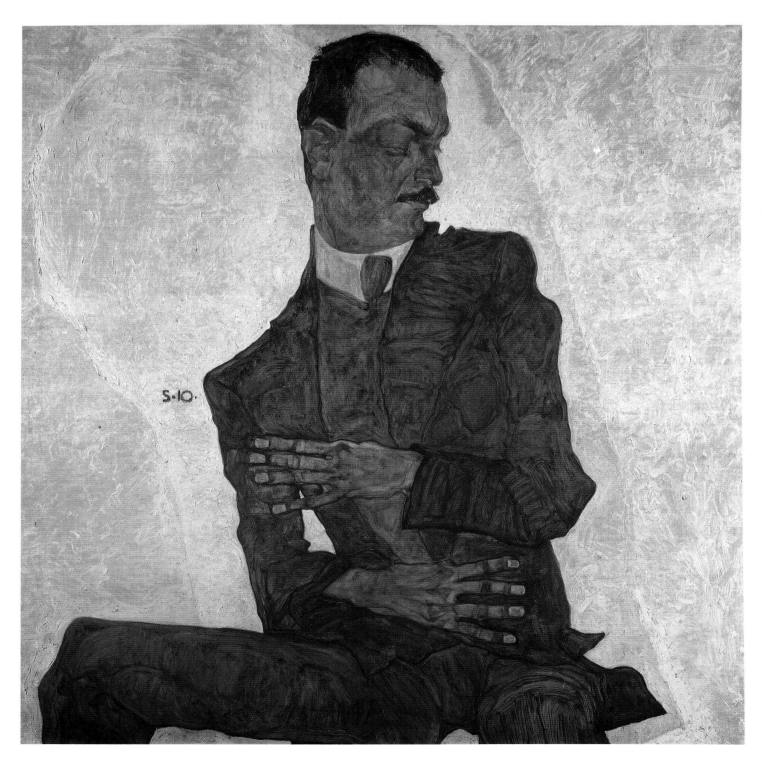

Portrait of Arthur Roessler,

1910

Oil on canvas
39×39 inches (99.6×99.6 cm)
Historisches Museum der Stadt Wien,
Vienna

This was one of Schiele's earliest commissioned portrait oil, painted in a year in which no fewer than eleven were produced and heralding the emergence of his remarkable portrait style.

Born in 1877 and well established as art critic of the *Arbeiter Zeitung* by the time Schiele painted his portrait, Arthur Roessler was to become the champion of Schiele's art. He published some five books about the artist from 1912 to 1923. The two had met after Roessler saw Schiele's work at the Neukunstgruppe exhibition at the Pisko Salon in December 1909 and January 1910. Their friendship was genuine if often argumentative;

Roessler played a paternal role throughout Schiele's life, buying a considerable number of works, supplying material for works, and writing encouraging letters and reviews.

The composition of the painting reflects the increasingly standardized formula used by Schiele from 1910: the centrality of the figure whose austere pose and intense expressionism both contrast with, and are enhanced by, a neutral but increasingly void-like background. The frontality of the torso and the profile view of his turned head, together with closed eyes, owe something to the pose adopted by Gerti in Schiele's portrait of his sister

in 1909. The gestures made by arms and hands and the dreamy though slightly agonized expression of the face echo Roessler's early description of Schiele: 'He had tall, slim, supple fingers with narrow shoulders and long arms and long-fingered, bony hands . . . The features of his face were usually fixed in an earnest, almost sad expression, as though caused by pains which made him weep inwardly.'

Schiele projects himself into the body of an older, established man. Portraiture becomes a vehicle for exploring and expressing his own psyche as much as that of his sitter.

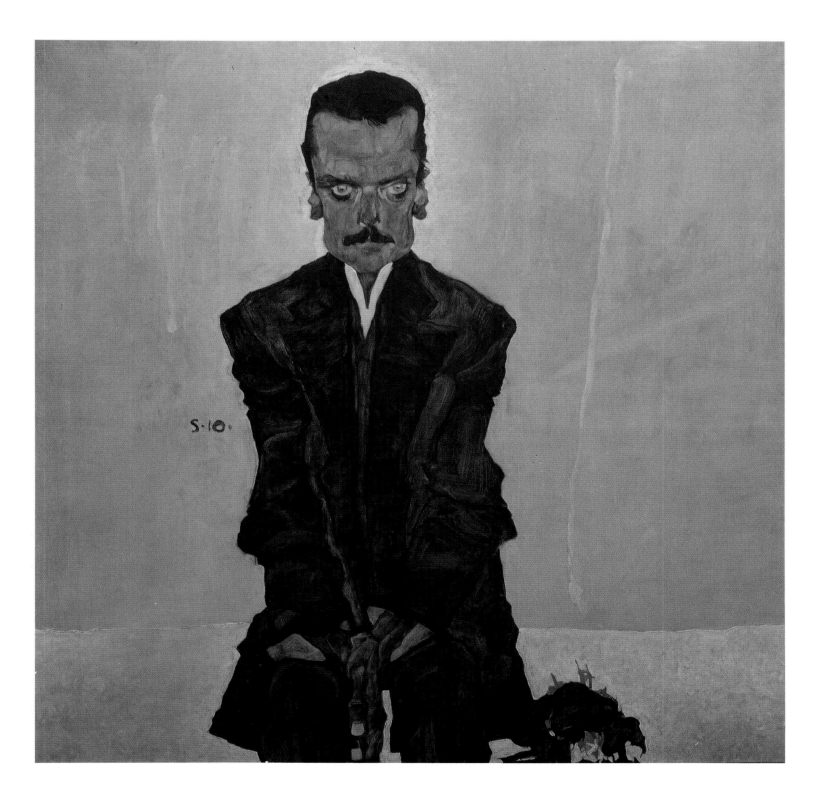

Portrait of Eduard Kosmak,
1910

Oil on canvas
39½×39½ inches (100×100 cm)
Österreichische Galerie, Vienna

This was the last and in many ways the most intense of the 1910 commissioned portraits. This work has a square format and concentrates the image against an increasingly murky void similar to that in the portrait of Roessler. Eduard Kosmak confronts the viewer with a rigidly frontal pose and a disturbed and disturbing stare.

Kosmak was an amateur hypnotist (this in some way explains the stare), who edited two Viennese journals: *Der Archi-tect* and *Das Interieur*. In 1911, in the latter, he published a reproduction of Schiele's *Sunflower* from 1909 and Comini has argued that the sunflower lying on the floor in this portrait is perhaps a silent reminder of a mutual project underway involving Schiele and Kosmak. It also evokes a mood of death and decay.

The pose adopted by Kosmak seems to stem from Edvard Munch's *Puberty*, but whereas Munch's work portrays a young girl and her growing awareness of her sexuality, Schiele depicts a middle-aged man on the fringes of madness. His taut body and clenched hands, covering and empha-sizing his genitals, seems to suggest a desire to return to the womb.

Once again, Schiele uses his subject matter as a vehicle for an Expressionist transmutation of idea and image, reflect-ing his own angst and enabling him to pursue a quest for his own artistic voice.

Portrait of Poldi Lodzinski,

1910
Pencil and gouache
17¾×11½ inches (45×29.5 cm)
Thyssen-Bornemisza Collection,
Castagnola-Lugano

The portrait of Poldi Lodzinski heralds Schiele's transition from being a painter of portraits within the Ringstrasse, the street which served as metaphorical and physical delimitation of acceptable Viennese society, to a portraitist prepared to venture outside the circumferential façade of the city into the crowded immigrant suburbs. It is thus that a broader social dimension can be traced in Schiele's work and his claims to be the painter of the city's proletariat are thereby substantiated to a high degree.

Poldi sits, a white halo above her head, in almost sacred posture, smiling out at the viewer with an innocence which is contradicted by her wraith-like form and decaying hands. The pose once again stems from Munch's *Puberty*, a seminal work for many Viennese portraitists it now seems, and the allusion to sexual awakening is evident even in Schiele's fully clothed portrait of the young girl.

Ironically, the portrait was made as a study for a house in Brussels commissioned by Baron Stoclet, a patron of the arts who wanted Josef Hoffmann and the Wiener Werkstätte to design him a house in homage to International Art Nouveau. Schiele's designs for a stained-glass window with Poldi as the central motif were ultimately rejected. This was not because their subject-matter was inappropriate, but rather because the most typically Art Nouveau or Jugendstil feature, her brightly-colored patterned blouse, was too bold and rich to be transformed into stained glass.

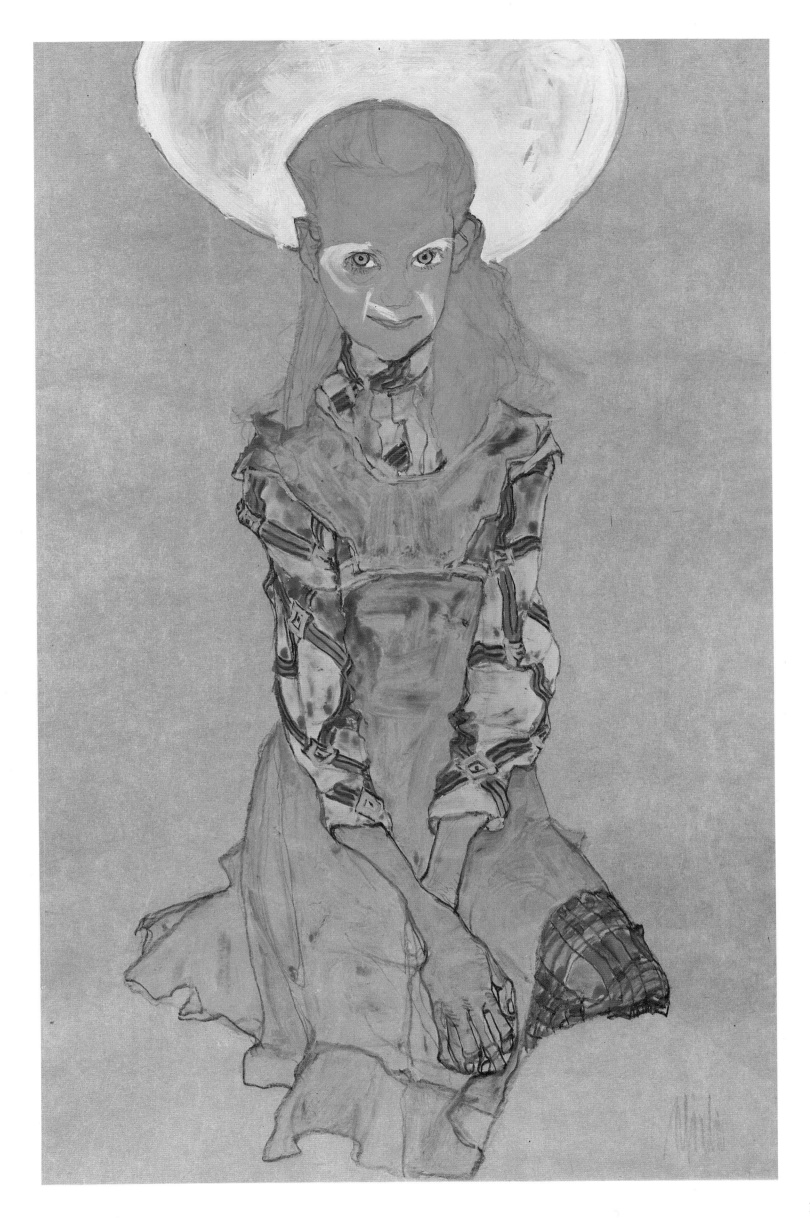

Agony, 1912

Oil on canvas
27½×31½ inches (70×80 cm)
Neue Pinakothek, Munich

This masterful oil, painted soon after Schiele's imprisonment in 1912, is a half-sized but nevertheless equally significant counterpart to the *Hermits* also from 1912. Both seek to depict allegorical double-images of Gustav Klimt together with Schiele, portrayed in the ascetic habits of monks, alienated from the world and undergoing a metamorphic and increasingly complicated relationship with each other.

The 'strong son' leading the 'weak father' which had been evoked in the *Hermits* is now replaced by a powerful image of Klimt who advances, gazing at Schiele with the penetrating stare of an hypnotist. His hands form an enigmatic gesture apparently akin to that of a sorcerer casting his spell. Schiele, in turn, seems held against his wishes as if under a spell or, rather, the power of Klimt. Schiele's white face and red rolling eyes express a look of horror, as if he is resigned to confronting his fate and ultimately succumbing to the 'agony' of social or artistic persecution. His hands are clasped in prayerful gesture. Comini believes that the mark on his right palm may well be an allusion to the stigmata and therefore to sanctified martyrdom.

The piling up of rock-like areas of color in a claustrophobic abstract pattern conveys a sense of domination and of dependence on past artistic style. This pattern fuses Wiener Werkstätte decoration with a Gothic, stained-glass effect, but the result is unique to the art of Schiele.

Stylistically, Schiele had broken away from Klimt back in 1910/11. The final purging, however, came in 1915 in an oil painting, now lost, entitled *Soaring* in which Schiele's artistic soul rises upward and into territory hitherto unknown (perhaps even unknowable), shedding its earthly body and early style as he ascends into new life. Schiele therafter remained devoted to his former mentor, but with a new-found detachment, right up to Klimt's death in February 1918.

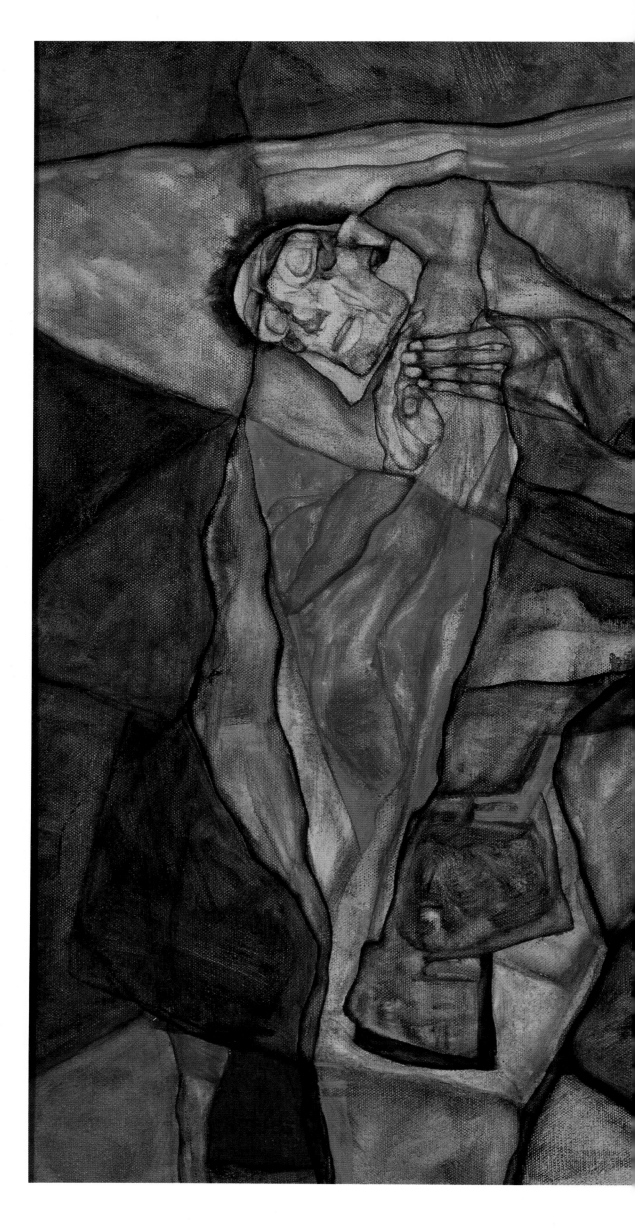

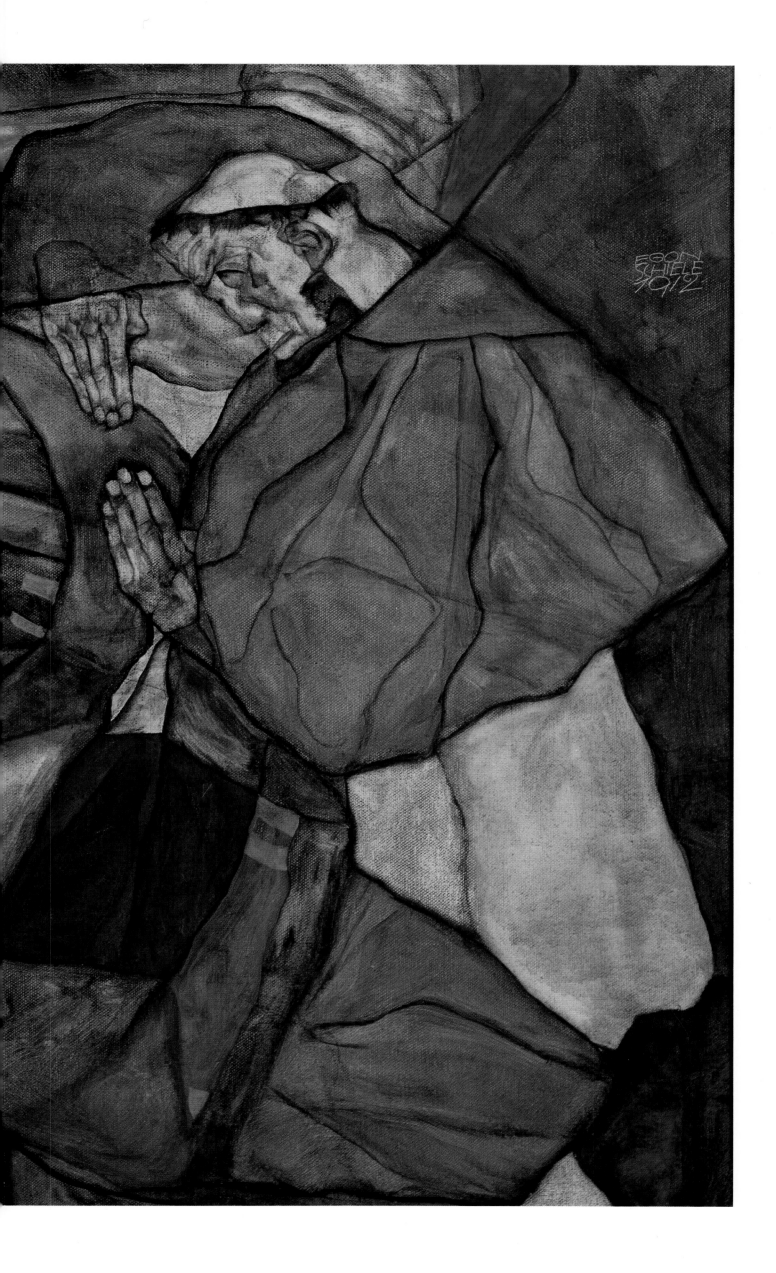

Double Portrait (Otto and Heinrich Benesch), 1913

Oil on canvas
47½×51 inches (121×130 cm)
Neue Galerie der Stadt Linz
Wolfgang Gurlitt Museum

This is a compelling and complicated double portrait of father and son, both in their different ways close friends of Schiele.

Heinrich Benesch features as one of several father-figures in Schiele's life and like the artist's father he was a railway official. He had first met Schiele back in 1910 after an exhibition at Klosterneuburg Abbey. Although his enthusiasm for collecting Schiele's work was not matched by his income he became one of the keenest collectors of the artist's drawings and watercolors. In an early letter to the artist, Benesch pleaded: 'Don't put any of your sketches, no matter what they are, even the most trivial things, on the fire. Please write on your stove in chalk the following equation: "Stove equals Benesch".' In the months before the double portrait was painted when Schiele was in prison, Benesch visited him three times and arranged the transfer of his belongings from Neulengbach to Vienna after the ordeal was over. Schiele was often heard to utter 'Herr Benesch will fix things.'

The paternalism which Schiele perceived in Heinrich Benesch is, not surprisingly, conveyed in the double portrait with Otto Benesch, his son. The older man stands large and assured and places a comforting though restraining hand on the shoulder of the young man. Schiele's recognition of the complex relationship between father and son was commented upon in later years by Otto's wife, Eva Benesch:

Had Schiele – consciously or unconsciously – understood a deep psychological situation? Heinrich Benesch liked to dominate. The intellectual burgeoning of his son began to make him feel uneasy. Schiele recognized the gaze into the world of the mind beyond all external barriers already in the boy who was then

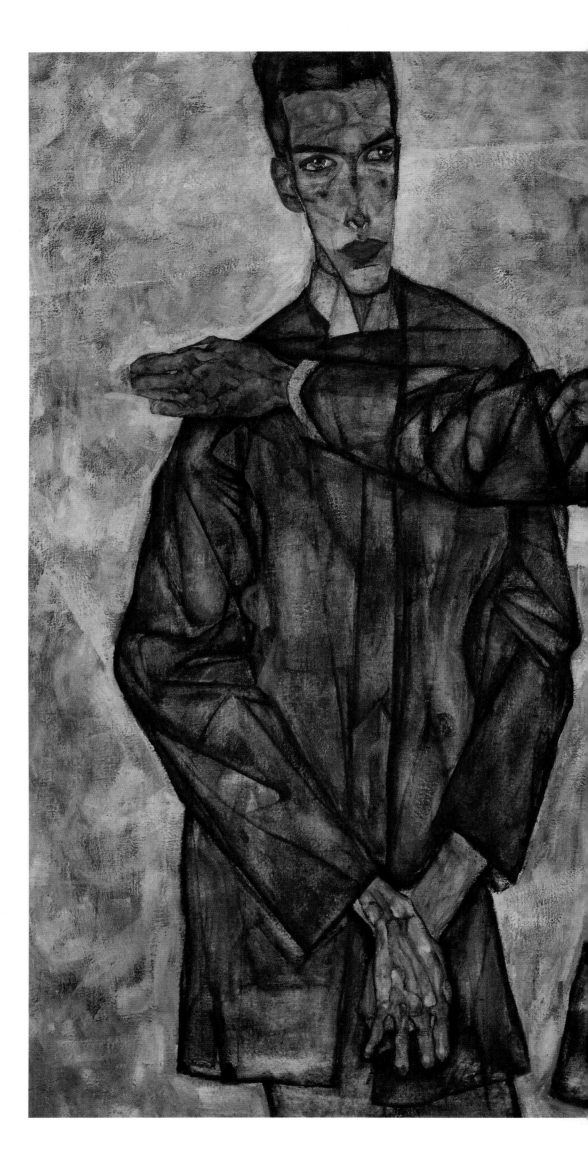

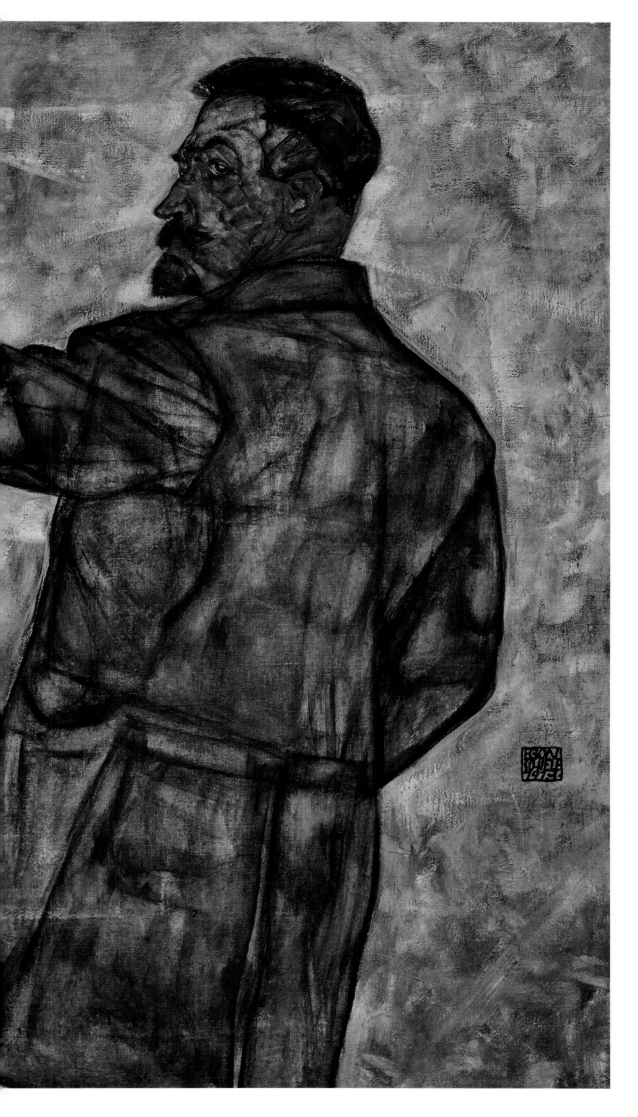

seventeen and he expressed it in the portrait. It was a mental world in which Otto Benesch quite naturally dominated.

Otto Benesch, soon to become a distinguished art historian and Director of the Albertina in Vienna, and who was to publish a catalogue introduction for Schiele's first major retrospective at the Galerie Arnot at the end of 1914, gazes out beyond the viewer with an expression of deep contemplation on his face. This is intensified by the lines across his high forehead and those outlining his already pronounced cheekbones. Schiele identifies with his close friend whose long hands clasped tightly in front of his groin echo earlier self-portraits by the artist. Otto had a marked tendency to massage his knuckles in moments of tension, a fact recorded graphically in the painting.

Preparatory sketches for the work indicate that Schiele had difficulty in placing the figures, beginning with Otto standing behind his father who, in turn, was seated to the right. The profile view of Heinrich combined with a fully frontal pose of Otto seems to have been intended from the start. The change in Heinrich's pose, however, from hands in pocket to arm outstretched, is visible clearly in the final oil which presents, loosely, a double image of Heinrich within a double-portrait with his son. The threatening background, which is on the verge of overpowering the images in front, is countered by the figures touching, a feature which unites them against the assault of the void. Comini has commented on the 'cubist' facturing of the background and relates this to other double-portraits around 1913, including *Hermits, Agony*, and *The Cardinal and the Nun*.'

The painting is one of the very few double portraits in which Schiele does not himself feature.

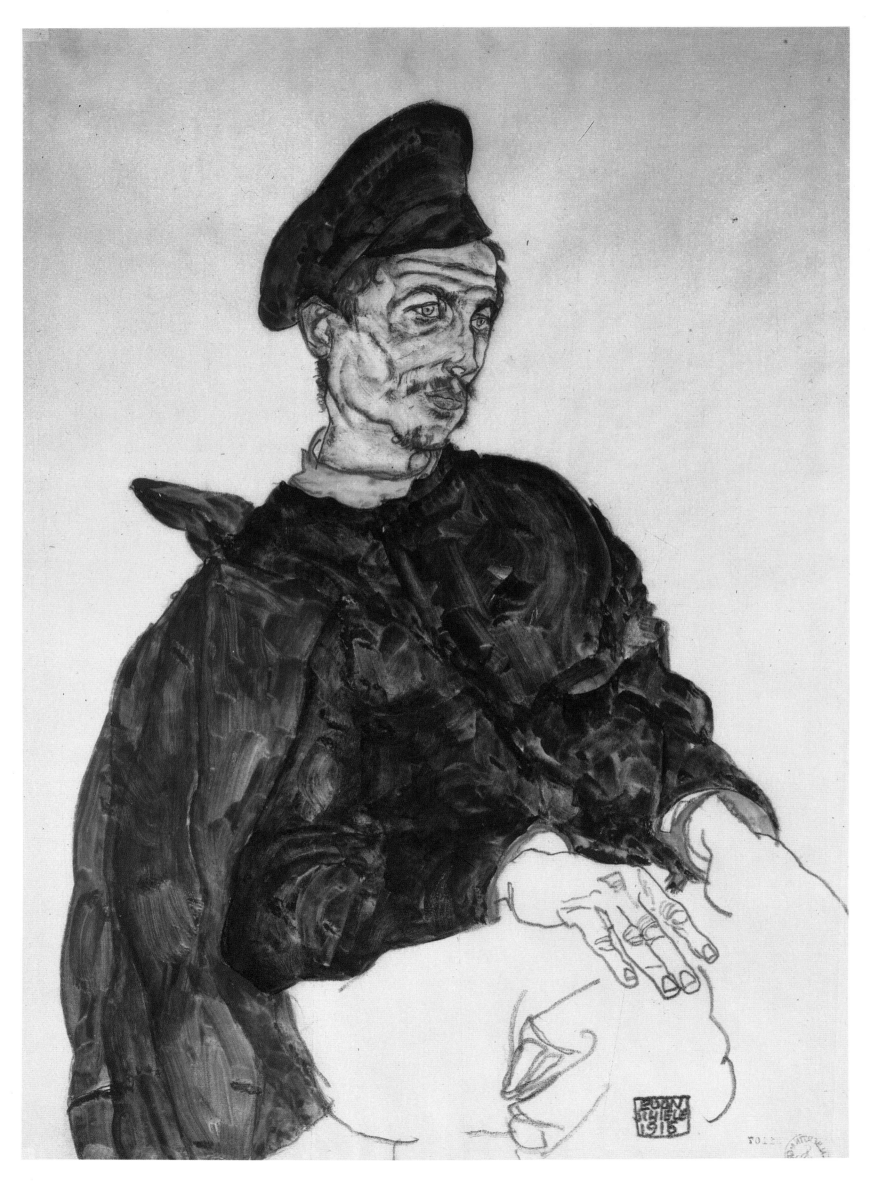

80

Portrait of a Russian Officer,

1915
Pencil and gouache
17½×12½ inches (45×31.5 cm)
Graphische Sammlung Albertina,
Vienna

Although the war curtailed Schiele's output in terms of oil painting, he compensated by producing a large number of sketches, drawings, and watercolors. This pencil and gouache study was produced in the early winter of 1915, when Schiele was back in Vienna, on guard duty, after his initial drafting to Prague.

The Russian officer is portrayed in a sympathetic and sensitive manner by Schiele which transcends any sense of captive and captor. His pose is relaxed and informal, echoed by the casual way in which his coat hangs off the shoulder and the almost jaunty angle at which he wears his cape. The furrowed brow and distant gaze combined with Schiele's blank background suggest a loneliness and yearning for his homeland.

Without reverting to more specific self-identification with his subject-matter, Schiele's empathy with the Russian prisoner-of-war is illustrated by the prominent, long, and bony fingers on the soldier's right hand which rests untheatri-

cally on his knee. Only the head and torso of the figure are completed. The left hand is absent and legs are sketchy and unfinished, and yet the work has a wholesome quality, resulting in part from the subdued but painful expression on the soldier's face.

'It is quite odd how listless all soldiers whom I have met so far are' wrote Schiele in his War Diary in 1916. 'Each one desires the end of the war, regardless of in what way. To me especially it makes no difference where I live, i.e. [for] which nation I live. In any case I am leaning far more toward the other side, that is toward our enemies; their countries are much more interesting than ours.'

Schiele's idealized and often naive entries in his diary find more credible if equally compassionate expression in his war portraits of both Russian prisoners-of-war and Austrian soldiers. Nineteen of these were exhibited at the Kriegsausstellung or Austrian War exhibitioin at the Moderne Galerie in May 1917.

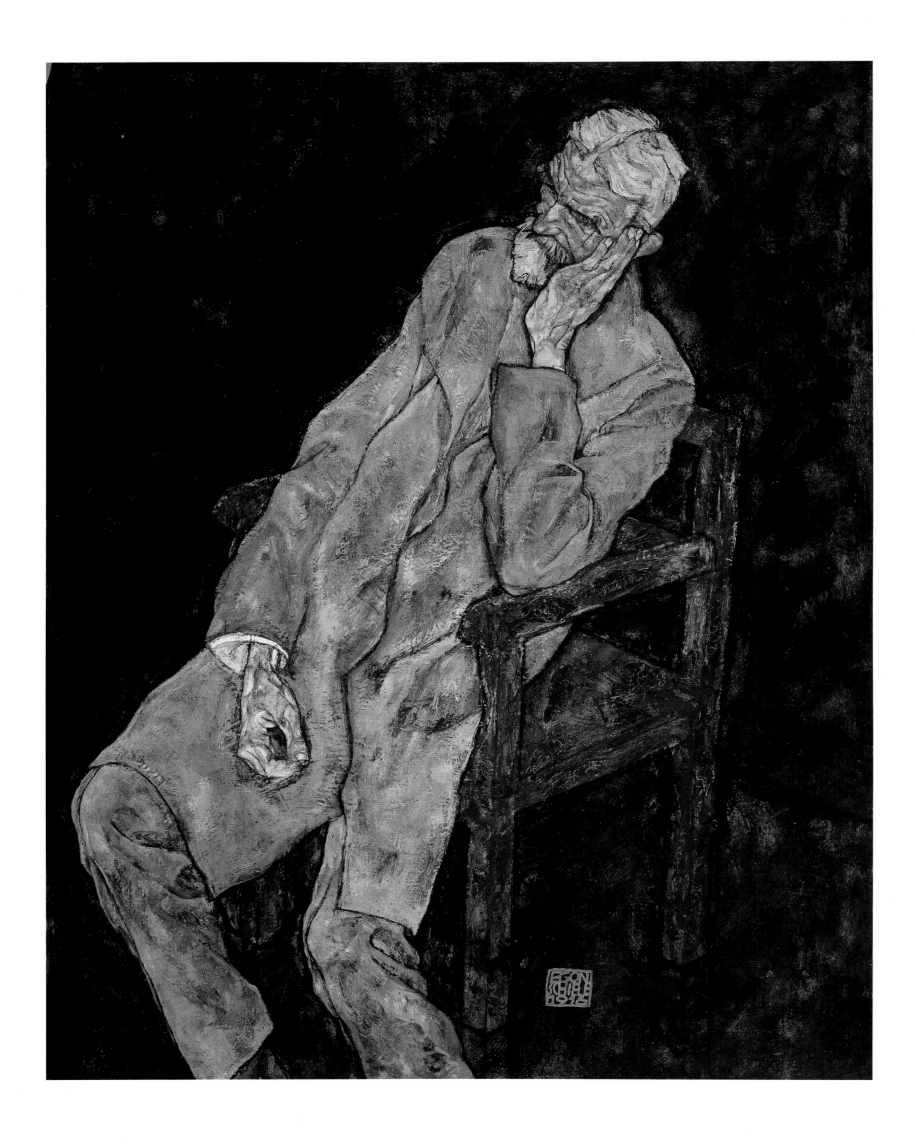

Portrait of Johann Harms,

1916
Oil on canvas
54½×42½ inches (138.3×100 cm)
The Solomon R Guggenheim Museum,
New York

Johann Harms was Schiele's father-in-law and at the time of being painted he was retired, an old man enjoying a quiet and contemplative life after working for years on the railways, as Schiele's own father had done.

The shyness and reticence of the old man, conveyed subtly by Schiele in the portrait, endeared him to the artist. Indeed, descriptions of Schiele by close friends seem to indicate certain affinities between the two men in spite of Shiele's more flamboyant personality which he often projected on to canvas.

The diagonal compositional format and impression of fragility in the sitter harks back to Schiele's portrait of the painter Karl Zakovsek in 1910. The thick overlay of paint applied with free brushstrokes but effectively binding background and motif with an overall cohesion anticipates the later portraits. This was, in fact, the first of the series of 'painterly' portraits which were produced by Schiele beginning in 1916.

Johann Harms had been the only wit-ness at Edith and Egon's wedding; a proud Protestant in predominantly Catholic Austria, and whose independent character is alluded to in Schiele's portrait by the dark background. 'I drew my father-in-law small and large on canvas,' wrote Schiele in his diary, and then 'I painted the dark background.' The chair and stage-like floor keep the void at bay and, as Comini has recognized, mark a further stage in Schiele's transition from 'existential to environmental' in his approach to art and a more socially integrated life.

The closed eyes, favorite large frock-coat, furrowed brow, and slumped pose of the ageing man, reflect Schiele's more objective approach to his subject-matter and lacks the self-reference so prominent in earlier work. In comparison with the last portrait Schiele painted of Paris von Gütersloh, the delicacy of old age and the life of passive reminiscence in this portrait of his father-in-law contrast markedly with the active life of his young friend, so evident in that late work.

Portrait of Albert Paris von Gütersloh, 1918

Oil on canvas
55×43½ inches (140×110.4 cm)
The Minneapolis Institute of Arts,
Minneapolis
Gift of the P D Mcmillan Land
Company

This was Schiele's last oil portrait, begun in January 1918 and remaining unfinished at the time of his death in October.

Paris von Gütersloh had been a friend of Schiele's since their mutual debut at the International Kunstchau in 1909. Expressionist painter, actor, producer, stage designer and writer, whose first novel, *The Dancing Fool* from 1910, was among the earliest examples of Expressionist fiction, von Gütersloh was greatly admired by Schiele, who painted his portrait as an homage both to friend and fellow artist.

The style of the painting is expressionistic with the loose handling of paint and fiery colors creating a vivid, swirling background which integrates with and neutralizes the legs and torso of the body. The hands and face reflect Schiele's precise draftsmanship and both in style and gesture hark back to the psychological portraits of friends and colleagues from 1910. There is also a strong hint of self-portrait in the dance-like actions of the arms and hands which attracts and repels the viewer while framing the intense and piercing stare of his eyes. The subtle allusion to dance and the almost comically twisted nose, a response to a similar feature in von Gütersloh's portrait of Schiele in 1918, perhaps refer to *The Dancing Fool*, but in a gentle self-effacing manner.

There is a rhythmical quality to the work, from the crooked contours of tie and nose to the more angular contours of bodily outline and open brushwork. This is broken only by the black halo which surrounds the body, an inversion of the white 'astral glow' used by Schiele in figurative work from 1910 and described by von Gütersloh as 'the atmospheric pressure of human beings' in his monograph entitled *Egon Schiele: An Attempt at Introduction* from the same year.

The painting was one of three late portraits shown after Schiele's death at the Secession Exhibition of Contemporary portraiture which ran from December 1918 to January 1919.

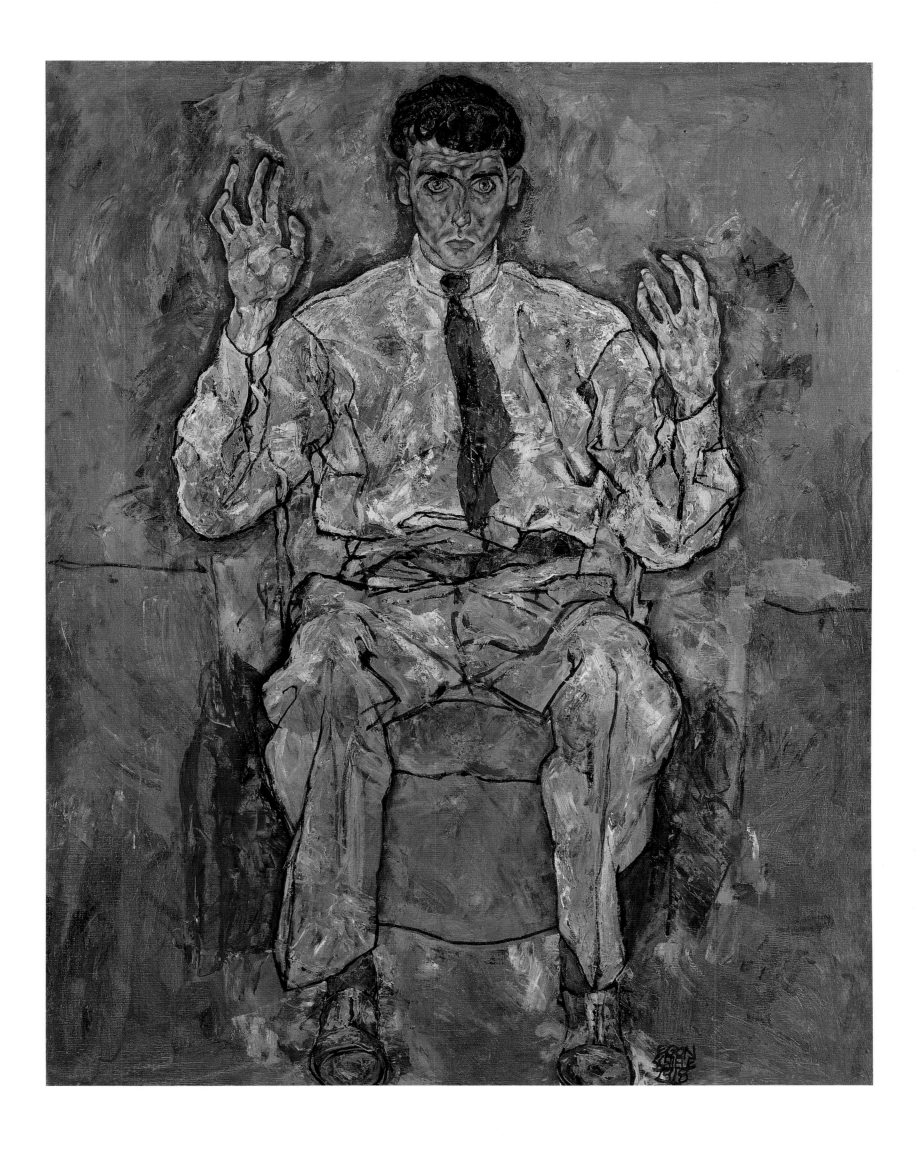

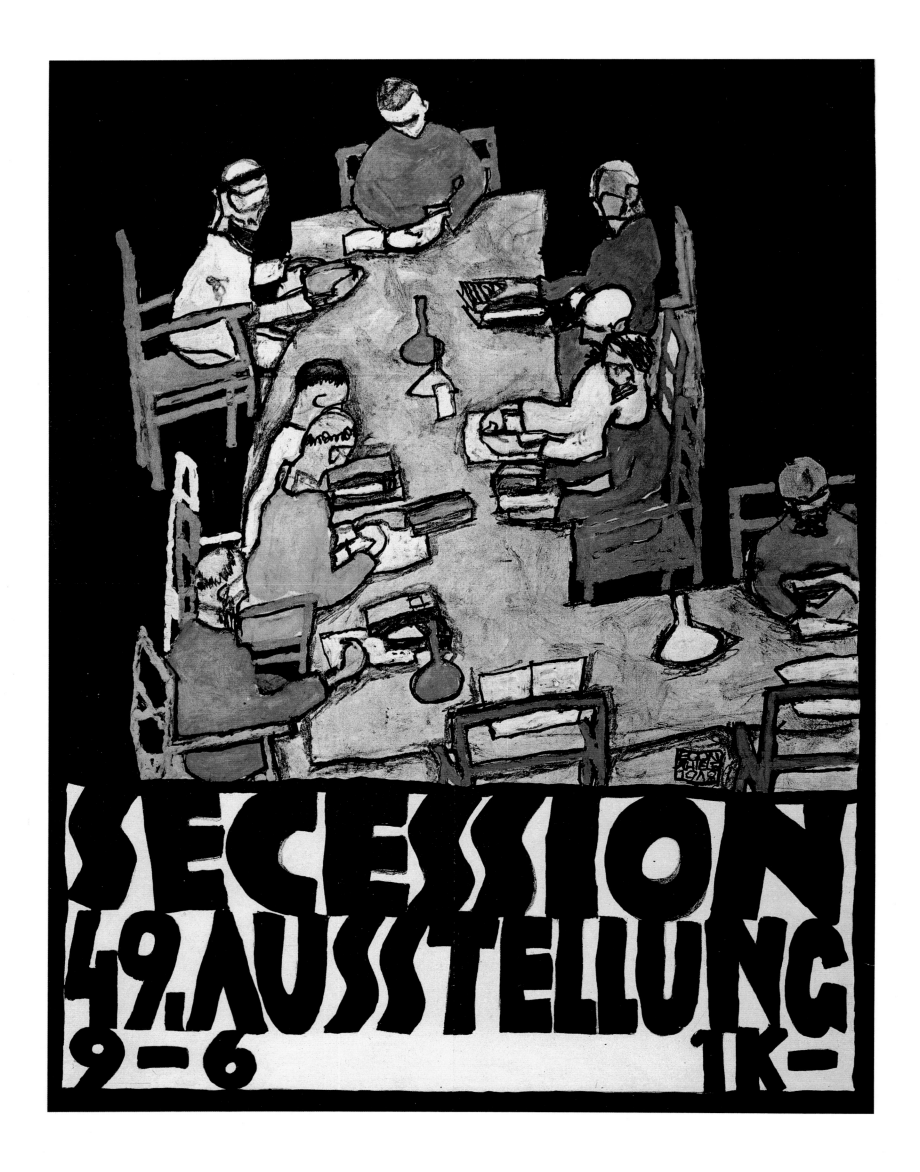

Secession Exhibition Poster,

1918
Color lithograph
Graphische Sammlung Albertina,
Vienna

As early as January 1917 Schiele had written a letter to Anton Peschka: 'I intend to do a large figure painting, with all my closest friends, life size, seated at a table.' A year later, Schiele began to explore the idea in his sketchbooks and to paint a large oil, which remains unfinished, entitled *The Friends*. Subsequently Schiele was able to transfer the idea and themes to a color lithograph which became the poster for the Secession Exhibition in March 1918.

The notion that Schiele was now at the forefront of Viennese painting was generated in part by the honor bestowed upon him by the Secession in granting him a large one-man show. It was also enhanced by the death of Klimt in February 1918 which is also alluded to, rather touchingly, in the poster. The empty chair, occupied by a figure clearly recognizable as Klimt in the sketches, is a stark monument to Schiele's artistic father-figure. The book on the table has a faint but definite rendition of Klimt's signature on the right-hand page.

The allusion to the Last Supper is clear and Schiele presides at the head of the table. The identification with Christ and his impending death is tinged with irony for Schiele was to die a few months later, but it also illustrates the artist's characteristic arrogance. There are nine figures or 'friends' around the table, possibly a reference to the nine major Viennese painters who also exhibited in the March Secession, and the empty place to the right of Klimt's chair might even be a wry reference to Kokoschka.

Kokoschka was recovering from a war wound in Dresden at the time but had refused to allow any of his work to be exhibited in Vienna in spite of Schiele's invitations as co-organizer of both the Kunsthalle and Secession shows in 1917 and 1918. Kokoschka felt betrayed by Vienna: 'I should never again be inclined to feel at home there, not even with the least important of my works.' Schiele seems to hint that Kokoschka might have betrayed Vienna through this neglect or animosity. Perhaps he is the Judas-figure in Schiele's metaphorical Last Supper.

The monk-like attire worn by all the participants around the table at once alienates them as artists from society but links them as friends and colleagues bound by a common purpose.

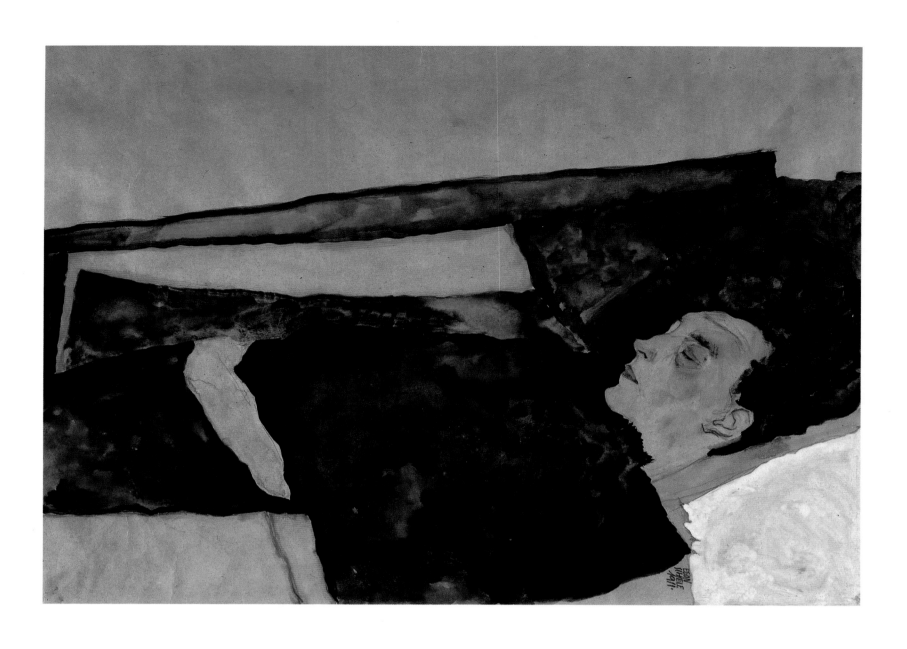

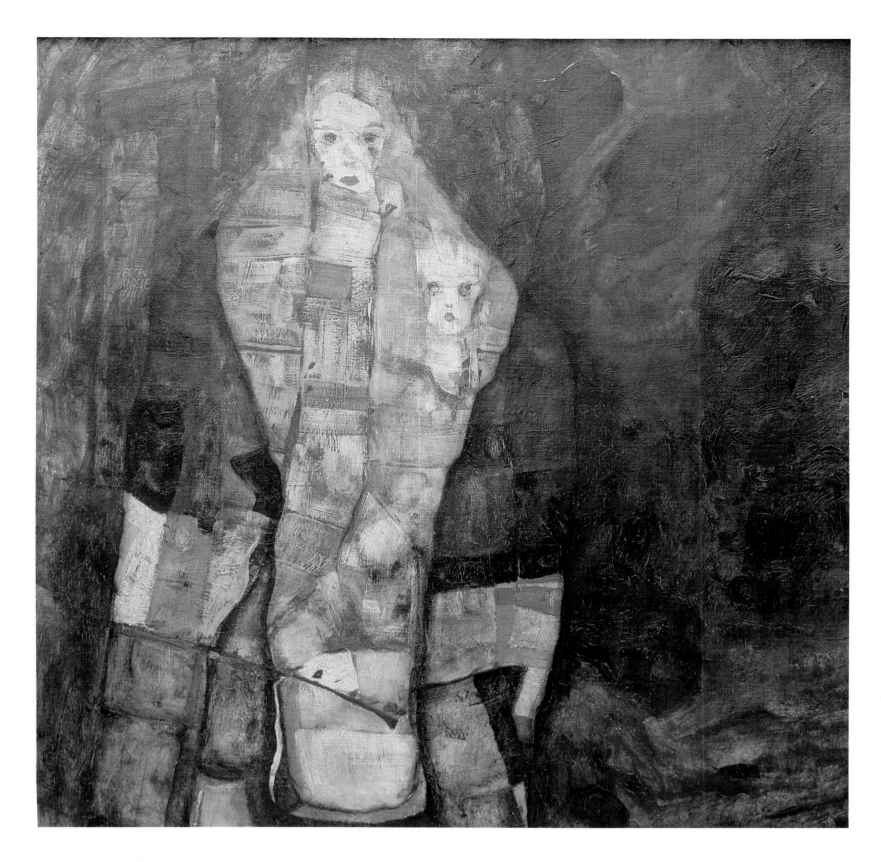

The Artist's Mother Asleep,
1911
Pencil and watercolor
Graphische Sammlung Albertina,
Vienna

Overleaf:
Pregnant Woman and Death,
1911
Oil on canvas
39½×39½ inches (100×100 cm)
National Gallery, Prague

Madonna, 1911
Oil on canvas
31¼×31⅝ inches (79.5×80.3 cm)
Private Collection

In a series of allegorical figure compositions, also begun in 1910, Schiele circumvented and finally confronted the issue of motherhood in his art. These two oils from 1911 follow on through a myriad of compositional and theatrical links with the two *Dead Mother* paintings made in 1910. The first of these was subtitled *Birth of a Genius* and unquestionably relates to Schiele's perception of his entry into the world. 'How great must be your joy – to have borne me?' wrote the artist to his mother in a letter in 1911.

Amid the morbid and grandiose oil paintings Schiele found time to make a pencil and watercolor sketch of his own mother asleep. This was essentially an artistic exercise, a relief from the ardures of allegorical exertion and with results

approaching sentimentality. Schiele's rendition of his mother is passive and detached and amply illustrates the lack of communication between them but hints at an underlying bond of affection.

Pregnant Woman and Death presents a haunting self-portrait, one of the earliest in which Schiele fulfils the roles of both a monk of death and a pregnant mother and thereby identifies himself as life-taker, life-giver, and ascetic, alienated from the world. So horrifying is the image that even the child, in its mother's womb but curtained off from the world by the folds in her gown, shields its eyes with clasped hands. Both mother and monk also close their eyes, and their bodies are enveloped in a dark, factured blackness of robe, oil, paint, and void.

The precedents for this style and subject-matter are varied, but Schiele's morbidity and autobiographical framework of reference give the work a unique character. At the Secession Exhibition in 1910, the graphic qualities and gothic assimilation of the morbid fixation with death and childbirth expressed in the work of the German artist, Käthe Kollwitz, seem to have struck a chord with Schiele. Her childhood memories of her grandfather, who was originally ordained as a Lutheran pastor, but ultimately became a sectarian founder of the 'Free Religious Congregation,' find expression in her art and in the art of others whom she influenced: 'a loving God was never brought home to us.' Klimt's *Three Stages of Woman* from 1911 and Edvard Munch's *Death of a Child* all seem to have had a bearing on Schiele's allegorical paintings in 1911.

Schiele's traditionally formatted *Madonna* (page 89) superficially exudes a greater sense of optimism by beginning the lifecycle without any allusion to death. The work is compiled from a scratchily painted patchwork of neutralized color; the residual Wiener Werkstätte influence in his work echoed finally in the off-central positioning of the motif. Using a rounded, triangular construction for the Madonna and Child reminiscent of Raphael, Schiele fuses mother and child in a manner which ambiguously suggests that it could still be either a foetus in the womb or a newly born baby sitting on its mother's lap protected by her left arm which surrounds its small sickly body.

With the combined impact of the multi-faceted image of the child, the specter-like image of its mother and the encroaching darkness behind, death once again rears its ugly head in a painting ostensibly devoted to motherhood. The Madonna complex: woman as mother; woman as whore is given brief credence in a work which warns of the dangers of motherhood while positing woman as both threatening and threatened.

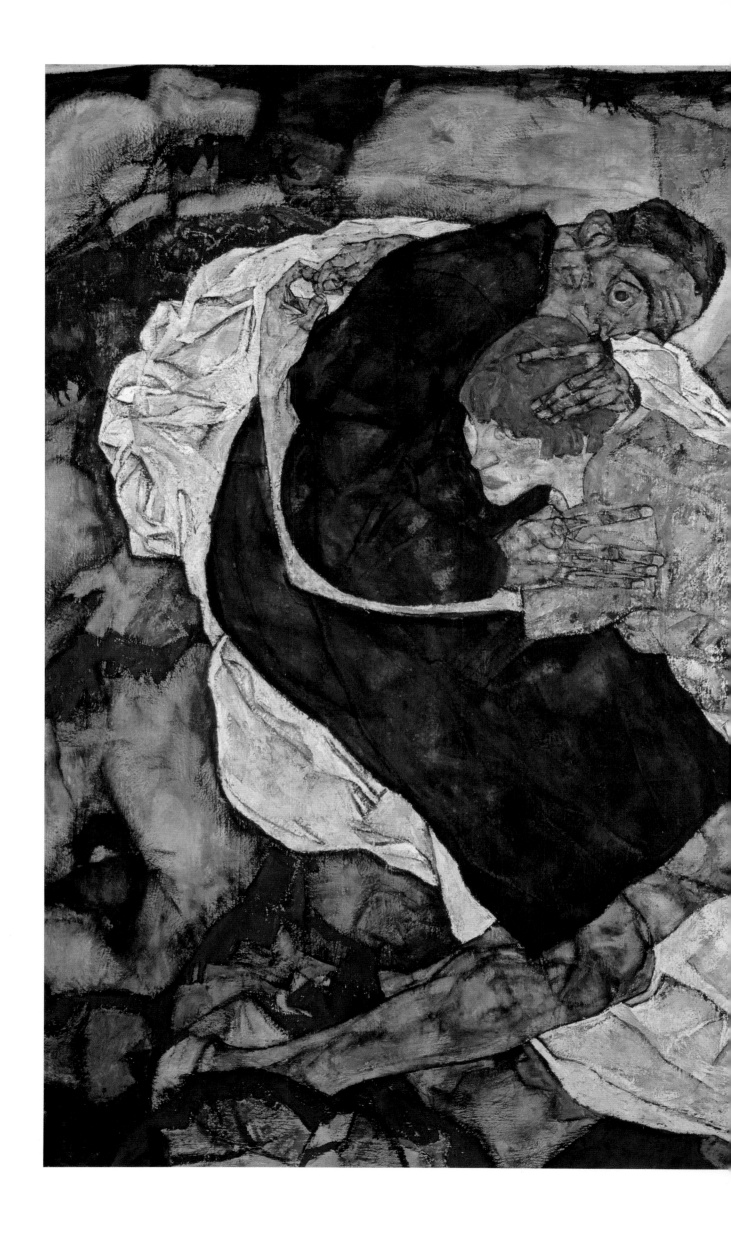

Death and the Maiden, 1915

Oil on canvas
59×70⅞ inches (150×180 cm)
Österreichische Galerie, Vienna

Schiele's allegorical double portrait has affinities with Kokoschka's *The Tempest* of 1914 and, indeed, with Käthe Kollwitz's *Die Tod und die Frau* shown at the Secession in 1911. Ultimately, however, what separates it from these and other expressionist oils are the explicitly personal and autobiographical references made by Schiele.

The painting signified the end of Schiele's long affair with Wally, which he proposed to continue into marriage. For his part, he proposed this in what was tantamount to a contract by which he and Wally went on holiday annually. Needless to say, it was rejected and, according to Roessler, 'she thanked him for the kind thought ... and then departed, without tears, without pathos, without sentimentality.'

Death and the Maiden conveys a final embrace between the artist and his former model and captures something of the emptiness of their parting. Schiele holds Wally with a physical detachment and an empty stare across his face while she clasps longingly to her lover. The tenacity of her grip and the sexual interlocking of her fingers contrast markedly with the unsexual pose of her body. There is a greater energy and evocation of writhing sensuality in the sheets on which the embrace takes place.

Once again, however, the most powerful image is of the ascetic artist surrounded by an undulating wilderness entwined in an embrace from which he may never escape. His body withers in decay and seems stiffened with rigor mortis. Kokoschka's *Tempest*, which depicts him with Alma Mahler in a stormy but life-affirming and passionate embrace, is alive with the fluidity and extravagance of the baroque. Schiele's *Death and the Maiden*, however, is rooted in a more Northern European, spiritual Gothic tradition, tempered only by the faint hope of redemption.

Mother with Two Children,

1915
Oil on canvas
59×62½ inches (150×159 cm)
Österreichische Galerie, Vienna

This oil painting was created in 1915 but repainted partly in 1917. It is a simple, charming image which is linked in terms of its subject-matter to the motherhood allegories from 1910 but also anticipates Schiele's last great allegorical masterpiece, *The Family* (page 108), unfinished at the time of his death in October 1918.

Compositionally the work is balanced with two doll-like children sitting on either side of their mother's large enfolding apron, a convention which can be traced back to Raphael and Leonardo. The allusion to death is slight but subtle, with the factured black paint an ever-encroaching presence in the background.

The gaunt, mask-like face of the mother, a symbol of death, contrasts with the supposed joys of motherhood and is directly related to Schiele's earlier work.

In the same year, 1915, Schiele also produced a design for a purse for his wife Edith, rendered in oil on paper and entitled *Mother with Children and Toys*, deriving in part from his own collection of folk-art kept proudly in a cabinet in his studio. The composition owes its color and centralized format to this design. Toni Peschka, son of Schiele's sister Gerti, and Anton Peschka, was used as the right-hand model by Schiele in the *Mother with Two Children*.

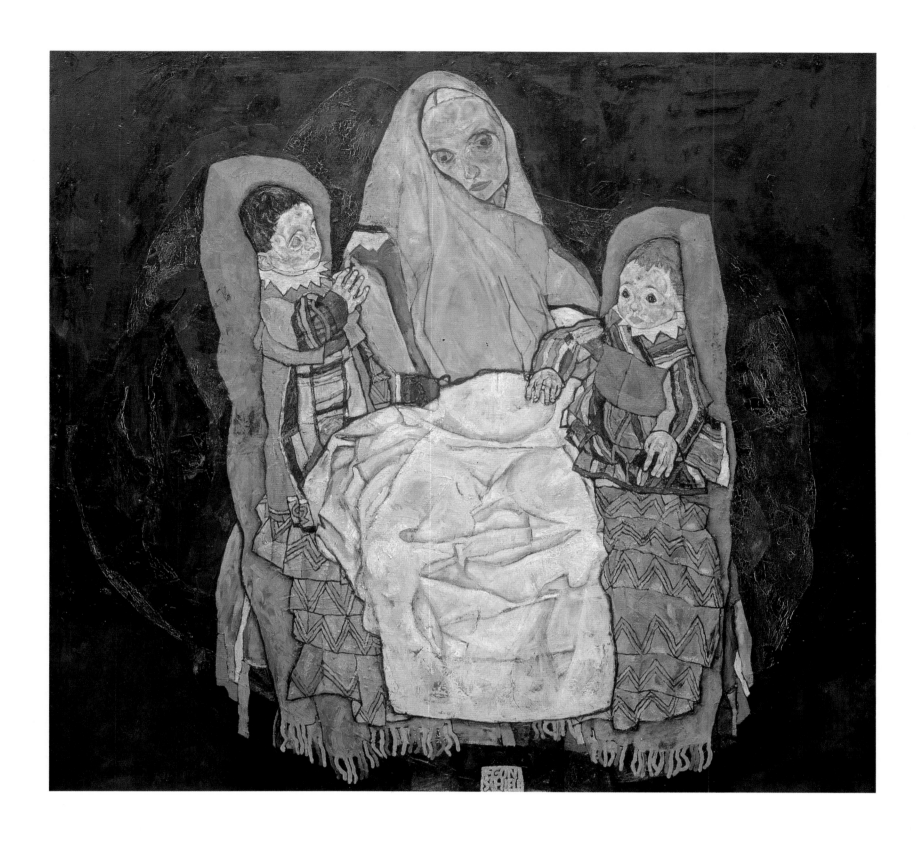

Portrait of Edith, Standing,

1915
Oil on canvas
71×43 inches (180×110 cm)
Haags Gemeentemuseum, The Hague

Schiele's first oil portrait of his wife is gentle, pretty, and fundamentally bland, as such it represents his early perception of his young bride. The portrait was life-size and Schiele confronted his 'model' from a similar, high viewpoint to that which he used in the portrait of Friederike Beer. The effect is to create a certain ambiguity about whether Edith is lying down or standing, but ultimately she appears to be standing because of her sketchily depicted feet and shoes.

The work was produced in August 1915, less than two months after Edith and Egon were married and after Schiele had been posted back to Vienna from Prague. Wearing her favorite, brightly colored striped dress – made from the curtains of Schiele's studio – Edith stands before us (and her husband) in a stiff, almost wooden pose with red cheeks and glazed eyes enhancing her doll-like quality.

The greatest technical challenge for Schiele in this painting were the vivid stripes of the dress which give a decorative appeal to the work. The face is mask-like and the hands hang self-consciously by her side but are unobtrusive. The background is neutralized by the figure, and even though Edith appears in lonely isolation, her trusting and naive expression suggests a sense of love and unity with her husband.

The bourgeois primness of her disposition, and the virginal rigidity of her pose, convey something of Schiele's sexual frustration in the early months of his marriage, particularly when compared to earlier portraits of Wally and his sister Gerti and even in later oils which show him and Edith finally locked together in ecstatic, sexual embrace.

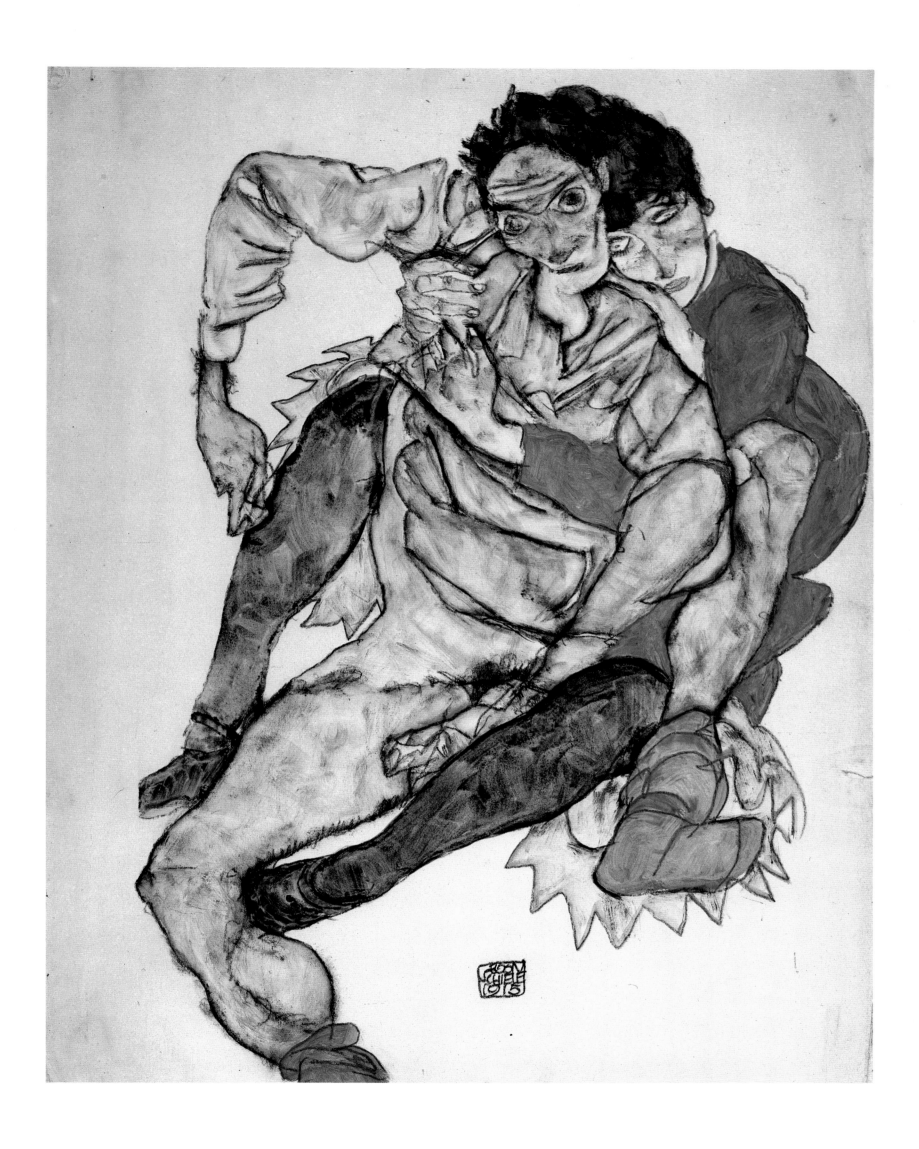

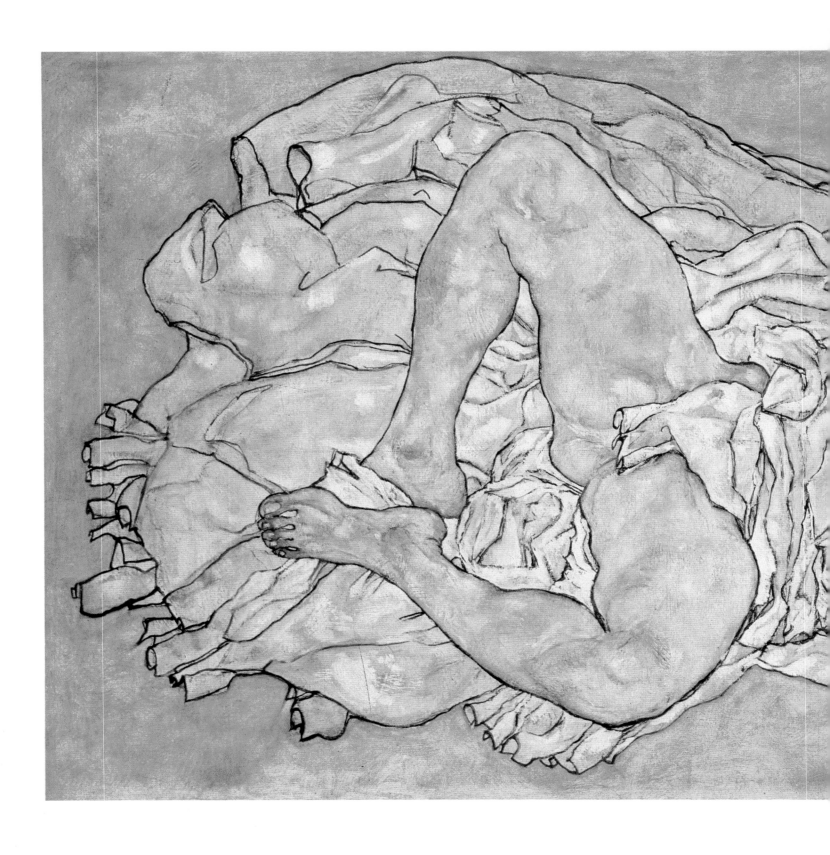

The Reclining Woman, 1917
Oil on canvas
37⅝×67¼ inches (95.5×171 cm)
Private Collection

The Reclining Woman, a painting which Comini suggests could be named _Desire_, attempts to solicit a sexual response in the (male) viewer as she lies, legs apart with the opening of her vagina provocatively emerging from beneath the sheet on which she lies. The white sheet and pale but fleshy body contrast with the bright, marbled yellow background and further highlight the vivid redness of vulva, nipples, lips, elbows, and ankles.

Her body is tense, expectant, and her hand claws the air in playful, almost feline manner, but with a sense of threatening aggression. Ferocity and sensual grace, the qualities of lioness or sexual goddess, are exuded by Schiele's model. The mood

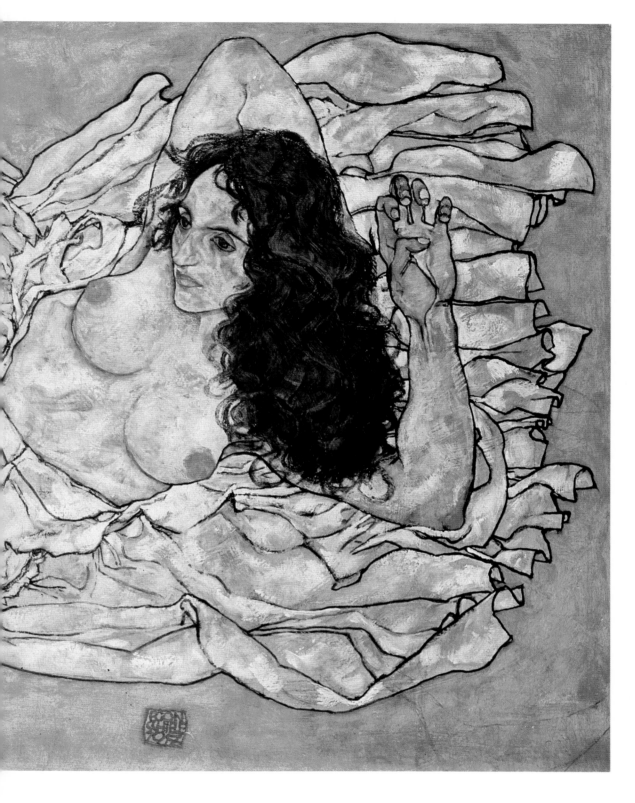

Overleaf:

The Embrace, 1917

Oil on canvas
47×67 inches (119.4×170.2 cm)
Österreichische Galerie, Vienna

In a work which ranks among the very great depictions of physical love and sexual embrace, Egon and Edith lie entwined against a set of white sheets which seem to writhe, in turn, against an expressively painted yellow backdrop. For Schiele, yellow was the most erotically charged color. Limbs, torsos, and even hair are joined together as the lovers embrace ever closer and Schiele nestles his face tenderly into the nape of his wife's neck. The separation of the sexual organs hints at a sense of sexual transcendence, conveying the idea of emotional and spiritual unity above all else.

The diagonal compositional format and now-characteristic hand gestures link the work with early paintings by Schiele but the painterliness and expressive harmony of brushstroke and image help to situate this work unequivocally in the later stages of his career.

of the painting is charged with sexual suggestiveness but the explicitness of earlier nudes has been reduced by the seemingly discreet but ultimately provocative draping of the sheet.

The painting is a late illustration of Schiele's continued fascination for female sexuality but also served as a study for *The Embrace* of 1917 (page 102), in which Schiele lies in ecstatic embrace with the same model against a similar background. He does not take up the sexual invitation fully, however, for his genitals remain at a distance and lust is replaced by an overwhelming tender passion in a work whose ultimate interest is an affirmation of love and communion with his wife, Edith.

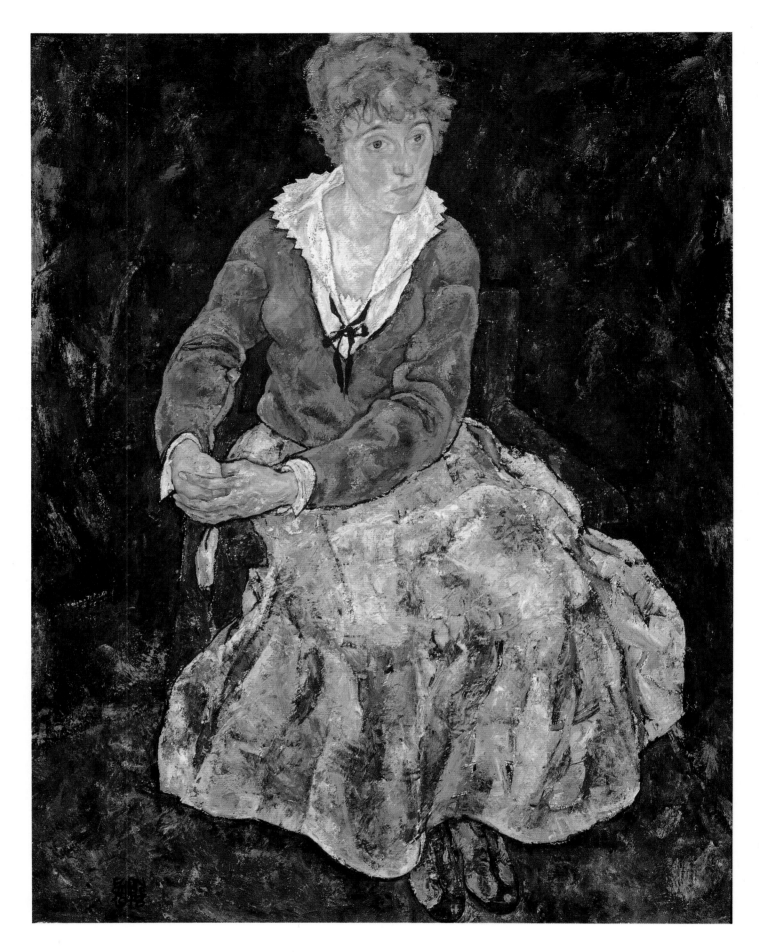

The Artist's Wife, 1918

Oil on canvas
55×43 inches (139.5×109.2 cm)
Österreichische Galerie, Vienna

Study for 'The Artist's Wife,'
1917

Pencil and gouache
18⅛×11⅝ inches (46×29.7 cm)
Graphische Sammlung Albertina,
Vienna

Schiele's *The Artist's Wife* was the last major family portrait in oil, but although signed and dated 1918, it was painted sometime after the 'study' in the early months of 1917 and only amended slightly and sold in 1918.

Although essentially unpenetrating in terms of psychic analysis, both study and finished oil give a deeper insight into the character of Edith than in the earlier portrait. The gentle, pretty face of the artist's wife has a more assured expression as she gazes into space, to the right and to the

left in each work. The study is a delicate, graphic rendition of a woman with a certain worldly experience. Her hands are prominent and elegantly recall those of her husband in his own self-portraits. It is almost as if husband or wife tough each other's hands in the study and then finally hold hands together in the oil painting. This, together with Schiele's more relaxed depiction of Edith, help suggest a greater marital harmony than that conveyed in the earlier *Portrait of Edith, Standing.* The clamped hands and head turned

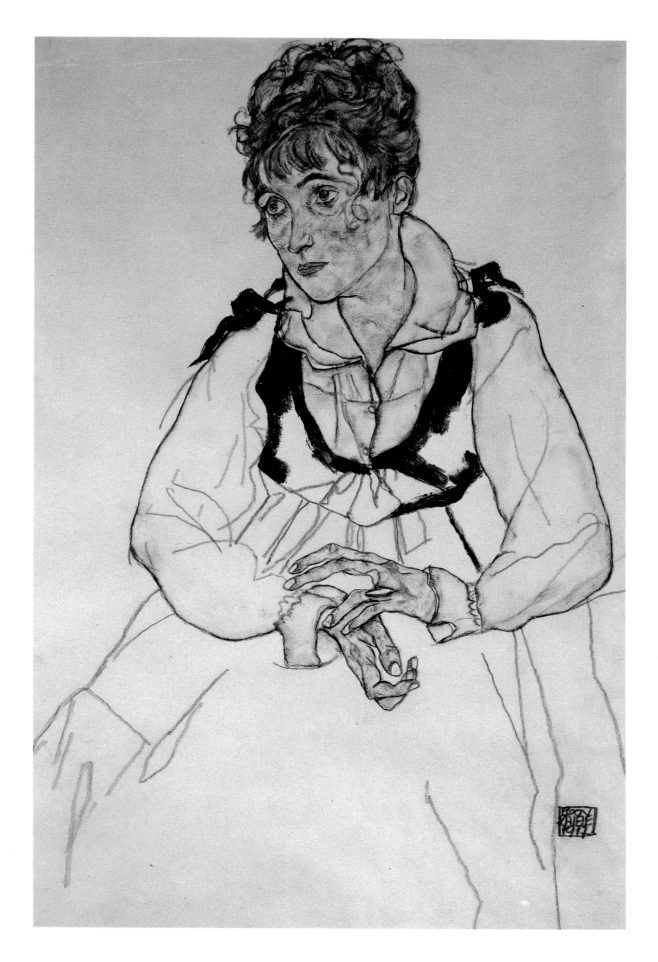

slightly to the left in the finished oil reflect Schiele's emerging interest in an oval compositional motif, most obviously used in *The Family* (page 108).

The background is painted in a rich and expressive style with traces of floor and wall meeting, together with the faint outline of a chair which negates the idea of total void. Edith's skirt is painted in a similar, free style as the result of a request by Dr Martin Haberditzl who bought the work for the Österreichische Staatsgalerie, of which he was Director. Initially,

Edith wore a tartan skirt, 'Scottish-style' in contemporary Viennese fashion parlance, but this was felt to be 'proletarian' by Haberditzl, who told Schiele so and thus it was overpainted. Edith's beligerent expression almost seems to suggest her displeasure at her enforced change of attire, but realistically it reiterates her growing self-assertiveness and strength of character.

Haberditzl bought the *Portrait of Edith, Sitting* for 3200 crowns for the Österreichische Galerie where it remains.

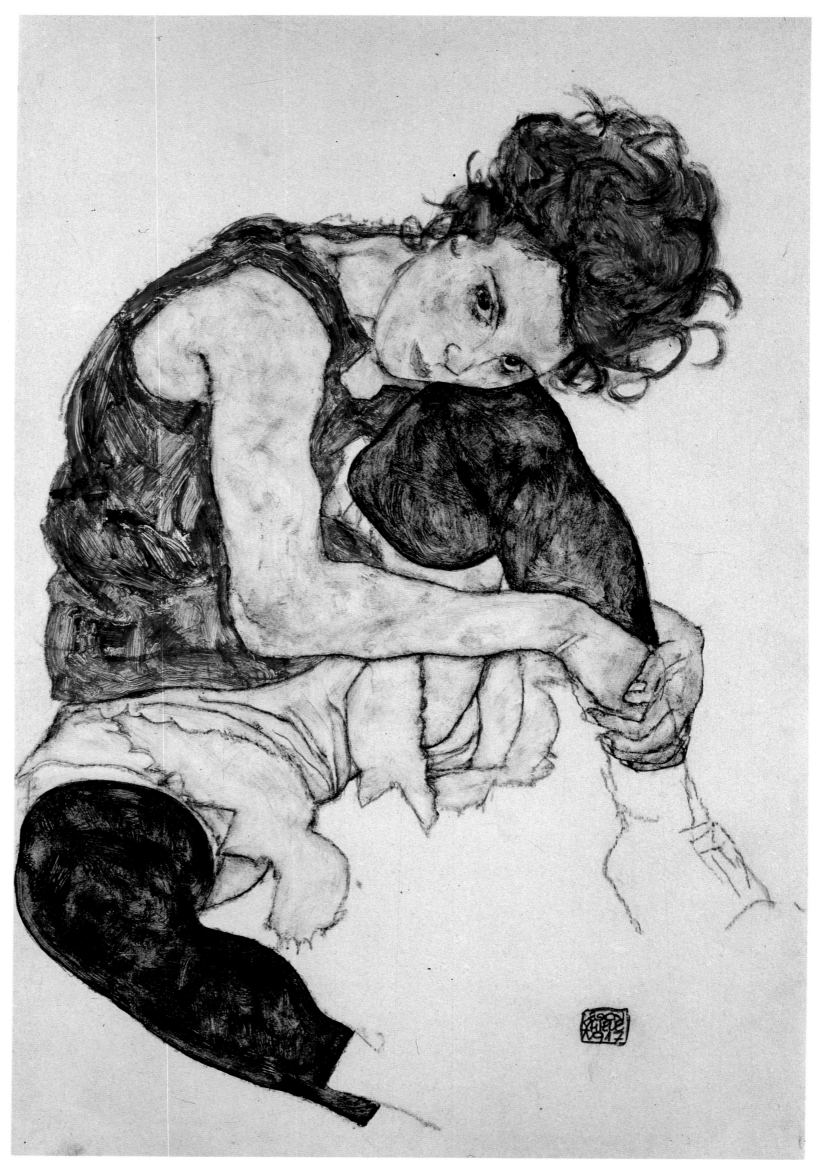

Woman Sitting with Left Leg Drawn Up, 1918

Watercolor and pencil on gouache
15×12 inches (46×30 cm)
National Gallery, Prague

As a consequence of being included frequently in recent exhibitions, not least *L'Apocolypse Joyeuse; Vienne 1880-1938* in Paris, this late watercolor has been accorded a status approaching that of an icon in late Viennese figure-study and portraiture. This success stems partly from its availability and accessibility, residing as it does in the National Gallery in Prague. This said, however, the underlying beauty of the image is one that has not been underestimated in recent surveys of Viennese art.

Sometimes erroneously entitled *The Artist's Wife*, because it was produced later in Schiele's career, it is a watercolor which conveys a part of the artist's recently found gentility and calm. Edith, although not depicted graphically, is referred to loosely in the pose adopted, and more explicitly in the facial expression, with her face titlted in manner which conveys an independent belligerence resembling that portrayed in *The Artist's Wife* (page 104). In fact, the model was one of two used by Schiele in the last years of his life. She exudes a grace and hidden sensuality which does not preclude a sexual interpretation but which essentially marginalizes this aspect of her femininity through the force of her healthy, almost clinical, beauty.

Her fiery red hair and green slip, evocations of the hair and eyes of Wally perhaps, combine with the dark stockings and silky undergarments, which she wears provocatively, to produce an image of restrained physicality.

In the last years Edith, ever-mindful of the need to keep income flowing, encouraged Schiele to maintain his output of erotic drawings for sale, which was necessary at least until the final, and ironically triumphant, exhibition at the Secession in March 1918. This unfinished watercolor was doubtless a response to that need but indicates the numbed eroticism which contrasts so sharply with the heady explicitness of the early, trauma-ridden years. This charming image, in its restraint and gentleness, is a manifesto to Schiele's later style of erotic art.

The Family, 1918

Oil on canvas
59×59 inches (150×150 cm)
Österreichische Galerie, Vienna

Although unfinished at the time of Schiele's death, *The Family*, initially entitled *Squatting Couple*, and shown under that title in the March Secession of 1918, is a remarkably balanced and unified composition and as such is typical of Schiele's later style.

The addition of the child, a sentimentally painted portrait of Schiele's nephew Toni, unifies the family group, of mother surrounded by father and son staring off into space with only Schiele confronting the viewer with a doleful smile. Mother and child create a coherent oval format with the squatting father-figure stacked behind, effectively framing the other two figures but in turn helping to stress the fact that all three are given equal visual prominence. There is little or no foreshortening; each figure has its own pictorial space.

The father-figure, with its melancholic 'separateness,' is closer to the darkness behind, but is still essentially integrated in painterly and thematic terms with the other figures. It forms a final self-image of resignation but lacks the angst and agony of former years.

Edith did not pose for this masterpiece; Schiele deemed her to be too plump at this stage, and she herself had strong reservations about posing for nude portraits. Her presence as mother-figure and lover, however, is indirectly felt. The painting, in presenting Schiele as both father-figure and creator of a family, is a late manifesto for a contented marriage. It heralded the announcement of Edith's pregnancy, proclaimed in the spring of 1918 and terminated, tragically, by her death in October.

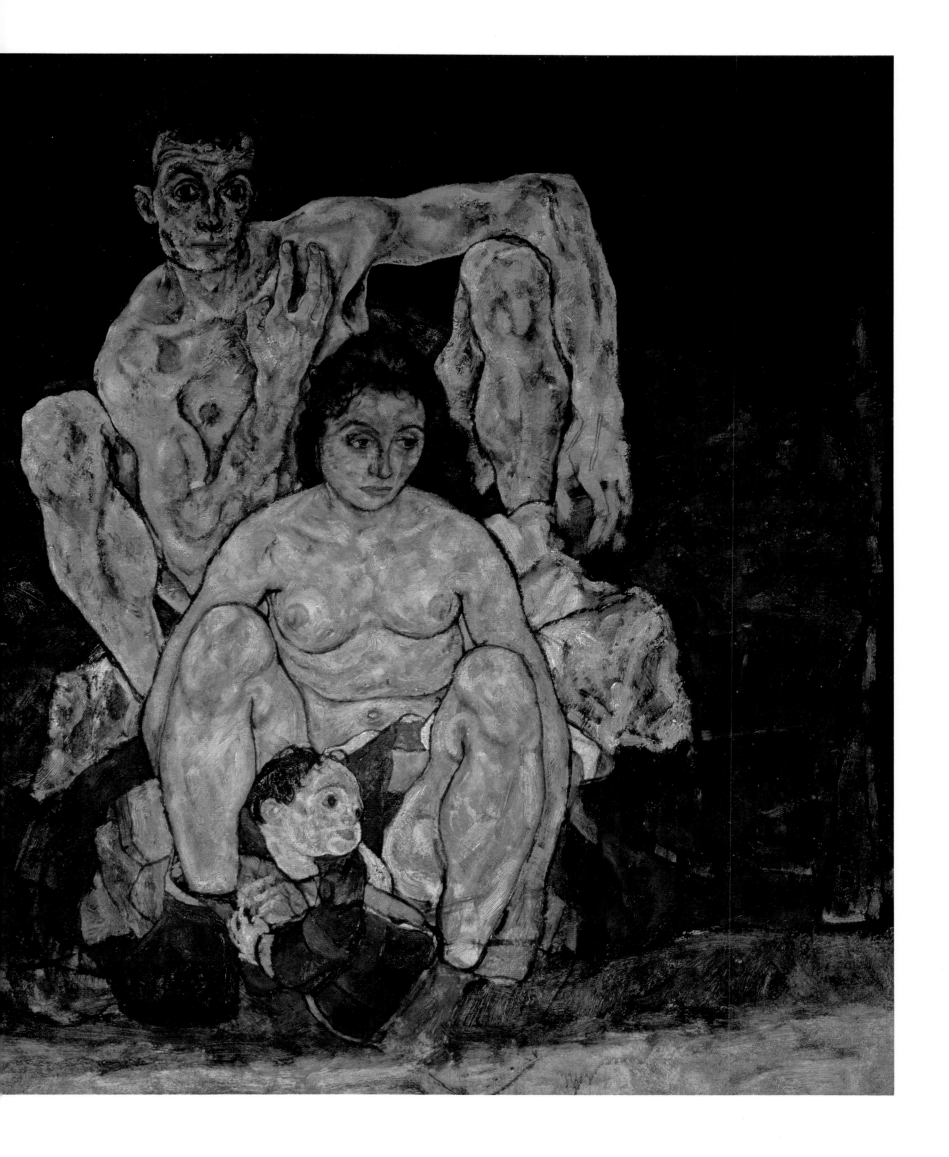

Short Bibliography

This bibliography is very selective and the reader is referred for fuller bibliographical references to Christian M Nebahey *Egon Schiele, Leben, Briefe, Gedichte*, Salzburg and Vienna, 1980

L'Apocalypse Joyeuse: Vienne 1880-1938 (exhibition catalogue, Centre Georges Pompidou, Paris, 1986)

Comini, Alessandra *Egon Schiele's Portraits*, Berkeley, CA, 1974

—— *Schiele in Prison*, London, 1974

Egon Schiele (exhibition catalogue, Marlborough Fine Art, London, October, 1964)

Egon Schiele (exhibition catalogue, Marlborough Fine Art, London, February, 1969)

Egon Schiele (exhibition catalogue, Fischer Fine Art, London, November, 1972)

Leopold, Rudolph *Egon Schiele*, Oxford, 1973

Schroder, Klaus Albrecht and Szeemann, Harald, eds *Egon Schiele and his Contemporaries*, London, 1989

Selz, Peter 'Egon Schiele,' *Art International*, iv, 10, 1960, p. 39f

Vergo, Peter *Art in Vienna 1898-1918*, Oxford, 1975

Werner, Alfred 'Schiele and Austrian Expressionism,' *Arts*, xxxv, 1, October, 1960, p. 46

Whitford, Frank *Egon Schiele*, London, 1981

Wilson, Simon *Egon Schiele*, Oxford, 1980

Index

Acknowledgments

The author would like to thank the following for help and encouragement: Joanna Wagstaffe, Suzannah Perry, Richard Humfreys, Chelsea Football Club, the Tate Library Staff, Frank Whitford, Simon Bone-Marlow, Geoff, Fred, and Tony, Tim Jones, John Owen, Mike Watson, and finally, Aileen Reid and Moira Dykes, my editor and picture researcher respectively. The publisher would like to thank Sue and Mike Rose who designed this book; Pat Coward who prepared the index, and the following institutions, agencies, and individuals for permission to reproduce the illustrations:

Archiv für Kunst und Geschichte: page 12
Deutsches Theatermuseum: page 15(below)
Fischer Fine Art Limited, London: pages 17, 49
Galleria Nazionale d'Arte Moderna, Rome/Photo SCALA: page 13
Graphische Sammlung Albertina, Vienna/Photo Lichtbildwerstatte Alpenland: pages 6, 7, 8, 9, 16(left), 23, 24(all three), 25, 31, 32, 41, 42, 44, 45, 50-51, 52-53, 55, 59, 61, 64, 65, 66, 67, 71, 80, 86, 88, 99, 105
Collection, Solomon R Guggenheim Museum, New York, Partial Gift, Dr and Mrs Otto Kallir, 1969: pages 82
Collection Haags Gemeentemuseum, The Hague: page 97
Hessisches Landesmuseum, Darmastadt: page 29
Historisches Museum der Stadt Wien, Vienna: pages 2, 16(below), 30, 58, 62, 70, 72
Kunsthaus, Zurich: page 34

The Minneapolis Institute of Arts, Minneapolis, Gift of the PD McMillan Land Company: page 85
Collection, The Museum of Modern Art, New York/ Courtesy Galerie St Etienne, New York: page 40
National Gallery, Oslo/Photo Jacques Lathion: page 11
National Gallery, Prague: pages 33, 90-91, 106
Neue Galerie am Landesmuseum Joanneum, Graz: pages 27, 39, 48
Neue Galerie der Stadt Linz/Wolfgang Gurlitt Museum: pages 1, 38, 78-79
Neue Pinakothek, Munich/Photo ARTOTHEK: pages 76-77
Niederösterreichisches Landesmuseum, Wien/Photo Lichtbildwerstatte Alpenland: pages 28, 36-37
Öffentliche Kunstsammlung, Kunstmuseum, Basel/ Colorphoto Hinz, Basel: pages 21, 22(below)
Österreichische Galerie, Vienna/Fotostudio Otto: pages 14(below), 20(below), 35, 73, 92-93, 95, 102-103, 104, 108-109
Österreichisches Museum für Angewandte Kunst/Photo Georg Mayer: page 10
Private Collection/Courtesy Galerie St Etienne, New York: pages 14(top), 19(below), 22(top), 26, 46, 68, 89
Private Collection/Phaidon Press Ltd: page 57
Collection Rudolf Leopold/Courtesy Galerie St Etienne, New York: pages 15(top), 18, 19(top), 20(top), 100-101
Statens Konstmuseer, Stockholm: page 15(top right)
Collection Thyssen-Bornemisza, Lugano, Switzerland: page 75